A FABLE FOR TOMORROW

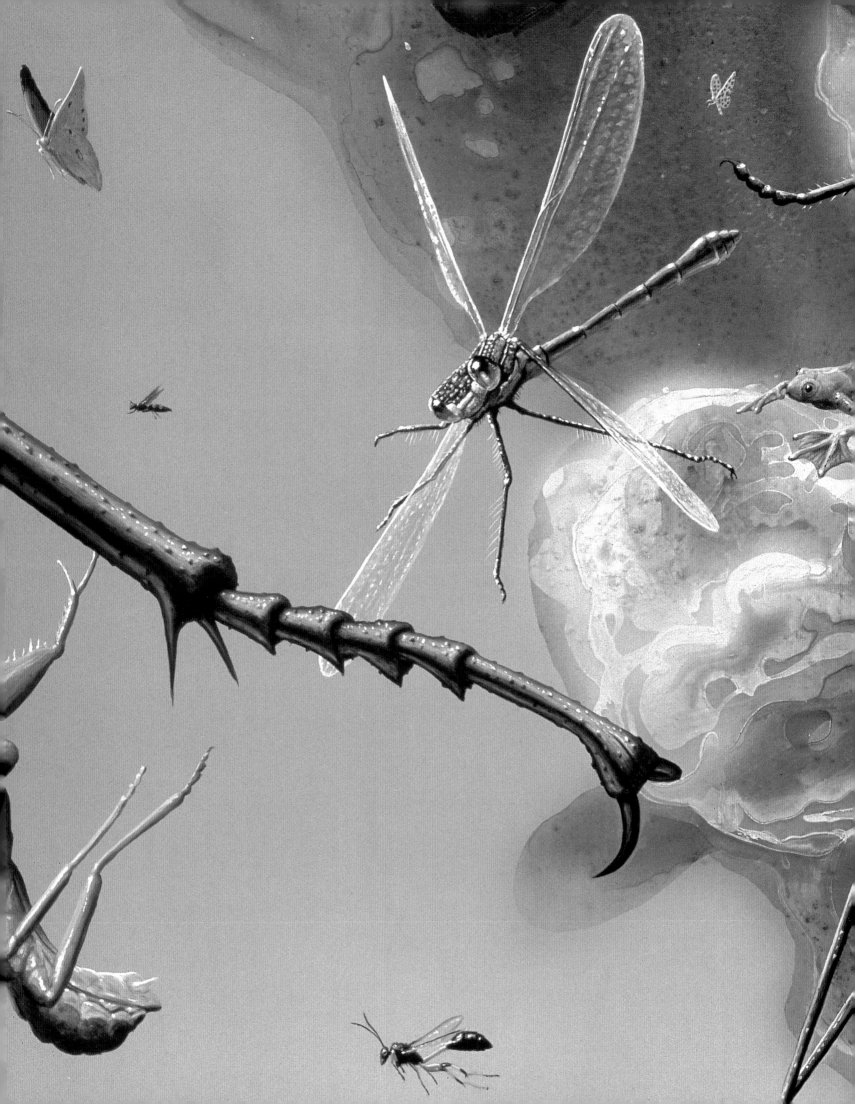

SMITHSONIAN AMERICAN ART MUSEUM, WASHINGTON DC,
IN ASSOCIATION WITH D GILES LIMITED, LONDON

JOANNA MARSH

with contributions by

KEVIN J. AVERY

THOMAS LOVEJOY

ALEXIS
ROCKMAN

A FABLE FOR TOMORROW

ALEXIS ROCKMAN
A FABLE FOR TOMORROW

Chief of Publications: Theresa J. Slowik
Designer: Jessica L. Hawkins
Editor: Jane McAllister
Production editor: Mary J. Cleary

 Smithsonian American Art Museum

The Smithsonian American Art Museum is home to one of the largest collections of American art in the world. Its holdings—more than 41,000 works—tell the story of America through the visual arts and represent the most inclusive collection of American art in any museum today. It is the nation's first federal art collection, predating the 1846 founding of the Smithsonian Institution. The museum celebrates the exceptional creativity of the nation's artists whose insights into history, society, and the individual reveal the essence of the American experience.

The Renwick Gallery, a satellite museum of the American Art Museum, collects and displays American crafts and decorative arts from the nineteenth to the twenty-first centuries, and is located on Pennsylvania Avenue at 17th Street NW.

For more information or a catalogue of publications, write: Office of Publications, Smithsonian American Art Museum, MRC 970, PO Box 37012, Washington, D.C. 20013-7012.

Visit the Museum's Web site at AmericanArt.si.edu.

Cover: *Biosphere: Orchids* (detail), 1993; see p. 77.
Title page: *Cataclysm* (detail), 2003; see p. 103.
pp. 6-7: *Evolution* (detail), 1992; see pp. 32–33.
p. 8: *Host and Vector* (detail), 1996; see p. 81.
p. 14: *Gateway Arch* (detail), 2005; see p. 108.
p. 62: *The Conversation* (detail), 2001; see p. 99.
p. 124: *Manifest Destiny* (detail), 2003-4; see pp. 106-7.
p. 144: *Railyard* (detail), 2008; see p. 119.
p. 156: *The Reef* (detail), 2009; see p. 123.

Printed and bound in China.

Library of Congress
Cataloging-in-Publication Data

Marsh, Joanna, 1976-
Alexis Rockman : a fable for tomorrow / Joanna Marsh; with contributions by Kevin J. Avery, Thomas Lovejoy.
 p. cm.
"Published on the occasion of the exhibition *Alexis Rockman: A Fable for Tomorrow*, held at the Smithsonian American Art Museum, November 19, 2010-May 8, 2011."

Includes bibliographical references and index.

ISBN 978-1-904832-86-7 (cloth cover : alk. paper)
ISBN 978-0-9790678-8-4 (soft cover : alk. paper)

1. Rockman, Alexis, 1962—Themes, motives–Exhibitions. 2. Nature–Effect of human beings on–Art–Exhibitions. I. Rockman, Alexis, 1962- II. Avery, Kevin J. III. Lovejoy, Thomas E. IV. Smithsonian American Art Museum.
V. Title.

ND237.R6758A4 2010
759.13–dc22

 2010024991

First published in 2010 by GILES, an imprint of D Giles Limited, in association with the Smithsonian American Art Museum.

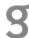

D Giles Limited
4 Crescent Stables
139 Upper Richmond Road
London, SW15 2TN, UK
www.gilesltd.com

CONTENTS

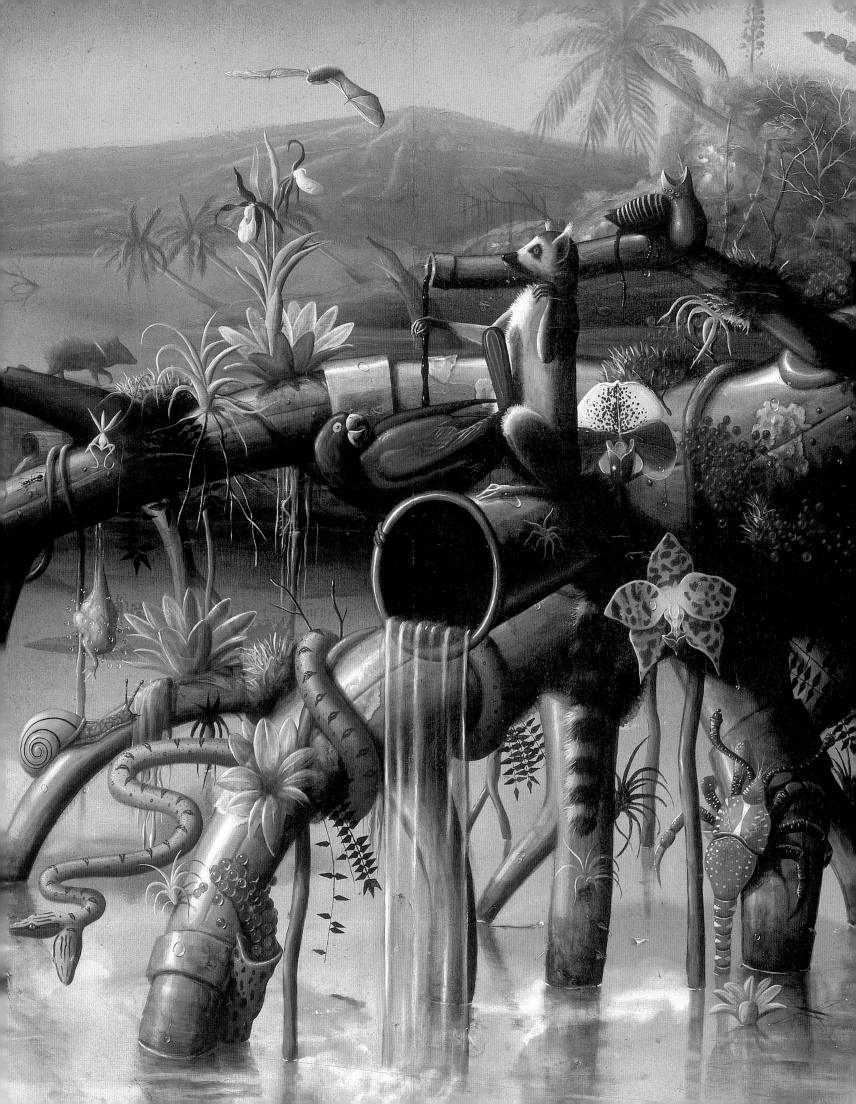

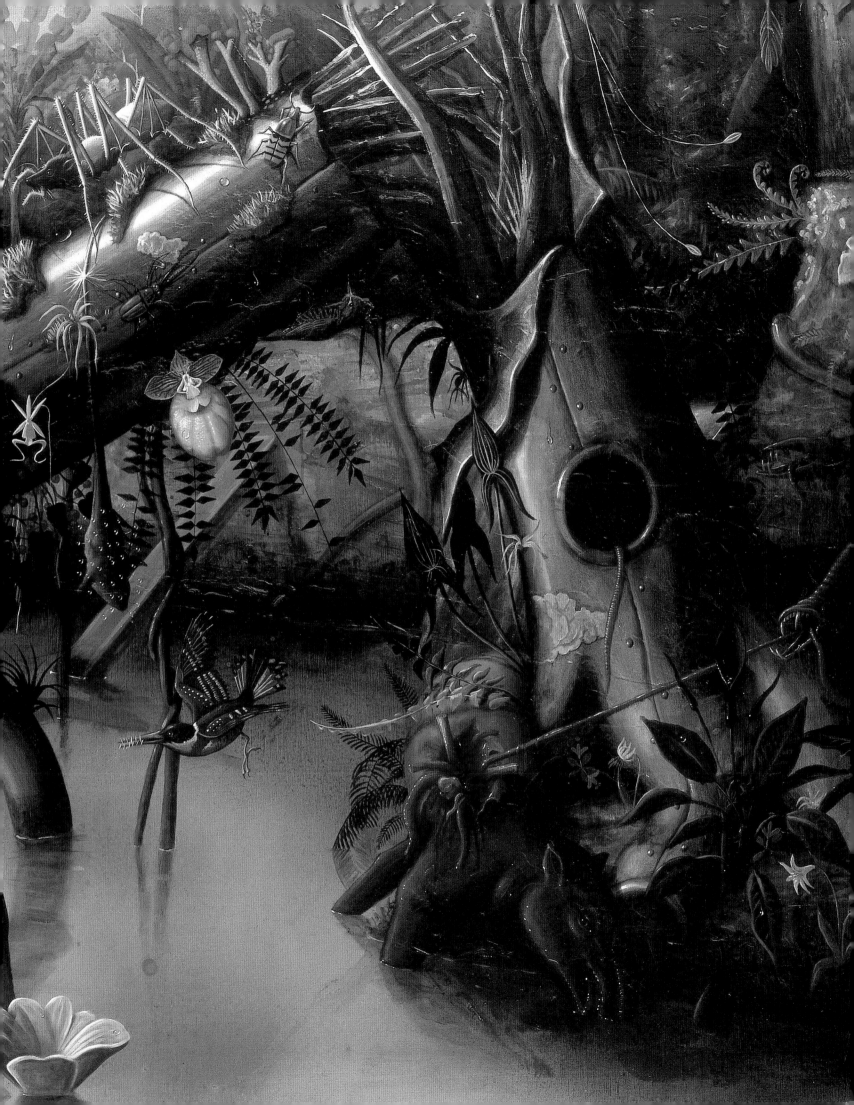

The Smithsonian American Art Museum gratefully thanks the following individuals for their generous support for *Alexis Rockman: A Fable for Tomorrow:*

The Cowles Charitable Trust
Wayne Fingerman
Dorothy Tapper Goldman
Barbara and Jonathan Lee
Nion McEvoy
Pamela K. and William A. Royall Jr.
Holly and Nick Ruffin
Betty A. and Lloyd G. Schermer
Sheila Duignan and Mike Wilkins

The Smithsonian American Art Museum is grateful to the following lenders to this exhibition:

Pamela C. Alexander
London Shearer Allen
Anonymous lenders
Baldwin Gallery,
 Aspen, Colorado
Barry Blinderman
Ruth and Jacob Bloom
Carlos Brillembourg
Melva Bucksbaum and
 Raymond Learsy
Cincinnati Art Museum, Ohio
Mr. and Mrs. Henry P. Davis
Beth Rudin DeWoody
Katherine Dunn
Richard Edwards
Andrea Feldman Falcione
 and Greg Falcione
Carol and Arthur Goldberg
Jay Gorney
Morris and Sherry Grabie
Haggerty Museum of Art,
 Marquette University
Samuel and Ronnie Heyman
Joy of Giving Something, Inc.

Marshall and Wallis Katz
Mr. and Mrs. Jonathan Lee
Rachel and Jean-Pierre Lehmann
Ninah and Michael Lynne
Judy and Robbie Mann
Museum of Sex, New York
Nestlé USA
Tim Nye
The Pappas Family
Michael Polsky
James and Abigail Rich
Alexis Rockman
Pamela K. and William A. Royall Jr.
The Rubell Family
Jeffrey Seller and Joshua Lehrer
Chuck and Joyce Shenk
William G. Spears
George R. Stroemple
Virginia Museum of Fine Arts,
 Richmond
Waqas Wajahat
Whitney Museum of American Art,
 New York

America's first great painting tradition began in the 1820s during the Great Awakening of religious ferment. In this high-keyed atmosphere, the intensely realistic landscapes of the Hudson River school became our first national school of art, giving visual form to ideas that underpinned the new democracy. Our verdant valleys and hills, ancient trees and crystalline rivers, glowing sunsets and rainbows all encouraged the utopian idea that America is God's creation, a Promised Land for those escaping political repression and religious intolerance in Europe. Thomas Cole painted *The Subsiding of the Waters of the Deluge* with this in mind, showing the optimistic aftermath of the Great Flood; in the distance floats the ark containing Noah's faithful, ready to populate a pristine New World, washed clean of the sins and errors of the Old World.

Alexis Rockman borrows the detailed realism of such Hudson River landscapes and turns this vision of the world upside down. He bases his paintings of environmental degradation on modern science, but he rejects the scientists' dispassionate objectivity. Instead, like an Old Testament Jeremiah, he paints an apocalyptic dystopia of biblical proportions. He shows God's creation laid waste by greed and ignorance.

It's almost a surprise that Rockman didn't go into film, as he aspires to a totalizing impact that is rarely associated with fine painting today. Viewing his astounding mural *Manifest Destiny*, an image of Brooklyn under water, feels like a 3-D experience with Dolby surround sound, a creative combination of *Ben-Hur* and *Waterworld*. He pushes the vocabulary of landscape painting and natural history dioramas to a new intensity. The result is art that is part fiery anger and part lamentation, a portrait of epic tragedy unfolding, foreseen by a prophet. His anger is sometimes shrill and off-putting, but it never completely masks the low moan of grief for a sacrificed past and lost future that runs through Rockman's entire enterprise.

Rockman's paintings summon the deepest concerns of science, religion, politics, and art, creating a common ground of concern. His career has unfolded during another period of religious fervor in America and across the world; now religion and science combine in the belief that stewardship of the planet is a moral responsibility. As I write this foreword, debate is raging about a massive oil leak in the Gulf of Mexico that may also be of biblical proportions, with all outcomes and impacts uncertain, underscoring the urgency of Rockman's message. It is a message for all humanity.

Alexis Rockman: A Fable for Tomorrow includes forty-seven artworks that trace the artist's career from the early lyrical meditation called *Pond's Edge* to the endangered beauty of *The Reef*. Three large-scale paintings—*Evolution*, *Manifest Destiny*, and *South*—are ambitious markers of Rockman's conceptual development.

Joanna Marsh, the James Dicke Curator of Contemporary Art, conceived this survey and worked with Rockman on the painting selection. Her catalog essay weaves the themes of Rockman's career and the history of America's environmental movement into a cohesive narrative. Contributing authors Kevin Avery and Thomas Lovejoy offer insights into the marriage of art and science in Rockman's oeuvre from the perspective of a distinguished art historian and a celebrated environmental biodiversity scholar.

The Smithsonian American Art Museum is an ideal venue for this cross-disciplinary approach. The Museum's collection of landscapes across more than two hundred years provides a superb context for Rockman's works, while the Smithsonian-wide emphasis on natural science and biodiversity affords a still richer framework for understanding. It is a great pleasure to present an exhibition whose themes are trenchant and timely.

Elizabeth Broun
The Margaret and Terry Stent Director
Smithsonian American Art Museum
May 2010

ACKNOWLEDGMENTS

In the spring of 2004, Alexis Rockman's painting *Manifest Destiny* premiered at the Brooklyn Museum of Art to inaugurate the museum's newly renovated main entrance. The post-apocalyptic vision of Brooklyn's waterfront was like nothing I had seen before. It has haunted me for years and was still fresh in my mind in 2008 when I found myself standing in front of *South* at Leo Koenig's Chelsea gallery. While the frozen terrain of the Antarctic landscape bore little resemblance to the overheated world of *Manifest Destiny*, its environmental message was unmistakably consistent. The painting reignited my interest in Rockman's work and began a conversation that has culminated in this publication and accompanying exhibition.

Alexis Rockman: A Fable for Tomorrow would not have been possible without the generosity of the lenders, both private and institutional, who entrusted us with their paintings. Rockman is a prolific artist; he has produced an exceptionally strong body of work over the last twenty-five years and established a diverse network of passionate supporters. Many collectors got in touch during the exhibition planning process and offered to lend their treasured paintings even before formal loan requests were drafted. In order to provide a thorough overview of Rockman's career, it was necessary to focus on a discrete selection of works from each period and/or series. As a result many notable pieces could not be included in the exhibition, but they are reproduced and discussed on the pages of this catalogue.

My great thanks to editor Jane McAllister, whose sharp eye and constructive suggestions enhanced the entire publication. Essayists Kevin Avery and Thomas Lovejoy deserve special acknowledgment for their enlightening contributions to the catalogue. Despite a wealth of existing scholarship on Rockman's work, both authors have brought a fresh perspective to their respective subjects. Avery's extensive research on nineteenth-century landscape painting and the development of panoramic and dioramic display traditions provides a critical backdrop against which to evaluate Rockman's own "panoramic" paintings and the nineteenth-century sources they quote. By contrast, biodiversity expert Tom Lovejoy has placed Rockman in the context of present-day environmental science and politics.

At the Smithsonian American Art Museum, I am indebted to director Elizabeth Broun for her resolute support of this project. Her incisive comments on the lead essay stimulated an ongoing dialogue about art and the environment. Chief curator Eleanor Jones Harvey was an enthusiastic champion of the exhibition from day one. I am profoundly grateful for her encouragement, equanimity, and wise counsel. Toby Jurovics served as a sounding board on

innumerable issues, as did Ross Randall. Deborah Earle ably assisted with research and permissions. Curatorial assistant Jennifer Bauman contributed with intelligence and good humor to many aspects of the exhibition. I am particularly appreciative of her incomparable research skills. In the Publications department, Jessica Hawkins developed the imaginative book design, while Theresa Slowik and Mary Cleary shepherded the manuscript through editing, design, and production on an impossibly short schedule. Claire Larkin and Eunice Park Kim helped produce an elegant gallery installation. Sincere thanks to Marie Elena Amatangelo for coordinating the efforts of Smithsonian staff, and to Elaine Webster for helping to raise funds for the project. As always, my tremendous appreciation goes to our Commission for their steadfast support of the Museum's contemporary art program.

I am grateful to many individuals who provided essential information on the location of Rockman paintings and details of the artist's early career: Richard Edwards and Kiki Jai Raj, Baldwin Gallery, Aspen; Leo Koenig and Elizabeth Baloug, Leo Koenig Inc., New York; Jay Gorney, Mitchell-Innes & Nash, New York; John Post Lee and Meredith Rosenberg, BravinLee Programs LLC, New York; Marc Jancou and Kelly Woods, Marc Jancou Contemporary, New York; Anne Bruder, Sperone Westwater, New York; John Berggruen and Karen Gutfreund, John Berggruen Gallery, San Francisco; Katherine Thorpe, Sotheby's, New York; Charlotte Perrottey, Christie's, New York; Michael Kohn, Michael Kohn Gallery, Los Angeles; Catherine Clark, Catherine Clark Gallery, San Francisco; Dawn Striff, Nestlé Corporation USA; and Linda Tesner, curator for the George R. Stroemple Collection.

Over the past two years, I have been supported by several bright interns who facilitated my research and took it upon themselves to become experts on Rockman's work. My heartfelt thanks go to Kay Brungs, Allison Dietz, Laura Fravel, and Sarah Primm. Other individuals deserving of mention are Channah Farber and Linda Cheverton Wick, both of whom endured countless conversations about the exhibition and responded with characteristic generosity and insight. My sincere thanks must also go to Alexis and his agent, Waqas Wajahat, who helped galvanize my thinking about the project and contributed immeasurably to its successful realization. Finally, my love and gratitude to Bennett, Patty, Lisa, and Alex for their endless patience and support.

Joanna Marsh
The James Dicke Curator of Contemporary Art

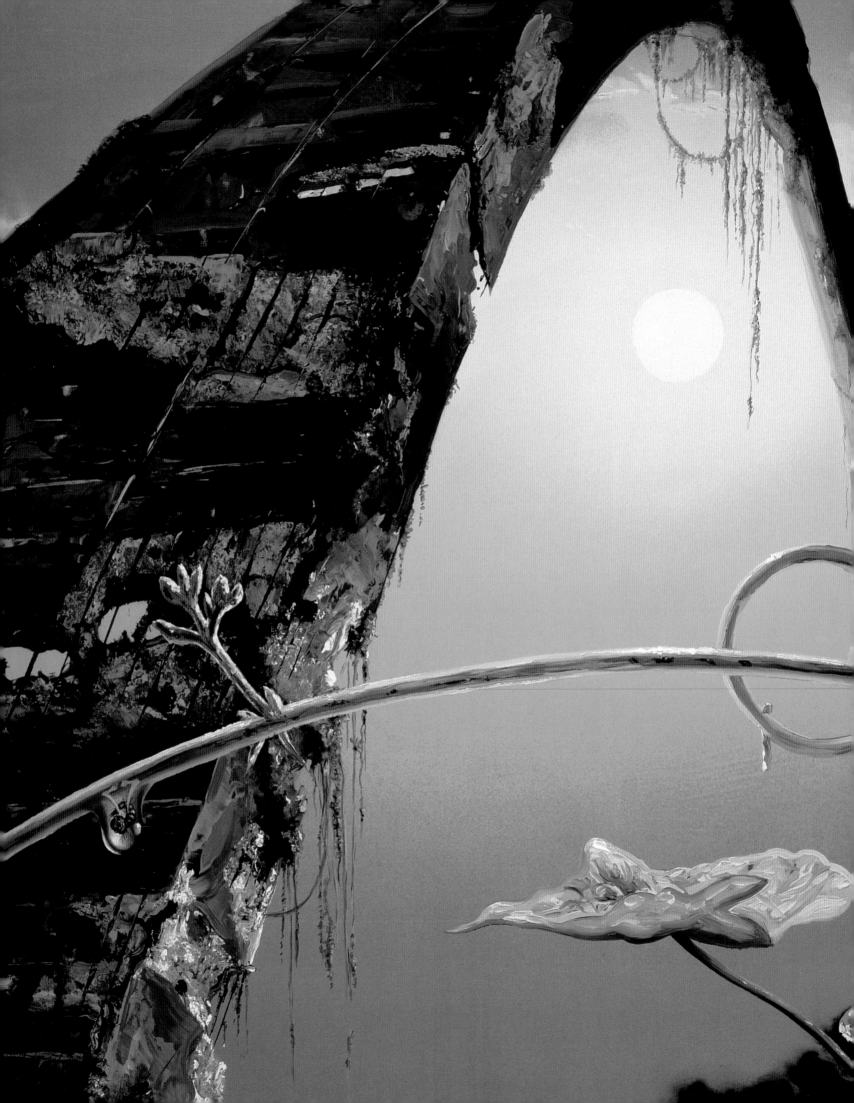

Joanna Marsh

Alexis Rockman

A FABLE FOR TOMORROW

Alexis Rockman's art defies easy categorization. His intricately associative paintings drift in unmarked territory, shifting between place, perspective, and genre with unexpected ease. Past, present, and future elide to form an image of the natural world that is familiar yet foreign, in which prehistoric creatures inhabit the ruins of modern monuments, and endangered eco-systems float amidst the cosmos. Such landscapes boast unimaginable bounty. Filled with shimmering detail and brilliant color, they are spaces of wonder-ment and awe. But as in nature, Rockman's paintings are besieged by tempests great and small. At times, the forces manifest with ravaging clarity, exposing the entropic pull toward natural and societal decline. The result is a body of work that hovers between the extremes of creation and destruction. These terrifying polarities have inspired artists for generations and are the basis for one of history's most compelling stories: the apocalypse.

The apocalyptic narrative, made visual in Rockman's work, has long been recognized as a major thematic component of art, literature, and film.[1] It looms in the background of cultural consciousness as an expression of our deepest social anxieties and a means of contending with the tragedies that buffet humanity. While the look and language of apocalypse has changed over time, from its biblical roots in the book of Revelation to its secular inter-pretation as a cataclysmic end, the events of history have conspired to ensure the supremacy of such myths. In the visual arts, eschatological imagery belongs to a pictorial tradition that stretches back to the Middle Ages with ninth-century illuminated manuscripts and liturgical texts. Distinguished artists from nearly every generation, including Albrecht Dürer, Hieronymus Bosch, William Blake, James Ensor, and Yves Tanguy, have employed apocalyptic tropes. In literature, apocalyptic rhetoric abounds in the tales of Edgar Allan

Poe; canonical science fiction texts by Ray Bradbury and H. G. Wells; and the postmodern fiction of Don DeLillo, Cormac McCarthy, and Kurt Vonnegut.

The filmic response to eschatological narrative is equally rich, despite its relative infancy within the larger genre. Often considered a subcategory of popular science-fiction cinema, the celluloid apocalypse has become a staple of popular culture and the primary creative response to the chaos that surrounds us. Recently, the threat of global climate change has spawned a deluge of natural-disaster films and docudramas that capitalize on our fear of such events and morbid fascination with their aftermath.[2] Although the science in science-fiction films is often sacrificed for the sake of a compelling narrative, the doomsday visions of Hollywood cinema nonetheless serve an important role in raising public awareness about social and environmental issues. As apocalyptic dangers, from nuclear annihilation to viral pandemic, have intensified, so too has the prevalence of apocalyptic storytelling. It is evident in the arts as well as the sciences. Over the last sixty years, apocalyptic narrative has become a common feature of environmental literature, employing many of the same fictive strategies as found in pop culture.[3] Nowhere is this more compellingly evident than in Rachel Carson's landmark publication *Silent Spring*.

Published in 1962, *Silent Spring* is considered one of the most influential and controversial texts ever written in the name of environmental reform. Carson's alarming exposé of the widespread dangers associated with agricultural pesticides stunned the public and infuriated industry executives. The central controversy of *Silent Spring* arose from its opening chapter, "A Fable for Tomorrow," in which Carson combines two seemingly incompatible literary genres—mythic narrative and factual reportage—to make real the hazard of toxins such as DDT. Written like a classic fairy tale, the prologue describes an idyllic farming community where "all life seemed to live in harmony with its surroundings."[4] The bucolic scene quickly deteriorates, however, as the landscape and its inhabitants fall victim to the effects of chemical pesticides. At the prologue's conclusion, Carson reveals that her fable is in fact a composite portrait of actual events:

I know of no community that has experienced all the misfortunes I describe. Yet every one of these disasters has actually happened somewhere, and many real communities have already suffered a substantial number of them.

A grim specter has crept upon us almost unnoticed, and this imagined tragedy may easily become a stark reality we all shall know.[5]

By concentrating the dire incidents into the space of a few pages and the setting of a fictional town, Carson heightens the drama of her scientific findings. Her visionary polemic spawned both intense criticism and extensive imitation, establishing conventions that have become a standard part of environmental rhetoric and activist literature.[6] More important, *Silent Spring* captured the attention of mass culture and galvanized the American environmental movement through its lyrical merging of allegory and empiricism. Carson's eloquent text documents not only the culmination of a distinguished career but also an ideological transition from acute ecological awareness to resolute environmental ethic. The present survey of Alexis Rockman's oeuvre follows a similar trajectory, as it traces the artist's development in concert with key themes and events from the history of the American environmental movement.

EARLY WORK

From Natural History to Ecological Imagination

Over the last twenty-five years, Rockman's art and attitudes have evolved from a focus on the mysteries of nature to the machinations of mankind. He has emerged as an environmental advocate in the spirit of Rachel Carson, bringing together imaginative and analytic imagery to raise awareness about the state of our planet. His work resonates with the salient features of "A Fable for Tomorrow." Like Carson's, Rockman's conceptual approach is steeped in history but equally forward-looking; he employs a self-consciously didactic mode of representation to comment on the folly of man; and he provocatively blurs the boundary between genres and disciplines. Finally, his vivid images contrive a fictional world anchored in disturbing reality. The confluences of art and science, fantasy and erudition are a defining feature of Rockman's work and recurring themes in the story of environmental reform.

The roots of modern ecology and environmental thought begin with the pioneering work of German naturalist and explorer Alexander von Humboldt. Widely regarded as the world's premier man of science

in the early nineteenth century, Humboldt sought to lay bare the inherent harmony that unites all aspects of nature. Through his extensive travels and publications, Humboldt demonstrated the necessity of a "universal" methodology informed by geology, climatology, physics, natural history, economics, social theory, and aesthetics. His conception of a holistic and interconnected natural world reached far beyond the sphere of scientific thought, animating the life and work of major cultural figures such as Frederic Church, Ralph Waldo Emerson, and Charles Willson Peale.[7] Their formulations of art and literature exemplify what Humboldt believed about the interaction between feeling and intellect. By placing Enlightenment rationality alongside Romantic fervor, Humboldt became one of the most famous intellectuals of his time.

This particular model was also of critical importance to Charles Darwin. From Humboldt, Darwin developed a passion for exotic travel and pragmatic observation that would inform his early career and start the young naturalist on a path toward his theory of natural selection. Humboldt's *Personal Narrative*, about his exploration in Latin America between 1799 and 1804, was of particular import to Darwin as he embarked

aboard the *Beagle* on his own scientific adventures. Darwin's journals from the voyage, in particular his account of the Brazilian rain forest, reflect Humboldt's synthesis of analytic and passionate description: "Here I first saw a tropical forest in all its sublime grandeur—nothing but the reality can give any idea how wonderful, how magnificent [it] is.... I formerly admired Humboldt, I now almost adore him. [H]e alone gives any notion of the feelings which are raised in the mind on entering the Tropics."[8] During the next two decades, Darwin crafted a theory of evolution firmly grounded in Humboldtian principles of ecological interdependence. The elder scientist's image of ineffable natural harmony, however, could not withstand the impact of Darwin's competitive worldview. In 1859, *The Origin of Species* was published and Humboldt died in Berlin. The notion of a benign and harmonious natural world was forever supplanted by a veritable battleground of opportunism and chance—both central tenets of Darwinian thought.

Humboldt's legacy, however, survives today in the work of twenty-first-century scientists, scholars, and artists who continue to nurture the humanist drive for connectivity. In many ways, Rockman's aesthetic program is a fulfillment of this

I

Ernst Ludwig Taschenberg, "Aasinsekten an einem Maulwurfe," 1892, from *Die Insekten Tausendfussler und Spinnen*. Picture Collection, The New York Public Library, Astor, Lenow and Tilden Foundations

integrative vision, as it reaches across disciplines incorporating all manner of artistic and scientific information.[9] The artist's view of nature, on the other hand, is rife with Darwinian struggle. His earliest pictures depict scenes of primal conflict and relentless adaptability tempered by an aura of childlike whimsy. *Pond's Edge* [plate p. 64], one of Rockman's first paintings inspired by a natural history subject, introduces a classic protagonist of evolutionary theory— the *Periophthalmus*, or mudskipper, an amphibious fish that can "walk" on land. We are plunged directly into the scene, as if peering through the side of an aquarium tank, and confronted with the monumental face of a mudskipper resting at the surface of an impossibly still pond. Despite its scale, the turgid creature bears the stylized innocence of a storybook character. His bulging eyes scan for food: skyward toward a dragonfly and downward to a mosquito larva. A precise blue line delineates sky from water, allowing us to see the animal from both above and below the water's edge. The effect is surreal and vaguely scientific, recalling the cross-sectional drawings in a biology textbook.

The compositional device employed in *Pond's Edge* is a signature of Rockman's work of the last twenty

years, providing a means to simultaneously represent terrestrial and aquatic ecosystems. In this early picture, the division remains largely abstract, anticipating the artist's shift to a more detailed mode of representation between 1986 and 1988. Like the mudskipper, Rockman appears poised between two different states, but his intentions are clear: to capture the animal world with instinctual precision.

In *Object of Desire* [plate p. 66], Rockman transitions to a more overt adversarial power dynamic. The painting is based on an image by German entomologist Ernst Ludwig Taschenberg, which documents an experiment by Taschenberg's French colleague Jean-Henri Fabre [fig. 1]. Fabre's unorthodox trials were attempts to prove the "intelligence" of insects, and here the scientist explores how insects locate and consume a carcass. The illustration shows a mole suspended from a branch just above the ground. Wildflowers bloom in the foreground, while a menagerie of winged insects blankets the animal's fur. The scene is almost idyllic. Rockman's adaptation, in contrast, is purely Darwinian. Set against a caustic orange background, the body of a small mammal appears to liquefy before our eyes as a mass of green beetles overwhelm its corpse. The

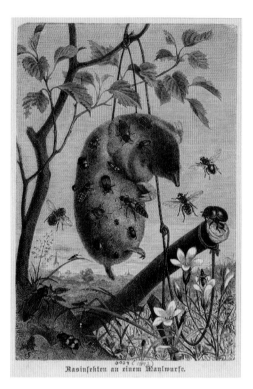

Aasinsekten an einem Maulwurfe.

2

Sam Taylor-Wood, *Still Life*,
2001, stills from 35mm film/DVD.

dripping paint and disintegration of form create a visceral sense of natural consumption and introduce two recurring themes: the inexorable cycle of life and death, and the inevitable march from proliferation to decay. Rockman's allusion to these ideas, though often elliptical, borrows from a variety of art historical traditions.

The human preoccupation with mortality has taken many different forms in the visual arts. During the seventeenth century, still-life painting evolved as a popular expression for the transience of life. Often referred to as *nature morte* (literally "dead nature"), the genre encompasses a wide range of subject matter, from flowers and fruit to images of dead game and insects devouring plants, which serve as a reminder of death—a memento mori. These motifs, particularly flowers, were executed with microscopic accuracy in an effort to showcase each compositional element to fullest advantage. The rapid development of botanical observation and classification during this period also fostered the emphasis on scientific naturalism. More recently, the mediations on life and death that pervade Baroque still-life painting have been resuscitated by a generation of contemporary artists.[10] Christian Boltanski, Anselm Kiefer, and Sam Taylor-Wood are just a few

of the countless artists who have taken the genre beyond its traditional imagery. Rockman cites Kiefer, in particular, as a source of inspiration. Kiefer's elegiac paintings explore the fraught territory of German history using a range of organic materials, including dirt, straw, seeds and clay. British filmmaker Sam Taylor-Wood offers yet another contemporary parallel to Rockman's preoccupation with themes of decay and renewal. In her film *Still Life* [fig. 2], made in 2001, Taylor-Wood presents a visceral evocation of a traditional *nature morte*, in which the camera tracks the gradual deterioration of a sumptuous bowl of fruit.

Rockman's work of the late 1980s and early 1990s presents a similar vision of nature as a site of physical corruption. In *The Dynamics of Power* [plate p. 69], Rockman depicts themes of biological growth and decay in exacting detail. The painting offers a macroscopic view of an insect drama. A colony of leaf-cutting ants swarms the lifeless body of a Blue Morpho butterfly, all but obscuring the insect from view. A few lone soldiers carry aloft small fragments of the azure wings, while a tomato hornworm caterpillar looks on nearby. The action ensues upon a jewel-toned leaf that the industrious ants have already

3

Charles R. Knight, *Brontosaurus*, 1898, gouache on artist board, 18 ⅝ × 28 ½ in. The American Museum of Natural History, New York

begun to ravage. The natural chain of animal consumption reaches its apogee in *The Balance of Terror* [plate p. 67]. Again the technique of cross-sectional illustration is used, here providing an interior view of a large green apple with a mealworm at its core. The engorged insect burrows through the fruit, leaving behind a trail of feces. Meanwhile, a menacing Venus Flytrap stands to the left, waiting to capture and devour the insect. The purple, heart-shaped leaves have already ensnared an unsuspecting mosquito, and a blue butterfly hovering above seems likely to be the plant's next victim. The acidic phosphorescence of Rockman's palette contributes to the painting's eerie mood, as does the fluid handling of paint. Richly hued areas of opacity dissolve into transparent veils of glaze, creating a palpable tension between life and death.

Rockman considers *The Balance of Terror* the true start of his artistic career—an observation that is doubly significant given the painting's point of origin.[11] Based on an agricultural display (which the artist photographed and enlarged in his studio) from New York's American Museum of Natural History, the painting reveals the captivating blend of science and art that the artist first encountered while exploring

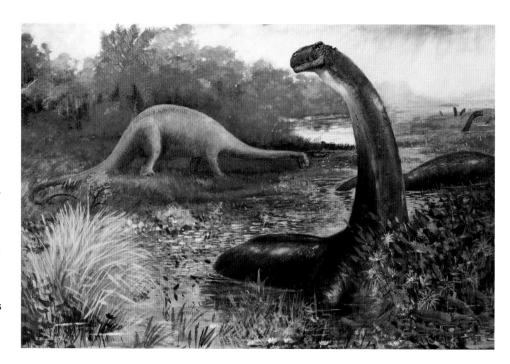

the grand exhibit halls of the Natural History Museum. Alexis Rockman's story begins in that renowned New York institution, where his mother worked as an assistant to anthropologist Margaret Mead. Surrounded by the paintings of Charles R. Knight [fig. 3] and the taxidermy of Carl Akeley [fig. 4], the young Rockman witnessed the joining of science and art to produce an experience that was equal parts education and entertainment.[12] This merging of didacticism and fancy is epitomized in the museum's habitat dioramas, to which we will return shortly, but its origins

stretch as far back as the sixteenth-century *Wunderkammer*, or cabinet of curiosities.

The modern natural history museum is a testament to the Enlightenment ideals upon which all modern museums are founded, and more specifically is a direct outgrowth of the Renaissance *Wunderkammer*. Popularized in Europe during the 1600s, cabinets of curiosities typically consisted of eclectic assemblages of plants, shells, fossils, minerals, animal skeletons, and so on. Many of the cabinets also included man-made objects: paintings, coins, medals,

classical antiquities, and ethnographic items from exotic locales. The collections, intended to present a microcosm of the universe, were loosely categorized according to origin and hierarchy, with specific sections devoted to arts and crafts, scientific instruments, and specimens from the three kingdoms of nature—animal, vegetable, and mineral.[13] While the primary purpose of the cabinets was to showcase the wealth and broad humanistic knowledge of their owners, they were equally designed to astound and mystify.

The *Wunderkammer* model, with its dual role of instruction and amusement, survived until the late eighteenth century before gradually splintering into two separate, yet parallel, museum paradigms. The bifurcated evolution of the American natural history museum is reflected in its two most influential progenitors, Charles Willson Peale—an entrepreneurial portraitist with a passion for natural science—and Phineas Taylor Barnum—a quintessential showman with a penchant for spectacle. Peale and Barnum each established enormously successful museums that combined art with astonishing displays of geological, ornithological, and zoological specimens. Despite the proprietors' sympathetic collecting interests,

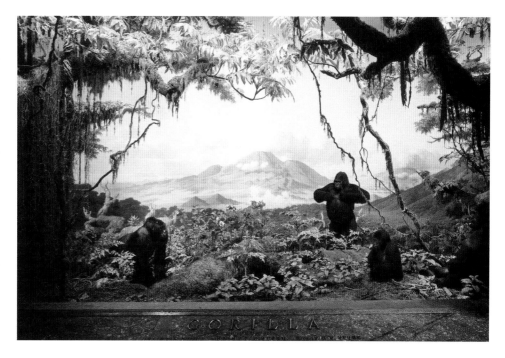

however, the underlying intention of the museums was acutely distinct.

Peale opened his Philadelphia museum in 1786 and managed the enterprise with his sons until financial distress forced the sale of the collections in the early 1840s. During those fifty-four years, the family amassed an astounding menagerie of natural history objects and paintings. The museum was founded on Peale's notion that nature is simultaneously hierarchical and harmonious. He explicated the idea in collection displays presenting the animal kingdom as rank ordered yet interdependent.

This organizing principle is evident in Peale's self-portrait, *The Artist in His Museum* [fig. 5], which describes the careful arrangement of bird specimens according to the Linnaean classification system. Like Alexander von Humboldt, Peale believed that connections within and across species represented a natural harmony, and that those relationships were the result of a cooperative rather than a competitive existence, one to be emulated by American society. Peale elucidated his concept of the natural world in exhibit catalogs and didactic labels installed throughout the

5

Charles Willson Peale, *The Artist in His Museum*, 1822, oil on canvas, 103 ¾ × 79 ⅞ in. Pennsylvania Academy of the Fine Arts, Philadelphia; Gift of Mrs. Sarah Harrison (The Joseph Harrison Jr. Collection)

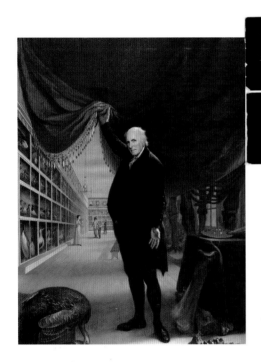

xpress purpose of was to educate the about natural science an social values.[14] In Γ. Barnum's museum but educational. operated his New York museum from 1842 to 1865 with the primary goal of entertainment and profit. He achieved those aims through ingenious public relation schemes, massive advertising campaigns, and a healthy dose of "humbug." As a savvy businessman, Barnum understood that the best way to captivate audiences and compete with other amusements was to offer the most outrageous and unlikely "discoveries." His museum combined genuine natural specimens with manufactured curiosities, like the infamous Fejee Mermaid, displayed under the guise of science.[15] Rockman similarly delights in oddities of nature, both real and fabricated. His images from the early 1990s, such as *Ornitholestes* [fig. 6], envision species and scenarios that confound our most basic assumptions of the natural world. Here, a tiny dinosaur prepares to feast on a nest of blue eggs. While the miniaturized creature recalls the trickery staged at Barnum's dime museum, the impeccable accuracy with which anatomical and botanical details are

rendered (note the glistening drops of dew in the foreground) illustrates a thoughtful respect for empirical fact. Barnum's museum epitomized this dichotomy. Although Barnum's tendency for deception was antithetical to the serious educational mission of museums as they evolved in the latter half of the nineteenth century, his natural history collections were considered among the finest of their time. Like Peale, Barnum recognized the value of assembling and displaying large collections of objects for public consumption. The emphasis on exhibition (as opposed to research) became a founding principle of the nation's most successful natural history museums. The institution that best reflected the educational ideals of the popular exhibition was the American Museum of Natural History in New York.

Founded by Albert Smith Bickmore in 1869, the American Museum of Natural History played a leading role in the perfection of taxidermy and other exhibit techniques that led to the development of habitat groups and ultimately full-fledged dioramas.[16] The dioramas at the Museum of Natural History have become an enduring childhood memory for generations of visitors, as well as a source of inspiration for countless contemporary

Alexis Rockman, *Ornitholestes*,
1991, oil on wood, 40 × 32 in.
Private Collection

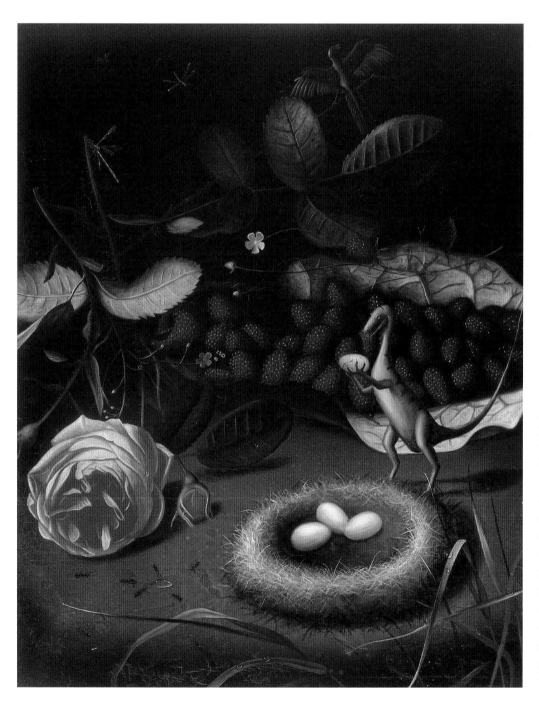

artists. Rockman recalls their magical
appeal:

> I used to spend a lot of time in the
> American Museum of Natural History
> in New York City.... The Akeley Hall
> was—and still is—the apotheosis of the
> American diorama tradition. Those
> dioramas presented lush, idealized ver-
> sions of specific sites, without humans. I
> remember looking at the mountain go-
> rilla diorama. There's a well-known pho-
> tograph of the site where that mountain
> gorilla lived. Akeley was buried there on
> that particular hill. Today it's all deforest-
> ed farmland. The diorama has become
> a time capsule. The museum exposed
> me to things about the Earth's history
> that had nothing to do with growing up
> on the Upper East Side of Manhattan.[17]

It should come as no surprise that
Rockman devoted a painting to his
favorite diorama there. *Forest Floor*
[plate p. 68] replicates a display
from the Hall for American Forests
and is the pinnacle of the artist's
early ruminations on growth and
decay. The tripartite compositional
format of Rockman's painting mim-
ics the multitiered structure and
omniscient perspective afforded by
the original diorama. Rockman vis-
ited the display frequently as a child
and young adult, and he remembers
being entranced by its unchanging

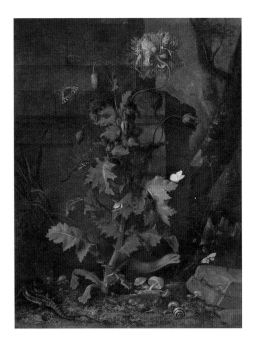

form. Time stood still in the diorama, allowing the artist to track the passage of years as he gradually grew tall enough to look down upon the forest floor. The painting is equally inspired by the canvases of Otto Marseus van Schrieck. Best known for his nocturnal scenes of woodland undergrowth [fig. 7], Van Schrieck paintings typically feature toads, snakes, and lizards that the artist captured and cared for near his home in the Netherlands. As with Van Schrieck's images, *Forest Floor* brings the spectator into a close encounter with the teeming life that hides beneath a pile of leaf litter.

The arrested moment captured in *Forest Floor* illustrates the underlying purpose of all dioramas: to present a complete view of an intact ecosystem at a specific moment in time. More important than the individual specimen (or model) on display is the message that all species are the product of complex interrelationships. To understand an organism, one must comprehend its habitat. This ecological approach extends directly from Alexander von Humboldt's notion of an interconnected world and his belief that art can inspire an appreciation for nature and scientific study. In his multivolume work *Cosmos* (1845–62), Humboldt anticipated the habitat concept by calling for

an art form that could reflect the diverse topography of the earth. He encouraged artists to accompany scientific expeditions and document the biological diversity of different regions—a practice that would later become standard in the production of habitat displays.[18] Humboldt's ecological philosophy and the environmental ethos he espoused find their ultimate expression in the museum habitat diorama.

Born in an era when scientific exploration and expeditionary travel were at their peak, habitat exhibits nurtured a reverence for nature by providing access to distant lands and exotic animals, in turn fostering a concern for environmental stewardship. The diorama gained popularity as scientists and museum professionals came to the harsh realization that nature's treasures were vanishing. Many of the earliest habitat groups at the American Museum of Natural History were conceived as a permanent record of life in specific locales.[19] By the early 1900s the habitat dioramas had become an important tool in the growing preservation movement. Not only did dioramas serve to promote awareness about imperiled species, but they also garnered the attention of government leaders who would go on to establish America's first wildlife

protection laws. Chief among these was Theodore Roosevelt, who helped raise funds for the museum's first exhibit halls and passed groundbreaking legislation to safeguard the very animals featured in the displays.[20] The power of wildlife dioramas to inspire awe and advocacy is a testament to their productive nexus of science and art.

From their first appearance, dioramas have captivated museumgoers with their mimetic fidelity and intimate portrayal of wild and elusive creatures. The classic diorama is set within a glass-enclosed alcove that ensures a limited and principally single-point perspective. The scene consists of taxidermy specimens positioned in a three-dimensional foreground of artificial soil, plants, and trees that evoke the animal's native habitat. Mounted behind the specimens, a curved landscape painting creates the impression of a limitless vista. Art historian Kevin Avery has observed that the habitat diorama "compels us primarily by its art," which draws our attention away from the objects themselves and toward the story unfolding within the scene.[21] Illusionistic and pictorial sophistication is likewise a significant source of inspiration for Rockman, who shares an undeniable affinity with the gifted fabricators of early diorama displays.

Famed taxidermist Carl Akeley, foreground artist Raymond De Lucia, and background painters William R. Leigh and James Perry Wilson, to name but a few, were each a distinctive hybrid of naturalist and artist, with specialties ranging from botany and taxidermy to traditional painting and sculpture. Their innovative techniques prompted Rockman, as a child, to create his own dioramas and vivariums (complete with painted backgrounds), and as a teenager to experiment with model making for stop-motion animation films.

While Rockman's boyhood dioramas incorporated living creatures in a realistic, albeit artificial environment, his early films made use of deceased pets to fashion mutated creatures in fictive scenarios. Inspired by the pioneering animations of Willis O'Brien in *The Lost World* (1925) and *King Kong* (1933), as well as the work of O'Brien's protégé Ray Harryhausen, Rockman's early experiments with animal mutation gave way to a similar fascination in his painted work. His mixing of species is best exemplified in *Still Life* [plate p. 70] from 1991. The painting depicts a *Wolpertinger*, a creature from Bavarian mythology fabled to inhabit Germany's alpine forests. Its body is an amalgam of various anatomical traits from rabbits, chicken, birds, and deer. The

fanged creature stands within the setting of a *vanitas* painting, surrounded by objects that represent the fleeting pleasures of earthly existence. A Bavarian flag is draped across the upper right corner, and in the foreground an albino hare (apparently attacked by the Wolpertinger) encircles a dish decorated with figures of domestic rabbits. The image is reminiscent of Dutch game pictures from the seventeenth century, in which spoils from the hunt are presented as symbols of both privilege and transience. Rockman's parody of the genre serves as a devilish reminder that nature is seldom as harmonious as it appears in the painted world.

The humor and horror of *Still Life* reverberate in the artist's paintings of cross-species copulation. In *Jungle Fever* [plate p. 71], for instance, we witness the union of a mantis and a chipmunk, while in *The Trough* [plate p. 72] a barnyard pig mounts a downy white goose. The latter scene unfolds in an industrialized barn where nary a plant is in sight, except for a few partially eaten carrots strewn in the foreground. Rockman's depiction of mechanized feeding systems prefigures his focus on genetically engineered livestock—the subject of a painting from 2001 titled *The Farm* [plate p. 48]. While

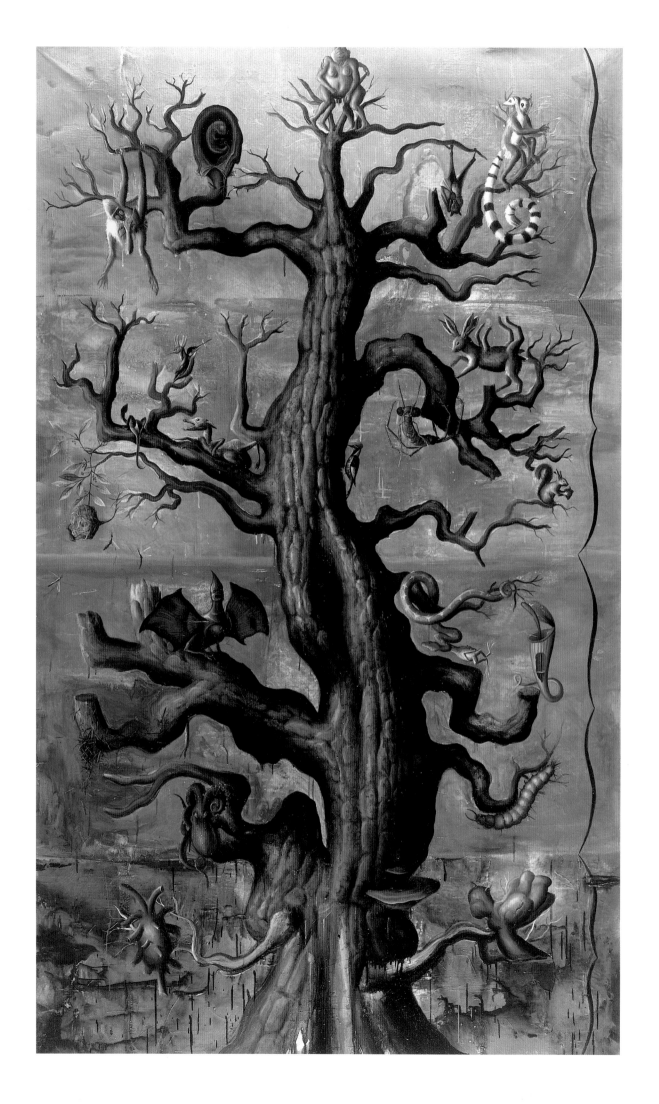

Phylum, 1989
Private Collection
Cat. 7

8

Ernst Haeckel, "Pedigree of
Man" (1859), plate 15 from
*The Evolution of Man: A Popular
Exposition of the Principal
Points of Human Ontogeny and
Phylogeny*. From the German of
Ernst Haeckel, 1896. Courtesy
Smithsonian Institution
Libraries, Washington, D.C.

the cartoon quality of these paintings contributes to their disturbing tenor, Rockman's scenes of animal fornication appear relatively innocuous when compared to the distorted hybrids that occupy his evolutionary trees.

The "tree of life" metaphor, mentioned by Darwin in *The Origin of Species*, suggests that evolution follows a system of divergences, or branches, that are taxonomically akin to a tree as it grows. Although Darwin's use of the metaphor failed to adequately account for his theory of competitive replacement, the phylogenetic tree became a common visual tool for early ecologists.[22] In Germany, Ernst Haeckel emerged as an avid spokesman for Darwinian evolution and posited his own arboreal picture of the living world. According to Haeckel, nature develops from a single set of roots (a common ancestor) and then diversifies in a multitude of directions. Rockman synthesizes the philosophies of these two great naturalists in his own phyletic structures, simultaneously acknowledging and dismantling their respective theories.

Rockman's earliest paintings of evolutionary trees began as straightforward diagrammatic images based on geological and taxonomic charts, natural history illustrations, and field guides [see plate p. 65]. From there the artist embarked on more complex and frightening depictions of real and imagined species. *Phylum* [plate p. 26] is a terrifying compendium of misshapen creatures arranged on a gnarled, lifeless tree. The painting reproduces Haeckel's "Pedigree of Man" from 1859 [fig. 8]. Rockman's canvas is divided into four horizontal registers of differing color. The parenthetical markings along the far right edge of the painting correspond to Haeckel's original engraving, which references the taxonomic groups depicted on each section of the twisted tree. Mammals are spread across the top layer, vertebrates in the next, invertebrates in the third, and protozoa in the bottom. Rather than representing conventional evolutionary progress, however, Rockman's tree conveys the failure of nature—an entropic nightmare yielding monstrous results. A carnivorous pitcher plant and two-headed snake occupy the lower branches, while in the uppermost register an eight-legged rabbit leaps across the limbs. The tree is crowned with a "human" form, a corpulent hermaphrodite, which reappears in Rockman's subsequent variations on the *arbor vitae* theme.

In *Harvest* [plate pp. 74–75] the mutant figure lounges on the leafless boughs of sprawling mangrove. The tree rises out of a murky green pool in what appears to be a wildlife

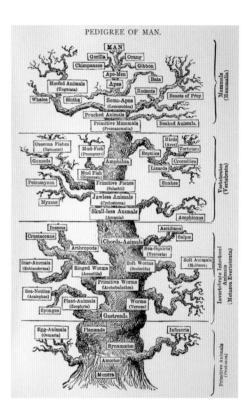

Hieronymus Bosch, *The Garden of Earthly Delights*, ca. 1500–1505, oil on panel, 85 ⅞ x 151 ¹¹⁄₁₆ in. Museo Nacional del Prado, Madrid

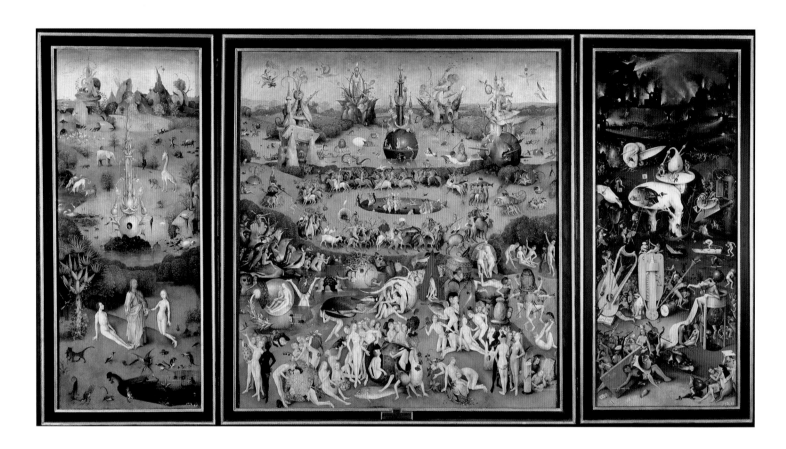

preserve or zoo. Its trunk and branches are sheathed in metal piping and a concrete enclosure guarantees the "protection" of the unusual animals on display. The panoply of hybrid creatures in a parklike setting recalls the eschatological imagery of Northern Renaissance painter Hieronymus Bosch. Bosch's *Garden of Earthly Delights*, ca. 1500–1505 [fig. 9], originally titled "The Millennium," is a throbbing panoramic landscape inhabited by hundreds of tiny nude figures that share the scene with an assortment of misshapen flora and fauna. Progressing across three panels, the painting moves from a ripe springtime garden through a sultry summer park to a frozen winter wasteland. It is within the third panel, amidst a scorched cityscape, that the apocalypse explodes in graphic detail. As in Rockman's *Harvest*, Bosch's scene is dominated by an unearthly tree, which has sprouted a human head. The figure is a personification of death, and the accompanying hybrids signal the transgressions of mankind.

In studying Rockman's phylogenies, it is impossible to ignore the symbolic significance of the tree within the context of the American conservation movement, which enjoyed its formative years just as Haeckel was sketching his canonical image of life's genealogical history.

No image better encapsulates the fight for wilderness protection than the giant sequoias of Mariposa Grove in Yosemite Valley. Extolled as one of the glories of nature, the sequoias represent one of the earliest preservation efforts in the United States. In June 1864, in the midst of the Civil War, Abraham Lincoln signed a law to safeguard the Yosemite Valley and the great trees there. More than sixty square miles of federal land was transferred to the care of the state of California on the condition that it would be reserved for public use and recreation. This early triumph succeeded in mobilizing a generation of wilderness advocates who would help establish Yellowstone Park in 1872, the world's first national park, and led to the nation's first environmental group, the Sierra Club, founded by John Muir in 1892.

Despite these milestones, the industrial drive for expansion and exploitative resource consumption continued unabated during the 1870s and 1880s. The result was the rapid depletion of forests throughout the West. In 1901 newly inaugurated president Theodore Roosevelt proclaimed the necessity of forest preservation through use, a strategy echoed and implemented by Gifford Pinchot, then director of the U.S. Forest Service. Pinchot's belief that trees could be cut while still maintaining the integrity of the forest emerged as the dominant ideology of the conservation movement.[23] Today, federal resource management agencies and nongovernmental organizations, like the Forest Stewardship Council, still follow the basic principle of "right use" in their mission to ensure the health, productivity, and sustainability of the nation's woodlands.

The nineteenth-century impulse to preserve parcels of nature manifested itself not only in the creation of America's first national parks but also in the development of zoological societies and public gardens. Rockman makes reference to such parks in both *Harvest* and *Aviary* [plate p. 73]. In the latter, an array of endangered, extinct, and imaginary birds roost within the confines of an artificial environment signaled by the metal-coated tree and blood-red sky. As with the evolutionary tree motif, the zoological park signifies the human impulse to impose order upon the natural world. In the era of their inception, however, these constructs were important indicators of the growing acceptance of ecological science and the attendant concern over wildlife depletion. By the turn of the century, prominent zoological and botanical gardens in London and Paris were already well established and attracting hundreds of thousands of visitors annually. In America the New York Zoological Society opened its park (commonly known as the Bronx Zoo) in 1899 with the dual goal of displaying animals in their natural surroundings and rescuing endangered species from extinction.[24] Much like the concurrent innovation of habitat dioramas, the proliferation of zoological parks signaled a new protectionist sentiment that came to dominate natural history in the twentieth century.

Rockman's use (and abuse) of standard scientific conventions functions as a reminder that our understanding of nature is mediated through a wide range of cultural inventions. Another such tool is the progressive mural. Popularized in the early twentieth century by artist Charles R. Knight [see fig. 3], who painted vast scenes of prehistoric life at major natural history museums across the country, the typical mural chronicles the history of life on Earth. Rockman parodies this evolutionary device in his stunning panoramic landscape *Evolution* [plate pp. 32–33]. Executed over six months in 1992, *Evolution* is the artist's first monumental landscape painting. The compositional format is based on Rudolph Zallinger's mural, *Age of Reptiles*, at Yale University's Peabody Museum of Natural History [fig. 10],

Rudolph F. Zallinger, *The Age of Reptiles*, 1947, 16 × 110 ft. Peabody Museum of Natural History, Yale University, New Haven, Connecticut

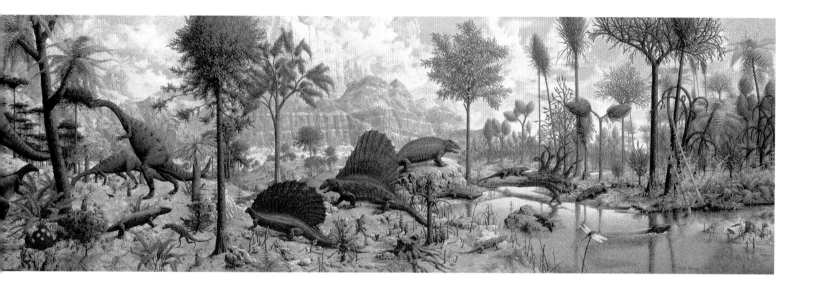

and the imagery reflects Rockman's interests in evolutionary biology, cryptozoology, genetic mutation, and the related visual tropes of taxonomies, time lines, and dioramas. The painting also references iconic works from the Hudson River school. As Kevin Avery describes later in this book, the panoramic scale and encyclopedic scientific content of *Evolution* resonate with the dramatic nineteenth-century landscapes of Albert Bierstadt, Frederic Edwin Church, Thomas Cole, and Thomas Moran. Like the nineteenth-century habitat diorama, the paintings of Bierstadt, Church, and Moran introduced audiences to far-flung places, from the rugged terrain of the American West and Pacific coast to the tropical jungles of the South American continent.

While these painters have had a profound and lasting influence on Rockman's formal and conceptual development, *Evolution* is more than an amalgam of nineteenth-century references. The painting is a riveting summation of the artist's early work, an inventory of images and ideas nurtured since childhood and laid out over four magnificent panels. Together the canvases present an eerie juxtaposition of real and imagined animals from prehistory to the present. According to the artist's schematic key [fig. 11], 214 plants and animal species—including a mallard, a Holstein, a river otter, and a Ring-tailed Lemur—are depicted in the 24-foot mural. Beneath the water's gleaming copper surface an array of aquatic creatures make their home amidst a veritable graveyard of skeletal remains. On the shoreline a phyletic tree with boughs overladen with mutated organisms has collapsed under the weight of its genetic failures. At the far right of the composition, Rockman's deformed hermaphrodite makes a command appearance, cautiously peering through the foliage as if he/she has just entered the Garden. But this is no Earthly paradise. Evolution is a feverish vision of genesis and apocalypse that heralded the end of an era for Rockman.

Evolution, 1992
Collection of George R. Stroemple
Cat. 13

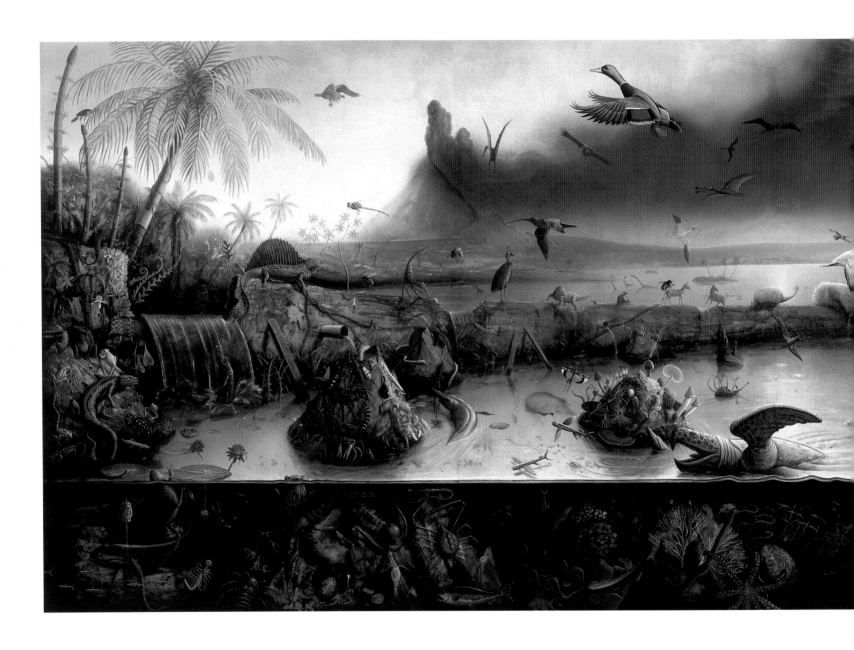

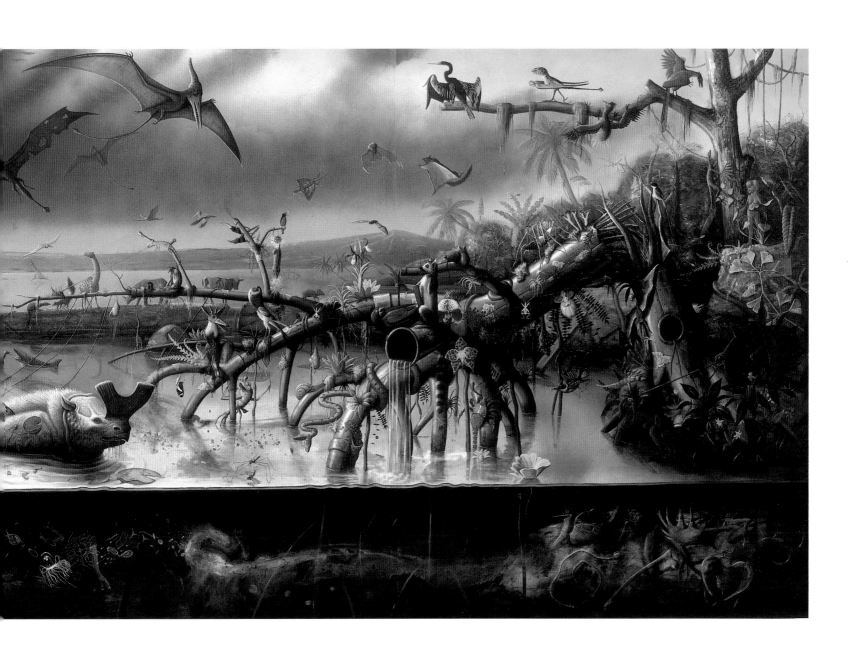

Alexis Rockman, key for
Evolution, 1992
[plate pp. 32–33; cat. 13]

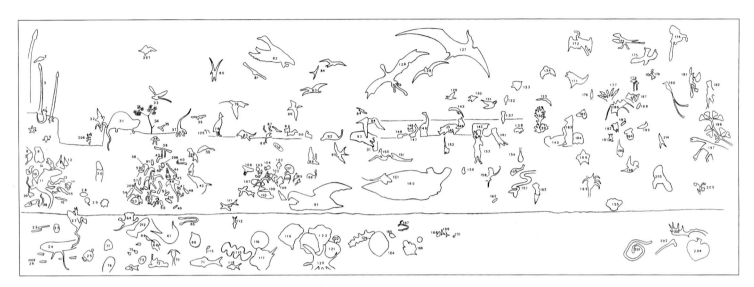

1. *Wepenthes sanguinea*
2. Cooper's Hawk
3. Horsetails
4. *Trichoglottis smithii*
5. *Paphiopedilum primulinum*
6. Cane Toad
7. New South Wales Tree Frog
8. Goliath Frog
9. Green Tree Frog
10. Mudpuppy eggs
11. *Hylonomus*
12. Arrowroot
13. Rough-skinned Newt
14. Red-eyed Tree Frog
15. Spotted Salamander
16. Texas Blind Salamander
17. Strawberry Poison Dart Frog
18. Kentucky Spring Salamander
19. Blotched Tiger Salamander
20. Grey Tree Frog
21. Poison Dart Frog
22. Mudpuppy
23. Amphibian eggs
24. African Lungfish

25. *Hallucigenia*
26. Ladyfish
27. *Rana dragtonii*
28. Bullfrog
29. Water Lilies
30. Coelacanth
31. Dimetrodon
32. Heliconia
33. Dragonfly
34. *Cecropia*
35. Army ant
36. Luna Moth
37. *Velociraptor*
38. Dragonflies
39. Marine Iguana
40. Emerald Tree Boa
41. Mata-Mata Turtle
42. *Tylosaurus*
43. Imperial Moth larvae
44. Mantis
45. Hoverfly
46. Hammerhead Shark juv.
47. Red ants
48. Katydid

49. Water Scorpion
50. Death's Head Cockroach
51. Purple Ghost Crab
52. Ten-lined Giant Chafer
53. Sally Light-foot Crab
54. *Cicada*
55. Plant Bug
56. Stink Bug
57. Red Cucujid
58. Banded Alderborer
59. Blue Morpho
60. Western Spotted Cucumber Beetle
61. Goldman's Leaf Beetle
62. Pseudo-sphinx Caterpillar
63. Giant Horned Beetle
64. Mudskipper
65. Coronet Fish
66. Spider Crab
67. Trilobite
68. Horseshoe Crab
69. *Hymenocaris*
70. Cyclopoid Copepod
71. Chum Salmon
72. Black Devil

73. Carpoid
74. Clown Loach
75. Brine Shrimp
76. Sea Scorpion
77. Trilobite
78. *Cicada*
79. Whimbrel
80. *Gnathosaurus*
81. California Condor
82. Mallard
83. *Tropeognathus*
84. Magnificent Frigate Bird
85. *Cynognathus*
86. *Ichthyornis*
87. Plesiosaur
88. Shrew
89. Bright Tropic Bee
90. *Eohippus*
91. Komodo Monitor
92. *Glyptodon*
93. Polar Bear
94. Three-eyed Caspian Tern
95. Barn Swallow
96. Chinese Saltwater Crocodile

97. *Archelon*
98. Sphincter Crab
99. Ravenel's Stinkhorn
100. Netted *Rhodotus*
101. Destroying Angel
102. Felt-ringed *Agaricus*
103. Barometer Earth Star
104. Alcohol Inky
105. Scarlet Waxy-cup
106. Oedipoda Grasshopper
107. Yellow-red Gill Polypore
108. White fungus
109. Menstral Oysterfan
110. Red-belted Polypore
111. Atlantic Flying Fish
112. Striped Headstander
113. Copepod
114. Vertebrate remains
115. *Tridacna*
116. Coral sp.
117. Angel Shark
118. Lyre-tailed Coralfish
119. Fan Coral
120. Giant Octopus

121. Brain Coral
122. *Cerianthus viridius*
123. Shelf coral
124. Nudibranch
125. Icthyosaur
126. "Dragonslayer" dragon
127. *Pteranodon ingens*
128. *Eudimorphodon*
129. Roseate Spoonbill
130. Brown Pelican
131. *Aracuri x rodentra*
132. Black-necked Red Cotinga
133. Flying Lizard
134. Eastern Yellow Bat
135. Daubenton's Bat
136. Yellow Lady's Slipper
137. Honey Possum
138. Collared Peccary
139. Tank Bromilliad
140. Hyacinth Macaw
141. English Pouter
142. Holstein Cow
143. Chameleon
144. Red Colobus Monkey

145. White Rhinoceros
146. *Titanotylopus*
147. Striped Skunk
148. Bandicoot
149. River Otter
150. *Laysan Albatross* juv.
151. Tiger Shark
152. Urinator
153. Wolpertinger
154. Parasite Larval case
155. Arum
156. *Planorbis sp.*
157. Rosy Boa
158. Garbage Freak
159. *Heliconius heurittoni*
160. *Brontotherium*
161. Ephemeropterid
162. Common Mosquito
163. *Limax*
164. *Dinichthys*
165. *Daphnia*
166. *Gonionemus murbachi*
167. *Hydra*
168. *Amoeba*

169. Silicon bodies
170. Procaryotic cells
171. Greater Glider
172. Anhinga
173. *Dimorphodon*
174. *Archaeopteryx*
175. Hoatzin juv.
176. Century Plant
177. Banana Tree
178. *Araucaria*
179. Flying Frog
180. Common Paradise Kingfisher
181. *Proavis*
182. Homo sapiens
183. Ring-tailed Lemur
184. *Paphiopedilum*
185. Nest Parasite
186. Bat-rat Spider
187. *Cladonia cristatella*
188. Hemopterid
189. *Vandopsis parishii*
190. Parasite egg sack
191. Ghost Orchid
192. Spider Bromiliad

193. *Chiasognathus granti*
194. *Paphiopedilum*
195. Golden-olive Woodpecker
196. *Ginkgo*
197. Proto-Chestburster
198. Toothed Kingfisher
199. *Alien* Facehugger x Robber Crab
200. Prairie Smoke
201. Rattlesnake skeleton
202. *Rhamphoryncus femur*
203. *Megaloceros antler*
204. *Homo sapiens* pelvis
205. Malaysian Tapir
206. *Drosophila*
207. *Teratornis*
208. Eastern-tailed Blue
209. *Scolopendra heros*
210. Agave Weevil
211. *Anabaena circinalis*
212. Giant Sea Scorpion
213. Wolf Spider
214. Arrowhead

AFTER NATURE

Toward an Environmental
Aesthetic

After completing *Evolution* in 1992,
Rockman embarked on a new aes-
thetic course. His paintings from
this period retain their sense of
naturalism, but are imbued with an
apocalyptic atmosphere that foretells
of a postnatural world lurking in
the future. The notion of a practice
that is literally and figuratively "after
nature" is eloquently described in
W. G. Sebald's *After Nature*.[25] Written
in 1988, *After Nature* consists of three
extended poems loosely based on
the lives of disparate historical fig-
ures: German Renaissance painter
Matthias Grünewald; eighteenth-
century naturalist Georg Wilhelm
Steller; and Sebald himself. At its
surface the first poem is an ambling
history of Grünewald's life and the
making of his famed *Isenheim Altarpiece*
(ca. 1512–16; see fig. 18). But beneath
the superficial gloss of biography lies a
haunting exploration into the physi-
cal and metaphysical dimensions of
Grünewald's iconography. He is re-
vealed, through Sebald's austere text,
as an artist who faithfully captures the
debased condition of humanity while
simultaneously engendering a fantasy
of portents and premonitions. The
parallel with Rockman's own work is
undeniable. In the paintings follow-
ing *Evolution*, the convergence of sci-
entific vision and visionary premoni-
tion becomes increasingly evident,
recalling the style of Rachel Carson's
"Fable" and the basic structure of sci-fi
cinema. Rockman channels these two
sources as his work gradually shifts
from the realm of natural history and
ecological imagination toward an art
of environmental awareness.

The artist's indebtedness to
science-fiction film is immediately
apparent in the "Biosphere" series—
the first body of work he produced
after *Evolution*. Based on Douglas
Trumbull's eco-thriller, *Silent Running*
(1972), the "Biosphere" paintings
imagine an apocalyptic vision of the
future in which flora and fauna must
be jettisoned into space to preserve
them from Earth's polluted environ-
ment. Similarly, Trumbull's film
tells the story of Freeman Lowell,
a forest ranger sent into space to
care for the planet's last remaining
trees, which are stationed aboard
a colony of interstellar biodomes.
Lowell's passionate dedication to the
orbiting forests meets opposition
when he and his crew are ordered to
destroy the domes and redeploy for
commercial service. The battle that
ensues in Trumbull's story between
ecological and economic interests
is a recurring theme in real-life

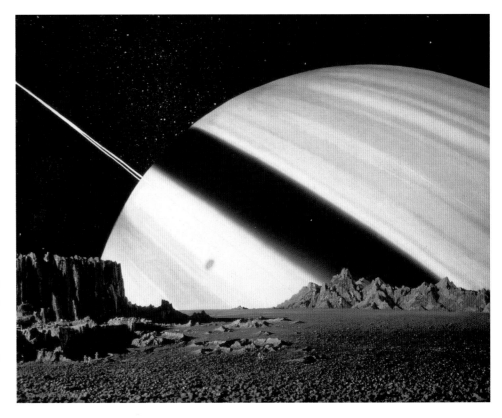

debates over environmental reform and a reminder of the key events that inspired the movie: the publication of Rachel Carson's *Silent Spring* in 1962; the first images of Earth from the Moon taken during the Apollo 8 mission in 1968; the first Earth Day in April 1970; and the establishment of the Environmental Protection Agency in December of that year.[26]

While humans remain absent from all of Rockman's "Biosphere" scenes, their presence is evidenced in the form of tubes, syringes, dissected and disfigured animals, and the spacecraft itself. Rockman borrows his space-age iconography from a range of sources in science fiction and pop culture: Stanley Kubrick's *2001: A Space Odyssey* (1968) and Andrei Tarkovsky's *Solaris* (1972) provide visual fodder for Rockman's desolate biosphere interiors, while images of planets and nebulae take their cue from Chesley Bonestell's photorealist paintings of the 1940s [fig. 12]. In *Biosphere: Orchids* [plate p. 77] six orchids float amid the emptiness of outer space. Serpentine tubing connects the flowers to an unseen life-support system within the interstellar greenhouse. Their lush white petals echo the lattice framework of the biosphere structure and the iridescent star clusters beyond. The painting's architectural details mimic the design of Buckminster

Fuller's geodesic domes [fig. 13]. A self-taught architect, engineer, and early environmentalist, Fuller believed that the survival of humankind would be compromised unless the world's natural resources could be effectively conserved. He spent nearly forty years working on the dome concept in an effort to devise efficient and sustainable housing solutions. Rockman's biodomes, on the other hand, support the life of Earth's most fragile ecosystems.

Buckminster Fuller, *U.S. Pavilion for Montreal Expo 67*, 1967, photograph, 5 × 7 in. reprint. Courtesy Estate of R. Buckminster Fuller, Santa Barbara, Calif.

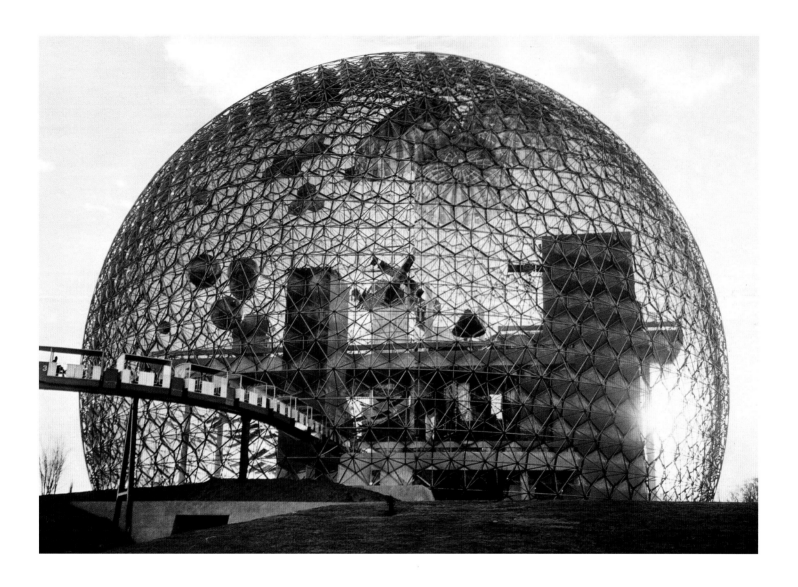

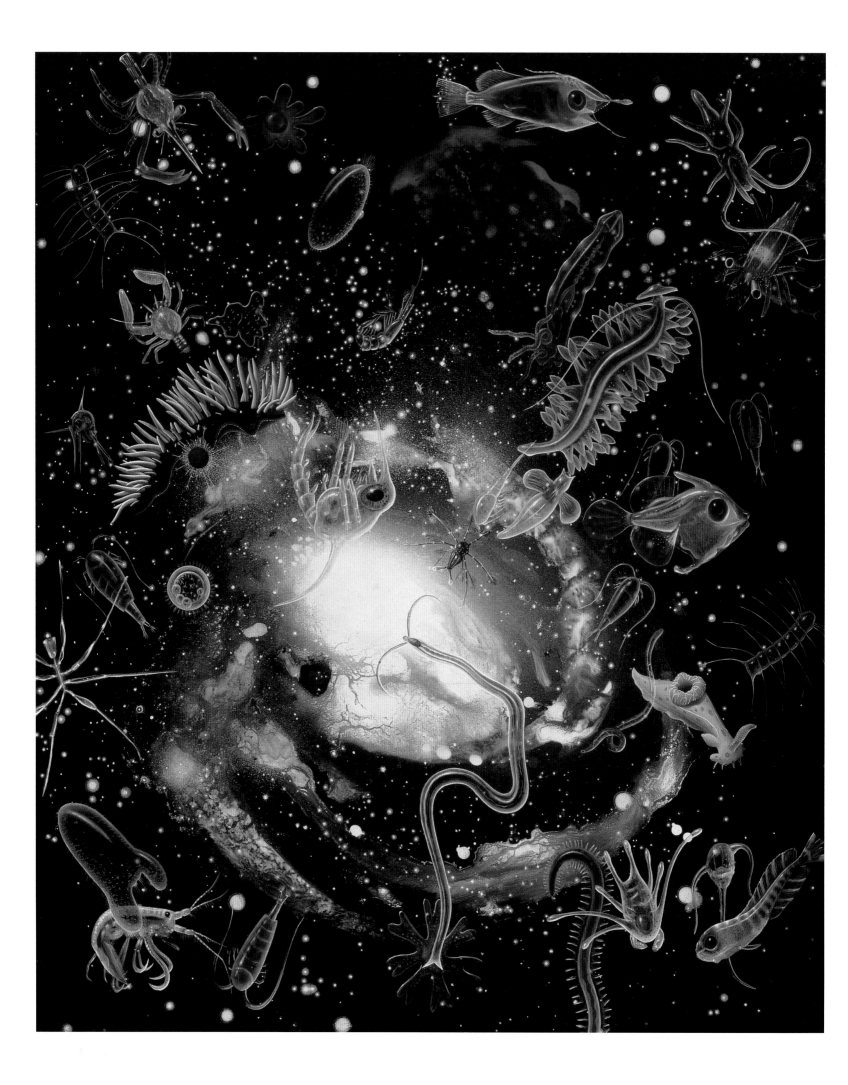

*Biosphere: Hydrographer's
Canyon*, 1994
Andrea Feldman Falcione and
Greg Falcione
Cat. 20

Ernst Haeckel, *Siphonophorae*,
plate 77 from *Kunstformen der
Natur* (Art Forms in Nature),
1904. Courtesy Smithsonian
Institution Libraries,
Washington, D.C.

Like a galactic Noah's ark, each "Biosphere" painting depicts an exotic array of plants and animals from geographic locations around the globe. *Biosphere: Tropical Tree Branch* [plate p. 76], for instance, shows a daisy chain of animals—a proboscis monkey, an anteater, an orange-and-black-striped poison dart frog, and a beetle—arranged along a moss-covered tree branch. A distant whirling galaxy is visible through the space-station window. Its twisting form suggests the primordial spiral of organic growth, an image that is repeated, in close up, in *Biosphere: Hydrographer's Canyon* [plate p. 38]. Here, a constellation of aquatic organisms creates a halo of organic life around a luminous celestial orb. Inspired by Ernst Haeckel's *Art Forms in Nature* of 1899–1904, a compilation of the scientist's exquisitely detailed watercolors and engravings [see fig. 14], the painting reveals the infinite variety of organic life that exists on Earth. This bewildering diversity, and its seductive beauty, is the principal theme of Rockman's next major body of work.

In 1994, Rockman journeyed into the dense South American jungle of Guyana along with friends Mark Dion and Bob Braine. The three artists spent two months documenting the incomparable biodiversity

of the equatorial streams and forests they encountered along the Essequibo river system. As Thomas Lovejoy describes in his essay in this book, the tropical rain forests of Guyana have long been the site of exploration and scientific discovery. For centuries, explorers have endured grueling conditions in the course of their research, requiring a fortitude of spirit and conviction of purpose that few of us need summon in daily life. Rockman considers his own expedition to be one of the most challenging experiences of his life, and unabashedly confirms the sense of physical and psychological isolation that comes from being "trapped" in the jungle.[27] But the journey had a liberating effect on his work. The artist recalls:

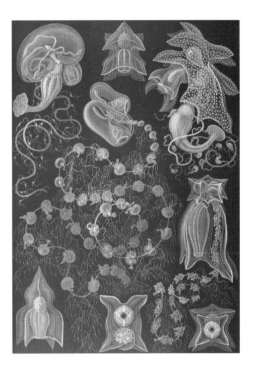

At the time I was responding to the bleakness and artificial light of the Biosphere paintings. I wanted to get out of my studio. My childhood experience in Peru and my familiarity with the careers of Alexander von Humboldt, Charles Darwin, William Beebe, and David Attenborough inspired me, but I didn't go to Guyana with any specific agenda. After several weeks, the impulse to draw became irresistible. Using a pencil, paper, and a magnifying glass, I started to make classic entomological drawings of insects we had caught. This process led to a notebook

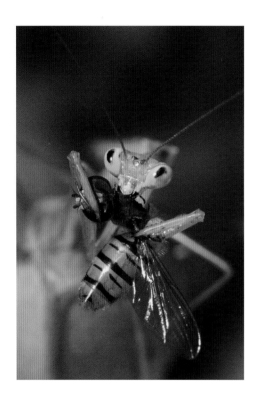

of ideas about paintings based on actual encounters—what happened to a catfish we caught, what insects came to devour it—that I wanted to make when I got back to my studio.[28]

The saturated palette of the Guyana paintings evokes the brilliant colors of the jungle, a festoon of deep greens, purples, and vermilions. As in his early work, Rockman alternates viewpoints dramatically, at times pulling back to provide a sweeping overview of the jungle interior and at other moments thrusting the viewer headlong into the ruthless food chain of a poisonous insect. What distinguishes the Guyana pictures from Rockman's previous work is their complete authenticity, the result of a self-imposed restriction to invent nothing and instead paint only the flora and fauna found in the rain forest. Despite their resolute fidelity to nature, Rockman's Guyana works are no less haunting than his imagined scenarios. They delight in the weirdness of what is real. Many of the paintings are small, single-frame images that capture a fleeting instant of intense drama. Almost photographic in their realism, the paintings bring us face-to-face with the vast array of insect life that inhabits the jungle. *Juvenile Mantis on Bromeliad Leaf* and *Flies* [plates pp. 83, 85] are

just two images from the Guyana that were inspired by high-speed wildlife photography of Stephen Dalton [fig. 15].

In *Host and Vector* [plate p. 81], Rockman presents an otherworldly view of the steamy interior jungle. Broad green cecropia leaves blanket the foreground. In the canopy above, large pendulous nests dangle like alien pods. They are home to the Montezuma Oropendola, a common tropical bird whose black and yellow plumage can be spotted on a nearby vine. The action revolves around three organisms: the bird, a snail, and a parasitic liver fluke. The three protagonists are positioned within the composition so as to form an equilateral triangle, suggesting their mutual dependency. The lush fecundity of the image evokes the landscape paintings of Martin Johnson Heade. Heade traveled to the South American tropics on three occasions to document the brightly colored hummingbirds, orchids, and passionflowers for which he became best known [fig. 16]. Rockman's reference to Heade is also evident in *Bromeliad: Kaieteur Falls* [plate p. 80], which proffers a cross-sectional view inside the tightly wrapped leaves of a bromeliad plant. Mist from the Kaieteur Falls obscures the background, save for a

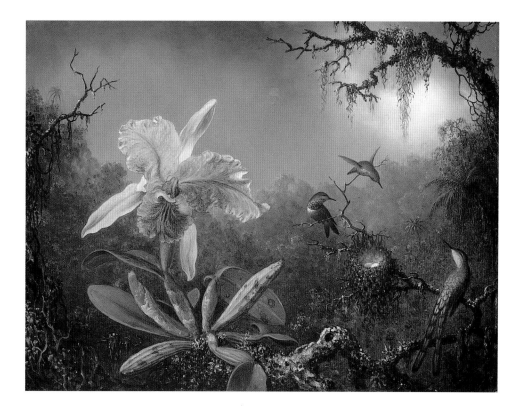

few loosely rendered trees, recalling Hudson River school landscapes of John Kensett and Thomas Cole.

Rockman's most enchanting image from the Guyana series is *Kapok Tree* [plate p. 82], which author Katherine Dunn eloquently and appropriately describes as a "flashlight painting."[29] It's twilight in the rain forest and we stand beneath the great kapok tree gazing up at the dense canopy and the starry sky beyond. The velvet darkness is momentarily broken by a pool of artificial light revealing a nocturnal world in motion on the ample trunk. The words of entomologist Edward O. Wilson seem to reverberate through the enveloping foliage: "The forest at night is an experience in sensory deprivation . . . black and silent as the midnight zone of a cave. Life is out there in expected abundance. The jungle teems, but in a manner mostly beyond the reach of the human senses."[30] It is an arresting, reverential picture that quietly acknowledges the sacred import of the ceiba tree and the diversity of life

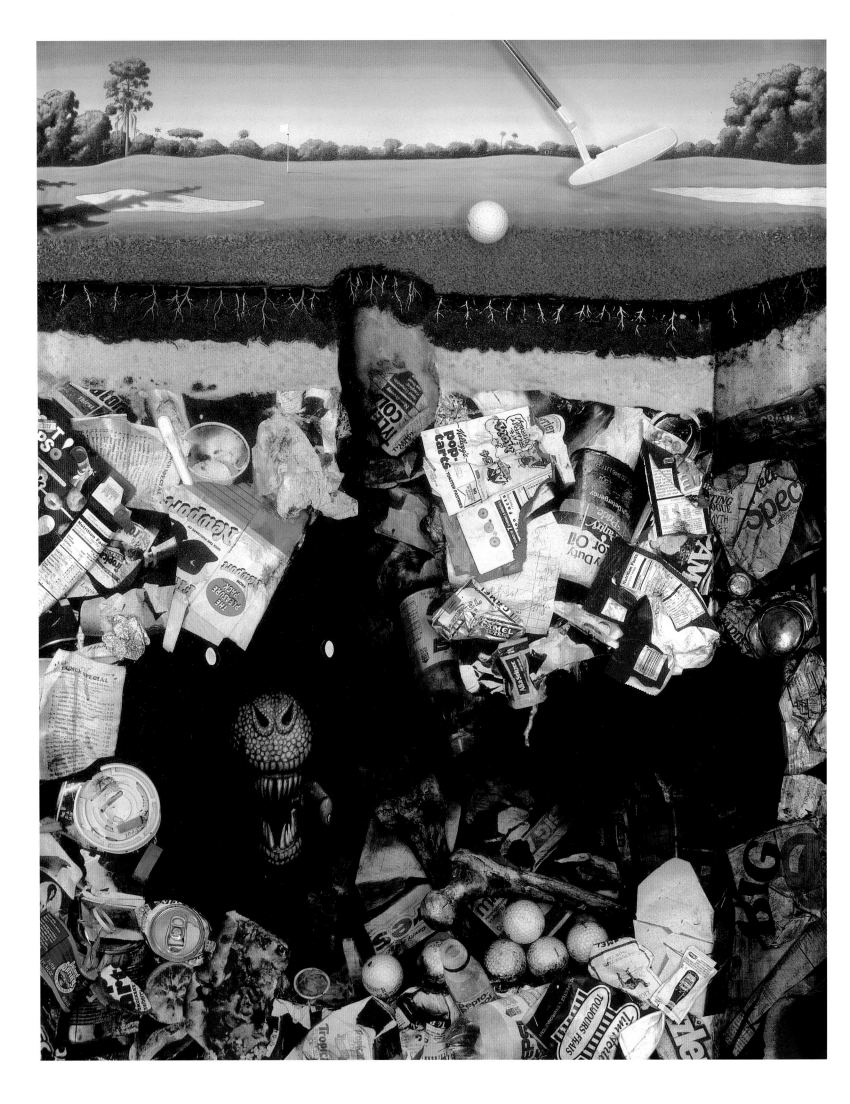

Golf Course, 1997
Collection of Ruth and Jacob
Bloom, California
Cat. 33

Arman, *Trash Mash No. 1*, 1971,
compressed refuse in polyester in
Plexiglas, 18 × 18 × 10 in.
Private Collection

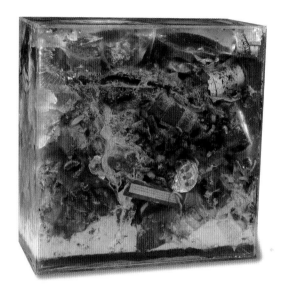

it supports. Rockman's kapok is yet another manifestation of the *arbor vitae*. But in this image we witness the tree of life as intended by nature, not man.

The sacrosanct canopy of the kapok tree seems a long distance from the urban landscape we encounter in the artist's concurrent body of work, "Concrete Jungle." Begun in 1992, the ongoing series focuses on the mingling of man and nature in the gritty environs of Rockman's native New York. Each painting depicts the myriad ways that human society has impacted the living systems with which we cohabitate. The artist gives particular attention to *r-selected species*, a term coined by ecologists to describe organisms that exploit the environmental conditions of human-disrupted ecosystems. In *Concrete Jungle III* [plate p. 92], a motley crew of scavengers gather in what has been described as an "urban laboratory without walls, where trash cans and open sewage pipes serve as conduits for guerrilla warriors."[31] Rats, pigeons, and cockroaches share the alleyway with a mangy, malnourished dog and a gray cat. Likewise, *Concrete Jungle V* [plate p. 93] diagrams the putrid dumping ground of a modern landfill where roaches, rodents, and a tick-infested cat compete for survival. A distant line

of skyscrapers is barely distinguishable through the thick air, polluted by smoke from an unseen industrial plant and the trail of fuel vapor left behind after a jet plane's ascent. In *Ready to Rumble* [plate p. 94], Rockman lands the viewer directly atop a stinking dump, where we are confronted by a pack of caped crusaders. Dressed in World Wrestling Federation regalia, a turkey vulture, rat, and scrappy alley cat spring into action to defend their terrain. As in the artist's earlier work, the unsettling mixture of cartoon cuteness and ecological ruin are a reminder of the ridiculous lengths to which we often go to soften and sanitize the unsightly aspects of modern society—a collective fantasy that Rockman gleefully parodies in his portrayal of urban decay.

Society's effort to modify and control the environment is epitomized by the ubiquitous suburban golf course, where carefully manicured grass, artificial ponds, and strategically placed trees provide a safe and orderly experience of nature. Not so in Rockman's world. *Golf Course* [plate p. 42] reminds us of the ecological decay lurking just below the surface of our most controlled environments. The image, part of Rockman's "Diorama" series, focuses on the fetid underbelly of an idyllic fairway. A cross-sectional

view reveals that the course is actually built atop a landfill, where a subterranean monster preys on unsuspecting linksmen. As with other pieces in the series, *Golf Course* incorporates a range of mixed media to generate a dynamic and variegated visual effect. The works were inspired by an exhibition at the American Museum of Natural History called *Amber: Window to the Past*, for which the museum used diorama techniques to evoke a prehistoric amber forest, where the sap from ancient trees would eventually fossilize into the golden-colored stone. While Rockman's "Dioramas" mimic the institutional language of didactic exhibits, his choice of subjects and media (household trash, scientific models, and taxidermy animals) invites an atypical encounter for the museum visitor.

Rockman built the dioramas by adhering objects to a digital photograph and then applying copious layers of synthetic resin to the surface to create a thick, impenetrable block. At various points in the process, Rockman incorporated his own painted images as well as elements carved from Styrofoam or sculpted from clay.[32] The resulting assemblages bring to mind the work of French Nouveaux Réaliste artist Arman, who famously collected and displayed the detritus of urban society. For his "Poubelle"

("Trashcan") series, Arman immortalized the rubbish of friends and fellow artists in Plexiglas boxes [see fig. 17]. Likewise, Rockman's accumulations use the materials of modern society to comment on the inherent tension between nature and culture. According to the artist:

> Every image in this cycle began with a childlike question. For example, what happens when a jet plane hits a bird? Or, what's living inside that wall? I wanted to invent a language for making pictures that included actual objects, such as specimens, garbage, and hardware, and then set in resin.[33]

In *Airport* [plate p. 95] the clash between natural creations and mechanized inventions becomes viscerally evident as a disoriented gull collides with a jet engine. Such bird strikes are the result of human encroachment on previously rural territory. Nature is forced to adapt or suffer the consequences, as demonstrated in this violent picture. Occasionally, however, nature enacts its own special revenge on mankind. Rockman's ironic self-portrait called *Ecotourist* [plate pp. 96–97] is one such example. Inspired by his 1994 trip to Guyana, the artist appears as an unfortunate victim of his own ineptitude. Having collapsed to the jungle floor, his body

plays host to an array of insects and mammals that devour (and carry off) various appendages.

> I wanted to treat my own body with the detachment and thoroughness that I often treated other subjects, so I constructed a life-size self-portrait that explores what would happen if I died in the neotropical rain forest. After consulting a pathologist, I decided—for vanity's sake—to stop just before bloating.[34]

The accompanying legend, in the upper left corner of the composition, is constructed in the vernacular of institutional dioramas to document the various types of flora and fauna represented below. A large Fresnel lens in the foreground further elucidates the process of decomposition, magnifying a legion of feasting maggots, beetles, and flies. The gruesome scene evokes the crucifixion imagery of Grünewald's *Isenheim Altarpiece* [fig. 18]. Painted for the Monastery of Saint Anthony in Alsace, France, the altarpiece served as a devotional picture for the Antonine monks as well as patients in the monastery hospital being treated for skin diseases. Accordingly, Christ's contorted body is shown covered with sores and gangrenous flesh. While Grünewald's artful depiction of physical decomposition is no match for the macabre

Matthias Grünewald, *Isenheim
Altarpiece*, ca. 1512–16, oil on
panel. Musée d'Unterlinden,
Colmar

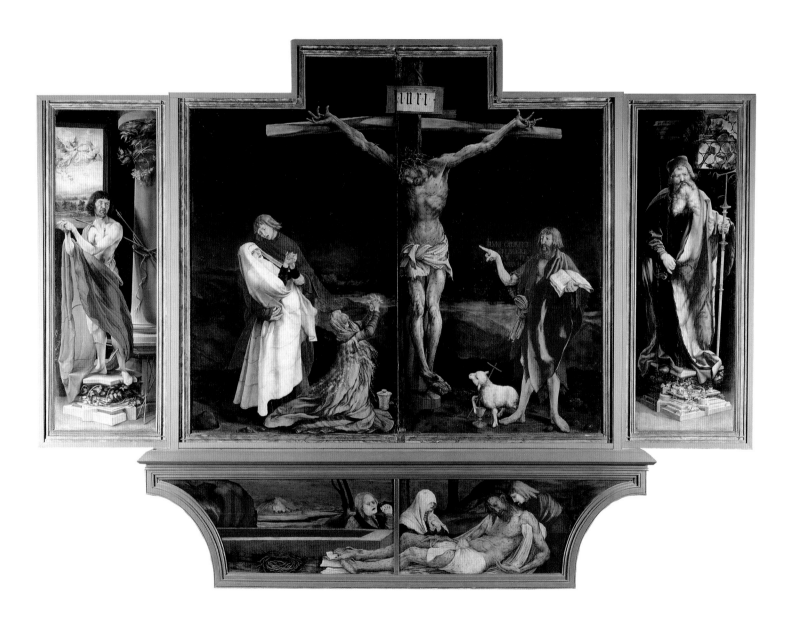

19

Production still from *Them!*,
1954, Warner Bros. Studios,
Burbank, Calif.

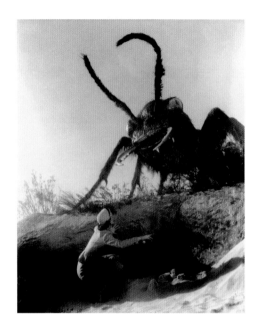

realism of Rockman's rotting corpse, both painters provide a stirring meditation on the continuity of life and death.

The portraits of Christ and Rockman also conjure the final section of W. G. Sebald's *After Nature*. In melancholic tones, Sebald has sketched his confessional self-portrait as a man devoured by emotional instability and nostalgia for an ailing world. The sense of damage, internal and external, is evocatively conveyed in a description of the gloomy postindustrial city of Manchester, England: "long have I stood on the banks/ of the Irk and the Irwell, those/ mythical rivers now dead,/ which in better times/ shone azure blue."[35] Traveling back in time, the narrator finds solace in the virgin mountain ranges and unexplored jungles of the African continent. Sebald's cerebral journey in search of untouched wilderness is aptly illustrated by Rockman's *Ecotourist*, in which he appears to have expired during a similar hunt for Edenic nature. The painting prefigures the artist's work of the late 1990s and illustrates his growing interest in expeditionary travel, a theme that took full form during a second trip to South America.

When Rockman returned to the rain forest of Guyana in 1998, he was prepared to catalog the trip with the same meticulous attention to detail that he had applied four years earlier. But the artist's original earnestness about field observation was quickly replaced by a fascination with pop-culture representations of ecotourism and the exotic allure of adventure travel. In the resulting series, titled "Expedition," the verdant jungle of Guyana becomes the backdrop for a human drama starring Rockman and his friends in the role of "ugly Americans" as they camp, fish, and commune on the Essequibo River.[36] Each painting presents a fictional narrative about the potential hazards of traveling in an unfamiliar and dangerous setting and the foolish naïveté of the typical ecotraveler.

In *The Hammock* [plate p. 98] an unsuspecting tourist sleeps under the stars, oblivious to the perils that surround him. The warm glow of a lantern underscores the traveler's romanticized notion of "getting back to nature." A shotgun leans against a nearby pole, just within arm's reach, but the gun won't defend against the swarm of angry mosquitoes about to wreak havoc on the traveler's exposed flesh. The exaggerated scale of the mosquitoes brings to mind classic sci-fi films, such as Gordon Douglas's atomic-age thriller *Them!* (1954; fig. 19) and Jack Arnold's *Incredible*

Joseph Wright of Derby, *An Experiment on a Bird in the Air Pump*, 1768, oil on canvas, 72 × 96 in. The National Gallery, London, Presented by Edward Tyrrell, 1863

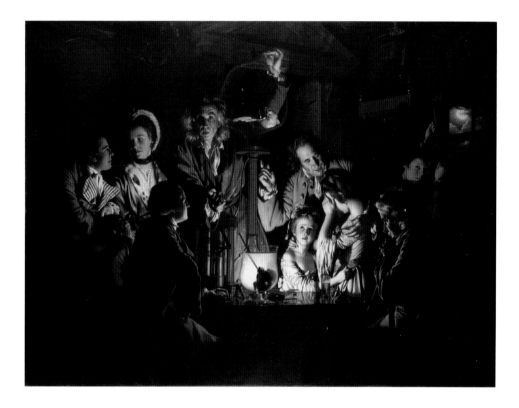

Shrinking Man (1957). As in Rockman's painting, both films dramatize a frightening reversal in which man becomes prey to common pests.

The Conversation [plate p. 99], in contrast, presents a seemingly peaceful exchange between man and nature. Rockman depicts two figures—a man and an ape—silhouetted by lamplight in an expedition tent. The amber illumination creates an aura of mystery and discovery, a device borrowed from Joseph Wright of Derby's famous painting from 1768, *An Experiment on a Bird in the Air Pump* [fig. 20]. The tranquil scene references not only the pioneering theories of Charles Darwin but also the studies of American zoologist Dian Fossey, who lived and worked with gorillas in the mountains of Rwanda for nearly eighteen years. Fossey's widely disseminated story (and untimely death by murder in 1985) continues to be a source of both inspiration and intrigue for aspiring naturalists. But Rockman is quick to remind us (through the potent image of a rifle)

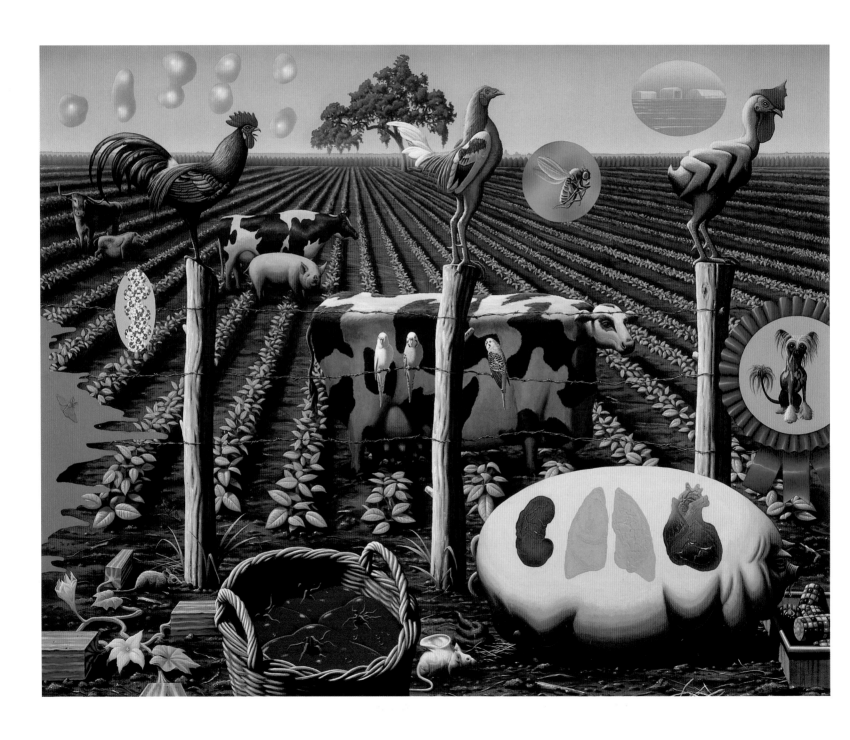

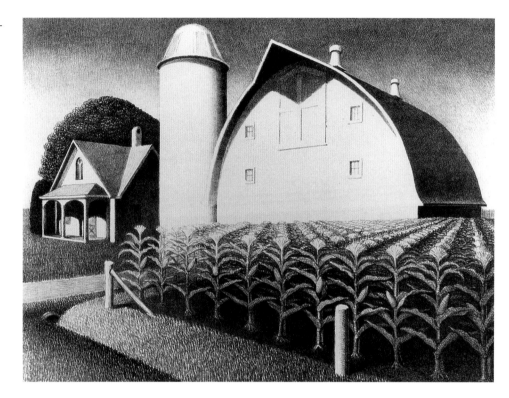

Grant Wood, *Fertility*, 1939, lithograph, 9 × 12 in. Fine Arts Museums of San Francisco, Gift of George Hopper Fitch

that the idealized conception of field-work is a tenuous illusion at best.

The uneasy relationship between man and nature is again Rockman's subject in the deceptively cheery painting *The Farm* [plate p. 48], which depicts the transformation of agricultural farming through the introduction of genetic engineering. Inspired by the agricultural landscapes of American artists Grant Wood [see fig. 21], Thomas Hart Benton, and Alexandre Hogue, *The Farm* channels both the optimism and angst of these Depression-era paintings. The wide-angle view of a soybean field not only recalls the perfectly aligned crop rows found in many Regionalist paintings of the 1930s but also suggests the importance of soy cultivation during that era. Dust Bowl farmers of the Great Depression used soy to regenerate their drought-stricken soil. More recently, the soy plant has earned the (dubious) distinction as the most common genetically modified crop in the United States. Scientists are currently exploring ways to bioengineer livestock, a process elaborated upon in *The Farm*. Progressing diagonally from upper left to lower right, Rockman illustrates the past, present, and future incarnations of three familiar farm animals—a pig, a cow, and a chicken—that have been gradually altered through artificial selection and/or genetic modification. The engineered livestock bear only anecdotal resemblance to their more common relatives, appearing instead like the primitive animal portraits of folk painter Edward Hicks [fig. 22].

Commissioned by the New York arts organization Creative Time, the painting was part of a public art initiative to raise awareness about the implications of genetic research. The image was displayed on a billboard at the corner of Lafayette and Houston streets in New York City. Rockman

Edward Hicks, *The Cornell Farm*, 1848, oil on canvas, 36 ¾ x 49 in. The National Gallery of Art, Washington, D.C., Gift of Edgar William and Bernice Chrysler Garbisch

MANIFEST RESPONSIBILITY
Artist as Advocate

Climate change research began in earnest in the late 1970s (the National Academy of Sciences issued the first major report on global warming in 1979) and gained wide public attention in the summer of 1988, during what was then the hottest season on record. Since then, climate change has become a pervasive topic of anxiety and debate, spawning countless research studies and international panels.[37] The phenomenon has been documented in a myriad of ways by climatologists around the world. The most alarming signs appear in the Arctic Circle, where shrinking glaciers and melting permafrost are harbingers of more serious effects to come. But for most of us, global warming remains an abstraction that has yet to produce a visible mark on day-to-day life. Alexis Rockman is trying to alter this perception. Since 2004 he has focused on giving concrete visual form to the vagaries of climate change and has emerged as a committed advocate for environmental reform.

Although Rockman has always dealt with the fracture between nature and culture, *Manifest Destiny* was the first work to confront the climate crisis and its human toll. As such,

conceived the project as a response to the biotech revolution, an issue he deems as one of the most trenchant and far-reaching topics facing scientists and the general public. *The Farm* once again merges art and science to startling effect and introduces an element of public activism previously unseen in Rockman's work. This activist impulse comes to full fruition in the artist's tour de force, *Manifest Destiny* [plate pp. 106–7], which urgently warns about the dangers of climate change.

it is a fulcrum in the artist's career, a pivotal summation of past work and sign of things to come. Like *Evolution*, also a turning point for the artist, the painting comprises four contiguous panels extending twenty-four feet in length. It depicts the port city of New York several hundred years in the future, following the complete demise of the Brooklyn waterfront as a result of global warming. The composition is framed at left and right by the ruins of two distinct bridges. On the far left panel a futuristic suspension bridge lies beneath the elevated waters of the East River. The design for the structure is the brainchild of architect Chris Morris, with whom Rockman collaborated to envision a new artery between Brooklyn and Manhattan.[38] The historic Brooklyn Bridge stands in ruinous decay on the far right panel of Rockman's painting, a victim of its own aging infrastructure. That the unmistakable towers remain largely intact is a testament to the ingenuity of its builders, John and Washington Roebling, but their degraded and overgrown facade is nonetheless a nostalgic image of the loss.

Constructed between 1870 and 1883, the Brooklyn Bridge is a potent symbol of the unbridled drive for technological progress that defined the nineteenth century.

Rockman makes reference to the era's industrial impulse in his title *Manifest Destiny*, which borrows the term coined by John L. O'Sullivan in 1845 in an article for the *Democratic Review*.[39] Issued in support of the nation's divine right to conquer and possess the westward boundaries of the continent, O'Sullivan's now-famous proclamation came to signify a political, moral, and philosophical ideal. The notion of Manifest Destiny functioned primarily as a catalyst for westward expansion, but art historian Peter John Brownlee observes that it also prompted artists to closely consider their immediate environs and note distressing changes that sharply undercut the doctrine's grand claims.[40] The most obvious (and egregious) sign of so-called progress was the stripping away of America's forests. Painter Thomas Cole was one of the first artists to represent the "ravages of the axe" in powerful visual allegories that entreat citizens to respect the natural splendor of their young nation.[41] As Kevin Avery describes in this volume, *Manifest Destiny* resonates with Cole's most famous work, "The Course of Empire," a five-part admonition of industrial expansion.

Manifest Destiny bears the closest resemblance to Cole's final painting in the series, *Desolation* of 1836 [fig. 23],

in which the wreckage of a Greco-Roman city is subsumed by nature. Cole's image of the collapsed empire is one of numerous paintings by the artist featuring architectural relics from English and European history. According to art historian Sarah Burns, Cole was haunted by thoughts of impending cataclysm and viewed the ruins of Europe as a specter of what America might become. A similar sense of foreboding permeates the poetry of Edgar Allan Poe, whose work Burns cites as a literary parallel to the doom portrayed in Cole's paintings.[42] In his five-verse poem "The City in the Sea" (1845), first drafted in 1831, Poe tells the story of an abandoned city slowly sinking into the sea:

> Lo! Death has reared himself a throne
> In a strange city lying alone
> Far down within the dim West,
> Where the good and the bad
> and the worst and the best
> Have gone to their eternal rest.
> There shrines and palaces and towers
> (Time-eaten towers that tremble not!)
> Resemble nothing that is ours.

The eerie metropolis closely resembles the post-apocalyptic waterfront of *Manifest Destiny*, where crumbling symbols of power lie beneath "melancholy waters" and a red glow upon

Thomas Cole, *The Course of Empire: Desolation*, 1836, oil on canvas, 39 ¼ × 63 ¼ in. The New-York Historical Society

the waves foreshadows the city's ultimate descent into the sea.[43] While the striking convergence of vision within these two works is merely coincidental, the comparison serves to reinforce the deeply historical nature of Rockman's practice. His images of cataclysm and decline mirror those of writers and artists from nearly two centuries ago and echo their prescient warnings about a future devastated by insatiable greed, ambition, and moral entitlement. But in Rockman's world, the end of modern civilization does not mark the end of all life. On the contrary, *Manifest Destiny* is teeming with organic growth. As in his "Concrete Jungle" paintings of the early 1990s [see plates pp. 92, 93], Rockman uses the image of urban decay to demonstrate the resilience of certain ecosystems and the adaptive powers of nature. Local flora and fauna that have survived the climatic scourge are joined by migrant life from equatorial zones. Maurice Berger has

inventoried the array of species that inhabit the scene: harbor seals, lampreys, carp, jellyfish, sunfish, and lionfish swim in the temperate river, while cormorants, egrets, gulls, and pelicans glide overhead.[44] Despite the surrounding devastation, *Manifest Destiny* confirms that life, in some form, will persist even if humanity does not.

Manifest Destiny and the subsequent "American Icons" series reflect a popular fascination with the post-apocalyptic disintegration of modern civilization and the visual iconography of the decay. A staple of eighteenth- and nineteenth-century painting, the aesthetic of the ruin continues to inspire artists and theoreticians across a broad range of disciplines.[45] In addition to the art historical and cinematic history of such imaginings, two recent television programs speculate on the impact of humanity's sudden disappearance from Earth: The History Channel's *Life After People*, which premiered in January 2008, and *Aftermath: Population Zero*, aired on the National Geographic Channel two months later. Both docudramas echo the thought experiment of American journalist Alan Weisman, whose book from 2007, *The World Without Us*, conjectures on what might cause the sudden and complete demise of

the human population and how the natural and built environment would react in such a scenario.[46]

Rockman continues his mediation on the ruin (and the impact of global warming) in the "American Icons" series, expanding the theme into new geographic and stylistic territory. Here, beloved national landmarks and bastions of power suffer the fate of Brooklyn's waterfront, but gone is the sardonic scientific gaze and tight brushwork of the preceding decade. The vestiges of modern society are now encrusted with a thick impasto of muddled strokes, giving the appearance of an ancient civilization conquered by time and nature. Buttressed by scientific evidence, Rockman's futuristic images envision how the nation might look after the disappearance of human life. Existing archaeological sites and abandoned cities provide fodder for the artist's imaginative wanderings on how quickly our built environment will crumble and which creatures will inherit our place.

In *Gateway Arch* [plate p. 108], Rockman depicts the popular Saint Louis monument in a state of ruin. Built between 1963 and 1965, the Gateway Arch is part of the Jefferson National Expansion Memorial, designed to commemorate the Louisiana Purchase and celebrate the Lewis

and Clark expedition, which commenced in Missouri. Bridging the east and west of the country, it is a symbol of Manifest Destiny and the expansionist impulse that drove explorers westward. An arching vine cuts horizontally across the composition, contributing to the monument's inevitable decay. In the foreground, a tiny insect hangs precariously within a drop of dew, recalling the meticulous images from Rockman's "Guyana" series [see plates pp. 80–91].

Similarly, the lush aquatic landscape of *Mount Rushmore* [plate p. 109] seems to have been transported from the jungles of South America. A snakehead fish, once native to Asia, now inhabits the dense mangrove forest that has sprouted in the Black Hills of South Dakota. Originally known as Six Grandfathers, the mountain was renamed by a nineteenth-century prospector to honor the New York attorney Charles E. Rushmore. The monument is a tribute to presidents George Washington, Thomas Jefferson, Theodore Roosevelt, and Abraham Lincoln. Sculptor Gutzon Borglum selected the four men based on their efforts to protect the American landscape. In an ironic twist, however, Rockman depicts the leaders nearly submerged beneath crystalline waters. The image evokes the enormous inland sea that once

Capitol Hill, 2005
Mr. and Mrs. Jonathan Lee
Cat. 45

24

Frederick Catherwood, "Plate 22, Teocallis, at Chichén-Itzá (on stone by A. Picken)" from *Views of Ancient Monuments in Central America, Chiapas and Yucatan*, 1844. Mortimer Rare Book Room, Smith College, Northampton, Massachusetts

extended from the Gulf of Mexico well into present-day Canada. Often referred to as the Western Interior Seaway, the waterway split North America into two halves for much of the Cretaceous period. Rockman's futuristic world looks strangely similar to this prehistoric past. Once a monument to environmental progress, Mount Rushmore now appears all but drowned by the regressive effects of climate change and the failure of contemporary policymakers.

The political implications of climate change are made even more overt in *Capitol Hill* [plate p. 54], in which Rockman portrays the historic home of U.S. government to resemble a Mayan ruin. In fact, Rockman's painting is influenced by the atmospheric drawings of Frederick Catherwood [fig. 24], who documented that "lost" civilization during a series of expeditions through the Yucatan. In Rockman's version a thick mound of vegetation engulfs the building and all but swallows its iconic dome. The degraded seat of power serves as a metaphor for the illusion of political stability, permanence, and efficacy. Executed during the second Bush administration, the "American Icons" paintings reflect Rockman's frustration with Washington politics and environmental policy.

Disney World I [plate p. 110] presents a haunting swamp. The futuristic "Spaceship Earth" is shrouded in a chilling gray fog, and the utopian vision of Walt Disney's Experimental Prototype Community of Tomorrow (EPCOT Center) seems a world away. In the foreground, two displaced survivors are caught in the act of copulation. The scene recalls Rockman's earlier images of cross-species fornication. Here, the union of a European wild boar and a South American nutria defies not only biology but geography as well. Disney's "small world" has come to pass with disturbing results. In *Hollywood at Night* [plate p. 111] the famous California hillside has devolved into a primitive landscape. The towering letters of the landmark Hollywood sign are barely discernible against the night sky. The city of Los Angeles is still visible in the distance, but its power has long been extinguished. The only remaining light emanates from a crescent moon and the twinkling bioluminescence of fireflies that have migrated westward to the City of Angels.

The relative calm of Rockman's "Icons" pictures finds a counterpoint in the concurrent series of "Big Weather" drawings [see plates pp. 57, 116–19], in which visceral

evocations of encroaching storms reveal the menacing power of nature's most destructive forces. Colossal cloud formations, tornadoes, dust storms, and hurricanes overwhelm the landscape (and the viewer), while man-made creations—oil derricks, rail tracks, and wind turbines—are rendered in miniscule detail along pencil-thin horizons. Whether anomaly or portent, these extreme environmental events emphasize the unpredictability of nature and the futility of trying to control its many vicissitudes. Rockman's expressionistic paintings surge with unbridled energy, as if channeling the turbulence of his subject matter. The series marks a major stylistic shift toward abstraction. Executed on heavily gessoed sheets of thick paper, the painted surface is awash in vivid stains, pours, pools, and drips. Rockman's exploration of this process-orientated technique is also evident in the artist's newest body of work, titled "Half-Life."

Inspired by the techniques of Color Field artist Morris Louis, the "Half-Life" paintings are dominated by large veils of viscous pigment and loose, improvisational brushstrokes. In *Only You* [plate p. 122], Rockman uses the popular catchphrase of Smokey the Bear, "Only you can prevent forest fires," to comment on the

destruction caused by wildfires. The painting depicts a massive conflagration inspired by the final scenes from the Disney movie *Bambi* of 1942. Rather than focus on an adorable protagonist, however, Rockman illustrates the fate of the insects that inhabit the forest. He explains, "I'm always fascinated by the things that are the least considered. The things that are uncared for, unattractive, unlovable."[47] In *The Reef* [plate p. 123], Rockman depicts a radiant beam of sunlight penetrating the shallow sea to a coral reef below. The painting is a subtle commentary on the hazardous depletion of Earth's ozone and the related impact of increased UV rays on coral reef systems. The phenomenon of ozone depletion offers a number of scientific and social parallels to global warming.

The most prevalent ozone-destroying chemicals—chlorofluorocarbons—are odorless, colorless, nonreactive, and, much like CO_2, apparently benign. As with global warming, the first indications that chlorofluorocarbons (CFCs) could be dangerous came in the early 1970s in response to the growing environmental movement. After researchers postulated that CFCs might behave differently in the upper atmosphere, they quickly established that while the chemicals were stable near Earth's

surface, they could have disastrous effects at the stratospheric level. Ozone depletion was first detected in 1976 and later confirmed by the discovery of a "hole" in the ozone layer above Antarctica. That finding led to a ban by the U.S. government on the use of CFCs in aerosol products, and an international phaseout initiated in 1987 by the Montreal Protocol. As with ozone depletion, some of the most significant research on climate change has originated from the South Pole. Ice-core samples taken in Antarctica are some of the longest on record. The cores provide a climatic record dating back nearly six hundred thousand years, which is enabling scientists to more accurately predict how the global climate will respond to increased greenhouse emissions as a result of human activity.

In November 2007, Rockman traveled to the Antarctic Peninsula with a team of guides to observe and document the landscape. The resulting painting, *South* [plate pp. 120–21], is an epic panorama of the "White Continent." Comprising seven monumental sheets of paper, the work is a diaristic account of the artist's twelve-day voyage aboard the Lindblad *Endeavour*, which traveled from the tip of South America to the Antarctic Peninsula. Just before reaching the peninsula, the boat

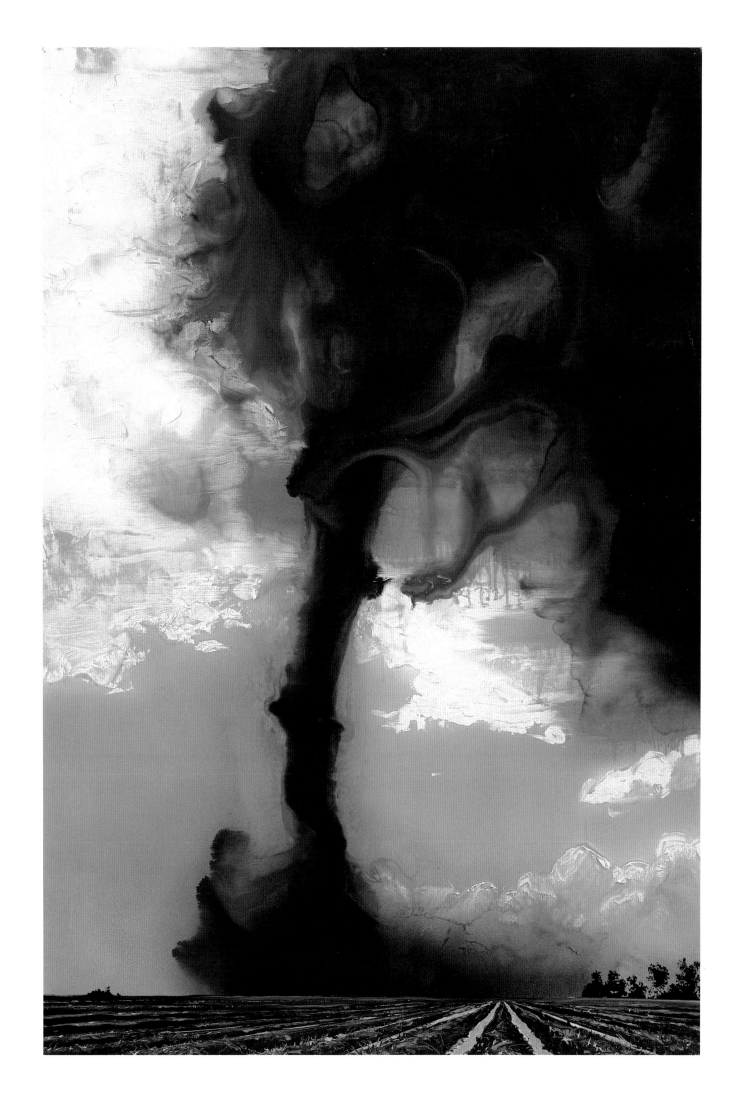

received a distress message signaling that another ship, the *Explorer*, had struck an iceberg and was sinking. Rockman's boat was the first to arrive on scene and the crew watched in stunned amazement as a fleet of lifeboats carrying the *Explorer* passengers bobbed in the choppy water. Thankfully, a larger vessel rescued the passengers, and the *Endeavour* continued on its journey. Rockman embedded a tiny reference to the incident in the frozen landscape of *South* [see fig. 32, p. 130]. Apart from this unsettling diversion, the artist recalls being struck by how alien the Antarctic landscape appeared when viewed in person. The near hallucinatory experience of traveling among the glaciers had a profound impact: "I've never seen anything like it. Ice conducts light, it gathers it, and projects it at you. That is something that cannot really be photographed, so the piece becomes a construction of notes, memory, and photographic documentation," states Rockman.[48] Each day the artist and a team of eight naturalists would venture by inflatable Zodiac rafts onto the peninsula, where they observed penguins, leopard seals, sheathbills, and other players in the ecosystem who cling to the edge of ice and coast to survive the inhospitable terrain. While Rockman's long-term interest

in scientific pictorialism remains evident in *South* (which documents every aspect of iceberg geology through simultaneous views above and below the water's surface), the artist's technique is an amalgam of his previous illustrative approach and the newfound gesturalism of his "Big Weather" paintings.

In this stirring image of calving glaciers and monumental ice shelves, Rockman achieves a balance between emotion and erudition that once again brings to mind Rachel Carson's timeless appeal in "A Fable for Tomorrow." Carson understood, as does Rockman, that environmental reform is accomplished not by science alone, but rather through a fusion with art. Science must infiltrate the realm of popular culture (and vice versa) to raise awareness about the most pressing ecological issues of each generation, from the loss of biodiversity and the hazards of chemical pesticides to the threat of global warming. Rockman's work demonstrates a steadfast belief in the power of art, literature, and film to effect such change. Over the last two decades, his images have evolved from didactic explorations of natural history and science to strident evocations of our impact on the natural world. This progression mirrors the gradual evolution of the American

environmental movement from a quiet concentration on ecological harmony to a cry for environmental reform that resounds today. The steady rise in environmental consciousness has fostered a generation of artists who have taken up the mantle of environmental activism.[49] Rockman stands out among these practitioners for the originality of his vision and the urgency of his message. Through the use of emotionally charged visual tropes—death, decay, ruin, and renewal—Rockman has created a stunning body of work that is a reflection of our times, a portent of events to come, and a call to arms.

NOTES

1 The scholarship on apocalyptic metaphors in art, literature, and film is extensive. Some of the most helpful studies include the following: On art, Frances Carey, ed., *The Apocalypse and the Shape of Things to Come* (Toronto: University of Toronto Press, 1999); Gail E. Husch, *Something Coming: Apocalyptic Expectation and Mid-Nineteenth-Century American Painting* (Hanover, NH: University Press of New England, 2000); and Norman Rosenthal et al., *Apocalypse: Beauty and Horror in Contemporary Art* (London: Royal Academy of Arts, 2000). On literature and film, Douglas Robinson, *American Apocalypses: The Image of the End of the World in American Literature* (Baltimore: Johns Hopkins University Press, 1985); Elizabeth K. Rosen, *Apocalyptic Transformation: Apocalypse and the Postmodern Imagination* (Lanham, MD: Lexington Books, 2008); Christopher Sharrett, ed., *Crisis Cinema: The Apocalyptic Idea in Postmodern Narrative Film* (Washington, DC: Maisonneuve Press, 1993); Lois Parkinson Zamora, ed., *The Apocalyptic Vision in America: Interdisciplinary Essays on Myth and Culture* (Bowling Green, OH: Bowling Green University Popular Press, 1982).

2 *The Day After Tomorrow* (2004), directed by Roland Emmerich, was the first Hollywood film to directly address the dangers of climate change. It wasn't until the release of Al Gore's documentary, *An Inconvenient Truth* (2006), however, that the film industry began to take up the subject in earnest.

3 M. Jimmie Killingsworth and Jacqueline S. Palmer, "Millennial Ecology: The Apocalyptic Narrative from *Silent Spring* to *Global Warming*," in *Green Culture: Environmental Rhetoric in Contemporary America*, ed. Carl G. Herndl and Stuart C. Brown (Madison: University of Wisconsin Press, 1996), 21–45.

4 Rachel Carson, *Silent Spring* (Boston: Houghton Mifflin, 2002), 2.

5 Ibid., 3.

6 Since the release of *Silent Spring*, the use of apocalyptic rhetoric has ebbed and flowed along with prevailing sociopolitical currents and climatic events, appearing at moments when environmental activists are seeking to alert, educate, and effect attitudinal change. Killingsworth and Palmer in *Green Culture*, 32–42. For more on Carson's rhetorical strategies in *Silent Spring*, as well as the use of apocalyptic rhetoric in the service of environmental advocacy, see M. Jimmie Killingsworth and Jacqueline S. Palmer, *Ecospeak: Rhetoric and Environmental Politics in America* (Carbondale: Southern Illinois University Press, 1992).

7 Much has been written in recent years on Humboldt's central importance to the nineteenth-century conception and representation of nature, and his continued relevance for twenty-first-century scholars and artists. For a fascinating look at Humboldt's contribution to the evolution of environmental thought, see Aaron Sachs, *The Humboldt Current: Nineteenth-Century Exploration and the Roots of American Environmentalism* (New York: Viking, 2006). For Humboldt's impact on nineteenth-century art and literature, see Barbara Novak, *Nature and Culture: American Landscape and Painting, 1825–1875* (New York: Oxford University Press, 1980), 66–74; Kevin J. Avery discusses Humboldt's influence on Frederic Church in *Church's Great Picture: The Heart of the Andes* (New York: Metropolitan Museum of Art, 1993), 12–22; and Stephen Jay Gould expands on this theme in his essay, "Art Meets Science in *The Heart of the Andes*: Church Paints, Humboldt Dies, Darwin Writes, and Nature Blinks in the Fateful Year of 1859," in *I Have Landed: The End of a Beginning in Natural History* (New York: Harmony Books, 2002).

8 Darwin quoted in Nora Barlow, ed., *Darwin and Henslow: The Growth of an Idea, Letters 1831–1860* (Berkeley: University of California Press, 1967). For more on Humboldt's contribution to the development of modern ecology and Darwinian evolution, see Donald Worster, *Nature's Economy: The Roots of Ecology* (San Francisco: Sierra Club Books, 1977), 132–44.

9 Jonathan Crary has suggested that Rockman and Humboldt are peripherally associated insofar as Humboldt conceived of nature as a preexisting artifact built by human hands (and minds) for mass consumption. While this is certainly true, the connection between Rockman and Humboldt goes well beyond a passing interest in the cultural construction of "nature." See Jonathan Crary, "Alexis Rockman: Between Carnival and Catastrophe," in *Alexis Rockman* (New York: Monacelli Press, 2003), 10.

10 John B. Ravenal, *Vanitas: Meditations on Life and Death in Contemporary Art*, exh. cat. (Richmond: Virginia Museum of Fine Arts, 2000).

11 Alexis Rockman, interview by Richard Armstrong in *Forum: Alexis Rockman*, exh. brochure (Pittsburgh: Carnegie Museum of Art, 1992), 3.

12 Art historian Rachael DeLue recently observed that "art and science merge almost seamlessly at the American Museum of Natural History in New York City." Rachael Z. DeLue, "Art and Science in America," *American Art* 23, no. 2 (Summer 2009): 2.

13 Horst Bredekamp, *The Lure of Antiquity and the Cult of the Machine: The Kunstkammer and the Evolution of Nature, Art, and Technology*, trans. Allison Brown (Princeton: Markus Wiener, 1995), 31.

14 For a fascinating account of the political and philosophical underpinnings of Peale's museum, see David R. Brigham, "'Ask the Beasts, and They Shall Teach Thee': The Human Lessons of Charles Willson Peale's Natural History Displays," in *Art and Science in America: Issues of Representation*, ed. Amy R. W. Meyers (San Marino, CA: Huntington Library, 1998); for more on the development and impact of Peale's museum, see *Mermaids, Mummies, and Mastodons: The Emergence of the American Museum*, exh. cat., ed. William T. Alderson for the Baltimore City Life Museums, MD (Washington, DC: American Association of Museums, 1992).

15 Andrea Stulman Dennett, *Weird and Wonderful: The Dime Museum in America* (New York: New York University Press, 1997), 27. For more on P. T. Barnum's life and museum, see Neil Harris, *Humbug: The Art of P. T. Barnum* (Boston: Little, Brown, 1973).

16 Karen Wonders, *Habitat Dioramas: Illusions of Wilderness in Museums of Natural History* (Uppsala, Sweden: Acta Universitatis Upsaliensis, 1993), 109.

17 Rockman, quoted in Crary, "Alexis Rockman," 64.

18 Wonders, *Habitat Dioramas*, 194.

19 Ibid., 127.

20 Stephen Christopher Quinn, *Windows on Nature: The Great Habitat Dioramas of the American Museum of Natural History* (New York: Abrams, 2006), 15–18.

21 Kevin J. Avery, "The Habitat Diorama and the Integration of Academic Art for Science" (unpublished paper delivered as part of the panel *Constructed Realities: Diorama as Art* at the College Art Association Conference, New York, February 15, 2007). For more on the historical development and construction of early dioramas, see Wonders, *Habitat Dioramas*.

22 Donald Worster, *Nature's Economy: The Roots of Ecology* (San Francisco: Sierra Club Books, 1977), 163–64.

23 For more on the early history of the American environmental movement, see Donald Worster, ed., *American Environmentalism: The Formative Period, 1860–1915* (New York: John Wiley, 1973); and Robert Gottlieb, *Forcing the Spring: The Transformation of the American Environmental Movement* (Washington, DC: Island Press, 1993).

24 Paul Farber, *Finding Order in Nature: The Naturalist Tradition from Linnaeus to E. O. Wilson* (Baltimore: Johns Hopkins University Press, 2000), 95.

25 W. G. Sebald, *After Nature*, trans. Michael Hamburger (London: Penguin Books, 2002). *After Nature*, published in Germany in 1988, was Sebald's first work of fiction. In 2009 it served as inspiration for an exhibition of the same name organized by the New Museum of Contemporary Art in New York.

26 For additional analysis of *Silent Running* within the context 1960s and 1970s environmental reform, see Robin L. Murray and Joseph K. Heumann, *Ecology and Popular Film: Cinema on the Edge* (Albany: SUNY Press, 2009), 100–107.

27 Alexis Rockman, interview with the author, New York, February 9, 2009 (hereafter "Rockman, interview with author").

28 Rockman, quoted in Crary, "Alexis Rockman," 142.

29 Katherine Dunn, "Alexis Rockman: Alive in Guyana," in *Guyana* (Santa Fe, NM: Twin Palms/Twelvetrees Press, 1996), unpaginated.

30 Edward O. Wilson, *The Diversity of Life* (New York: W. W. Norton, 1999), 3–4. Wilson is a leading authority on biodiversity. In this eloquently written text, he delineates the disastrous impact that humans have had on countless global ecosystems and calls for a renewed spirit of stewardship to ensure the planet's biological health. The cited edition of *The Diversity of Life* features Rockman's *Kapok Tree* as the cover image.

31 Barry Blinderman, "Who's Minding the Laboratory?" in *Alexis Rockman: Second Nature* (Normal: Illinois State University, 1995), 13.

32 Alexandra Irvine, "Deviant Nature," in *Alexis Rockman: Dioramas*, exh. brochure (Houston: Contemporary Arts Museum, 1997), 3.

33 Rockman, quoted in Crary, "Alexis Rockman," 202.

34 Ibid., 212.

35 Sebald, *After Nature*, 95–96. Sebald's poignant assertion that we live in a time "after nature" has been posited by countless environmental historians and cultural critics, most notably journalist Bill McKibben. McKibben's book *The End of Nature* argues that in the face of global climate change nature has ceased to exist (at least as we once knew it). McKibben, *The End of Nature* (New York: Random House, 1989).

36 Despite their striking similarities, Rockman's "Expedition" paintings predate the American reality television series "Survivor," which premiered on CBS in the summer of 2000. The artist is quick to note that his work mordantly critiques the behaviors glorified on the program (Rockman, interview with author).

37 The UN Conference on Climate Change in 1997 in Kyoto, Japan,

produced the first international treaty dedicated to the reduction of greenhouse gases, which took effect in February 2005. The Kyoto Protocol is due to expire in 2012. For a concise history of global warming, see Spencer R. Weart, *The Discovery of Global Warming* (Cambridge, MA: Harvard University Press, 2003).

38 Linda Weintraub, *Alexis Rockman: Manifest Destiny* (Kansas City: Grand Arts, 2004), http://www.grand-arts.com/past_projects/2005/2005_01.html (accessed Feb. 26, 2008).

39 John L. O'Sullivan, "The Great Nation of Futurity," *Democratic Review* 17 (July–August 1845).

40 Peter John Brownlee, "Manifest Destiny/ Manifest Responsibility: Environmentalism and the Art of the American Landscape," in *Manifest Destiny/ Manifest Responsibility: Environmentalism and the Art of the American Landscape*, exh. cat. (Chicago: Terra Foundation for American Art, 2008), 27.

41 Barbara Novak addresses the representation and meaning of the felled tree in Cole's work in *Nature and Culture: American Landscape and Painting, 1825–1875* (New York: Oxford University Press, 1980), 157–65; as does Nicolai Cikovsky Jr. in "'The Ravages of the Axe': The Meaning of the Tree Stump in Nineteenth-Century American Art," *Art Bulletin* 61, no. 4 (December 1979): 611–26.

42 Sarah Burns considers the political, cultural, and psychological implications of ruin imagery in several key works by Cole and Poe in the first chapter of her book *Painting the Dark Side: Art and the Gothic Imagination in Nineteenth-Century America* (Berkeley: University of California Press, 2004), 1–43. In referencing Poe's "City in the Sea," Burns (pp. 19–20) is careful to acknowledge that Poe and Cole were not acquainted and there is no evidence that they knew of each other's work.

43 Edgar Allan Poe, "The City in the Sea," in *Selected Writings of Edgar Allan Poe*, ed. Edward H. Davidson (Boston: Houghton Mifflin, 1956), 26–27.

44 Maurice Berger, "Last Exit to Brooklyn," in *Alexis Rockman: Manifest Destiny*, exh. cat. (New York: Brooklyn Museum of Art, 2004), 6.

45 *Ruins of Modernity* (Durham, NC: Duke University Press, 2009), edited by Julia Hell and Andreas Schönle, explores the connection between ruins and empire, and ruins as part of postindustrial cities/ landscapes.

46 Alan Weisman, *The World Without Us* (New York: St. Martin's Press, 2007).

47 Rockman, interview with author.

48 Quoted in Denise Markonish, ed., *Badlands: New Horizons in Landscape*, exh. cat. (North Adams, MA: Mass MoCA, 2008), 68.

49 This growing environmental consciousness within the art community is reflected by a steady rise in articles, conferences, and exhibitions about the natural world. Exhibitions include *Weather Report: Art and Climate Change*, curated by Lucy Lippard for the Boulder Museum of Contemporary Art in 2007; *Badlands: New Horizons in Landscape*, curated by Denise Markonish for MASS MoCA in 2008; and *Trouble in Paradise: Examining Discord Between Nature and Society*, curated by Julie Sasse for the Tucson Museum of Art in 2009.

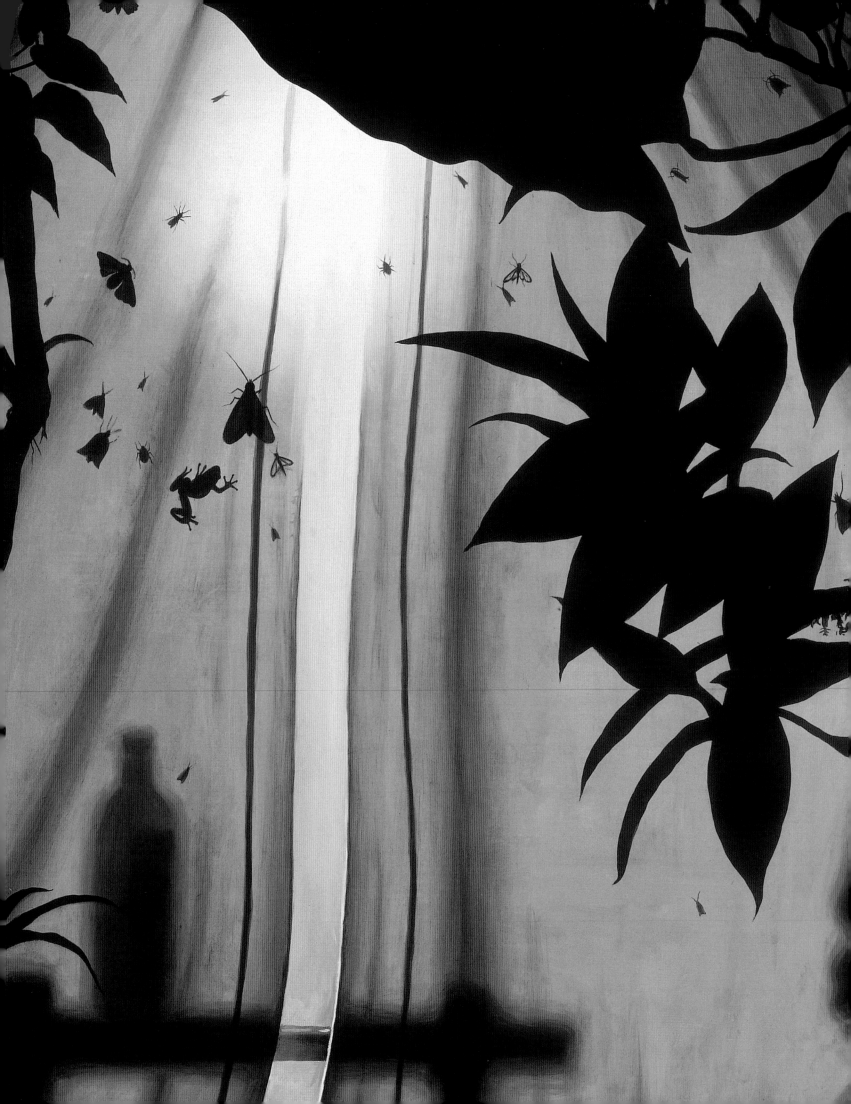

Plates

Pond's Edge, 1986
Rubell Family Collection, Miami
Cat. 2

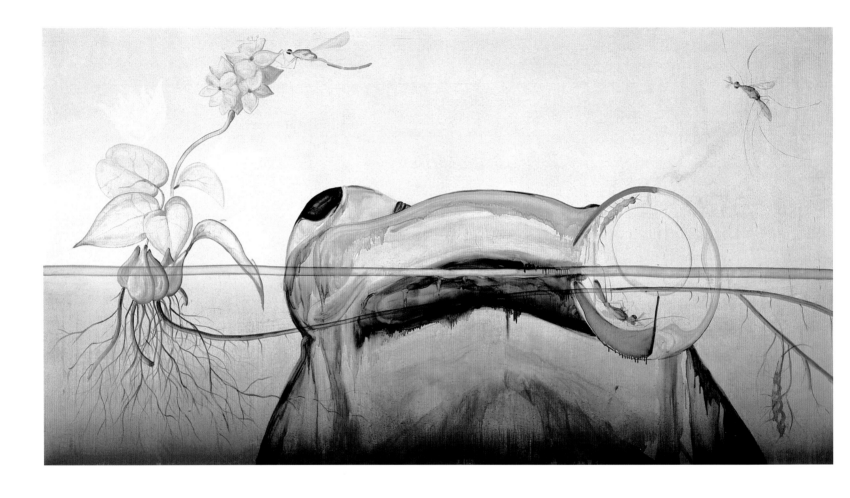

Amphibian Evolution, 1986
Courtesy of the Artist and
Waqas Wajahat, New York
Cat. 1

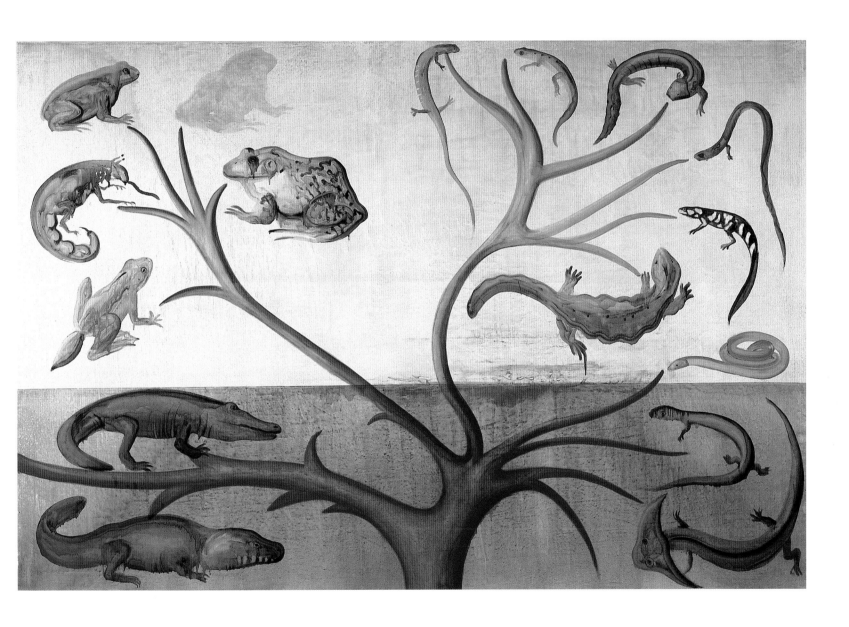

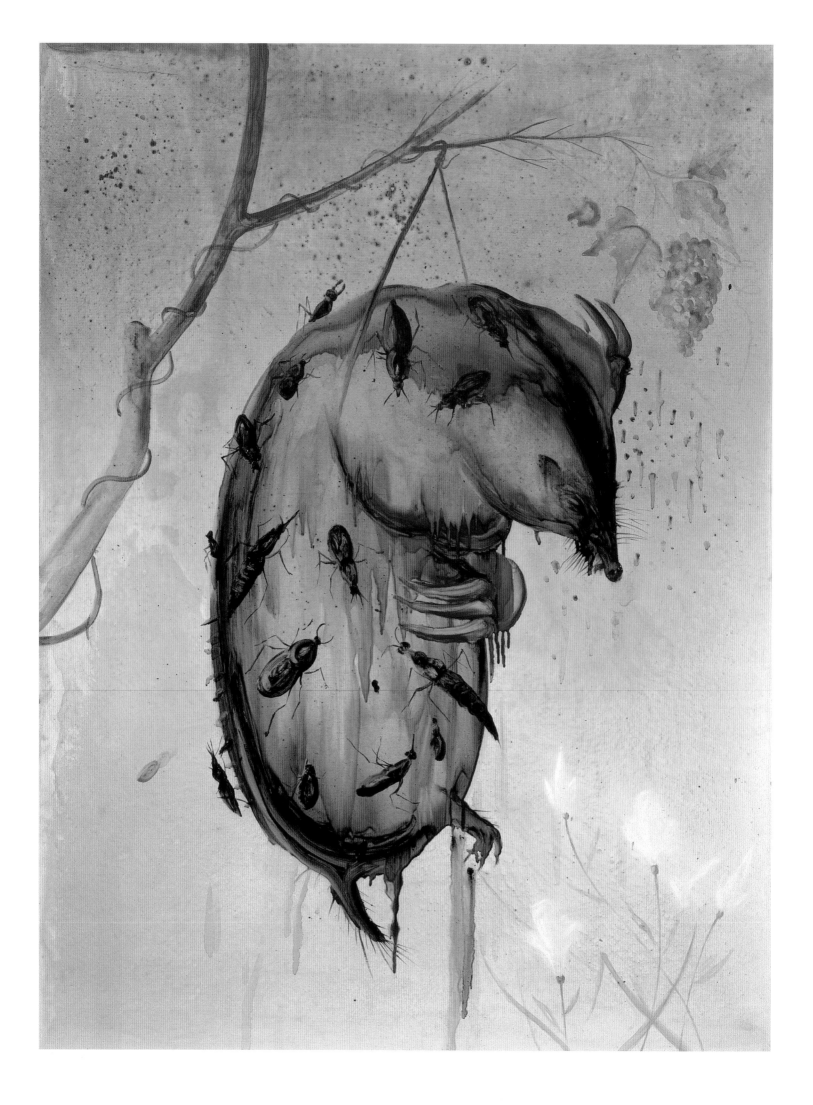

Object of Desire, 1988
Courtesy of the Artist and
Waqas Wajahat, New York
Cat. 4

The Balance of Terror, 1988
James and Abigail Rich
Cat. 3

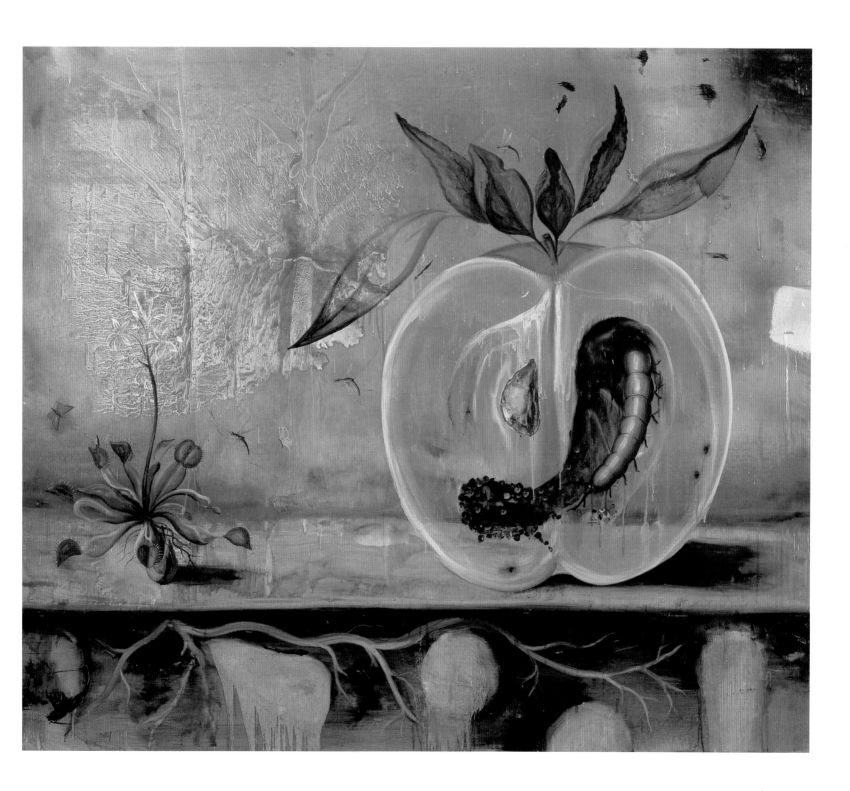

Forest Floor, 1989
Courtesy of the Artist and
Waqas Wajahat, New York
Cat. 6

The Dynamics of Power, 1989
The Carol and Arthur Goldberg
Collection
Cat. 5

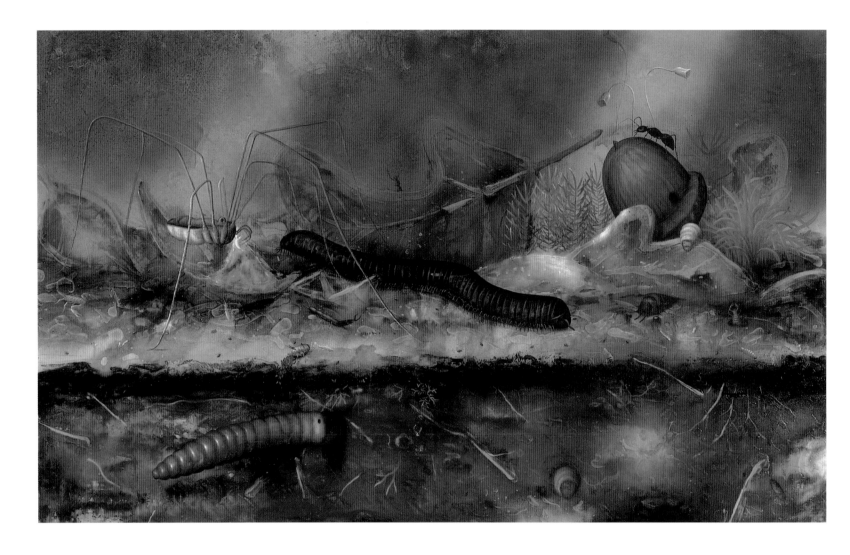

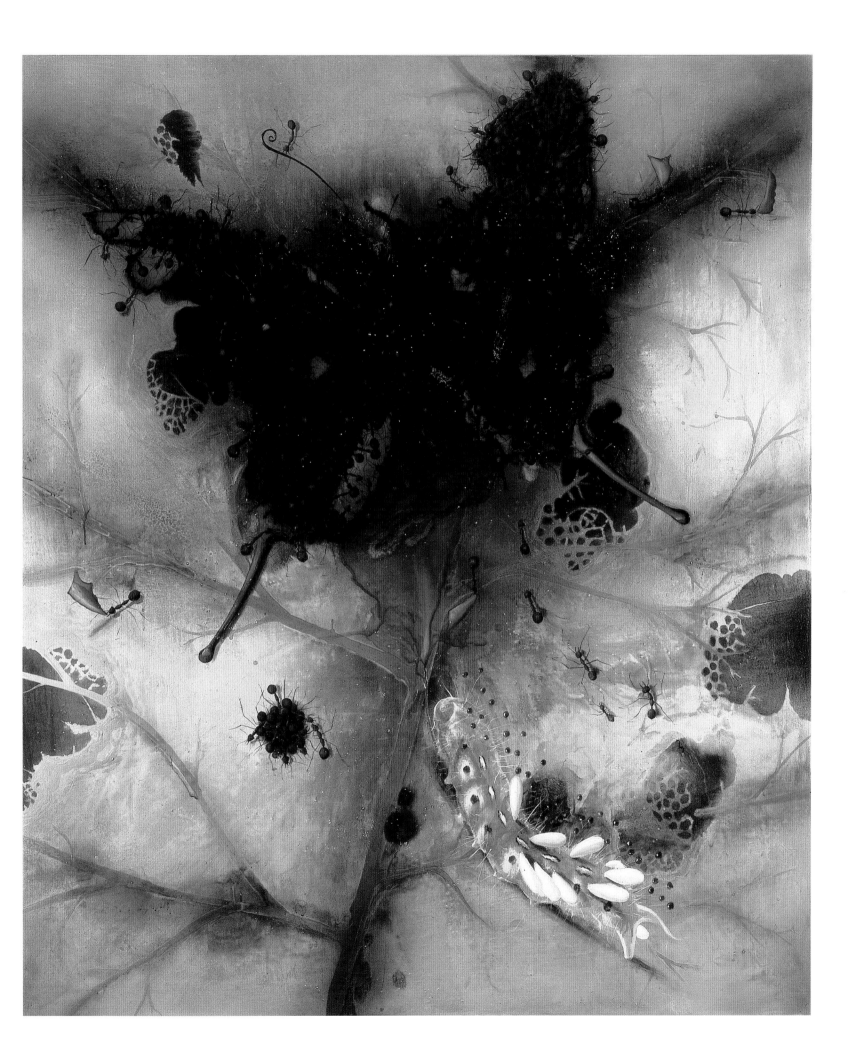

Still Life, 1991
Collection of Samuel and
Ronnie Heyman, New York
Cat. 9

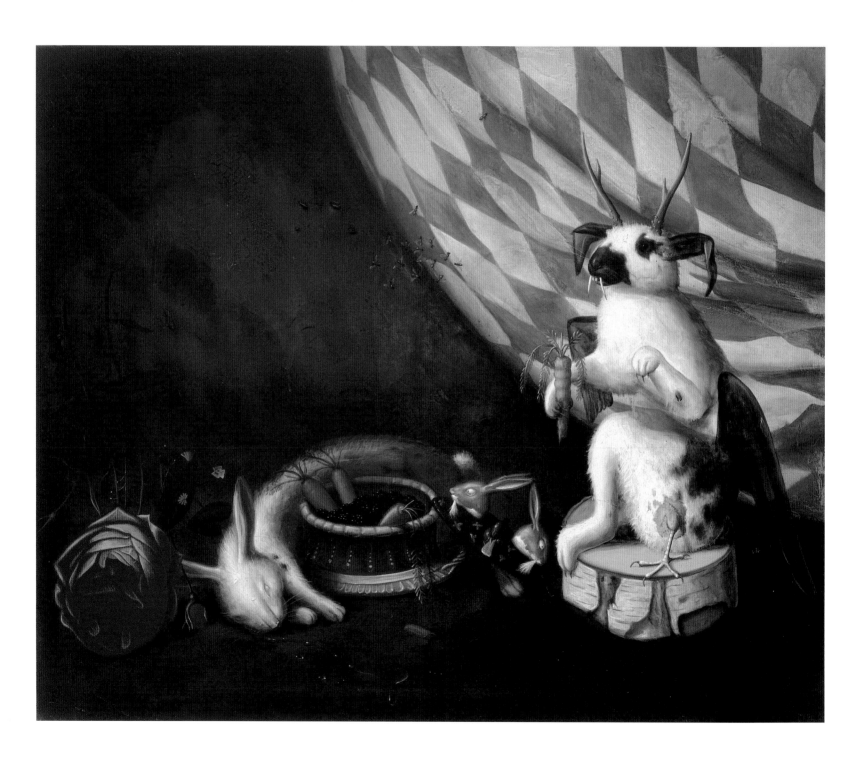

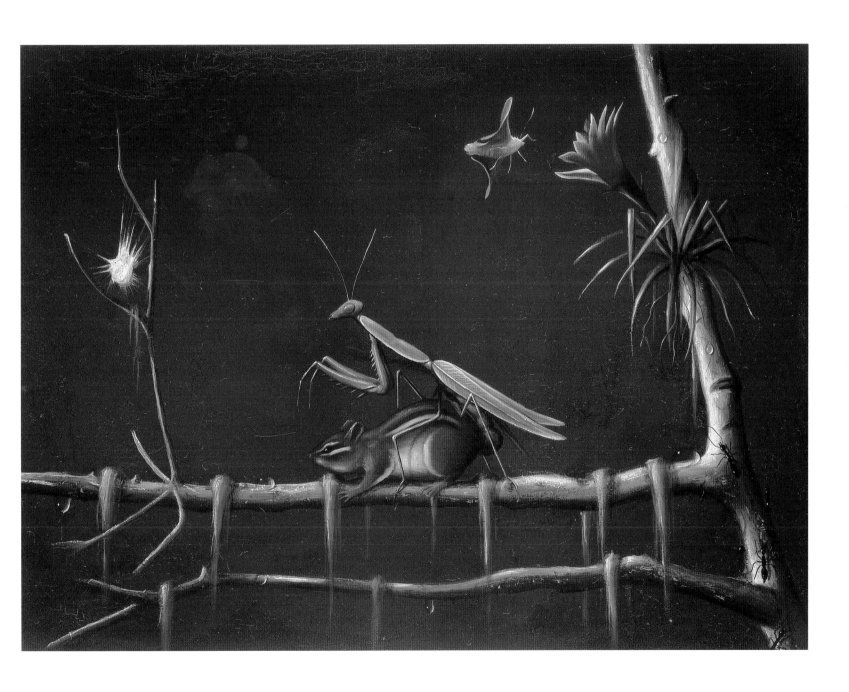

The Trough, 1992
Museum of Sex, New York,
Gift of the Peter Norton
Foundation
Cat. 15

Aviary, 1992
Private Collection
Cat. 10

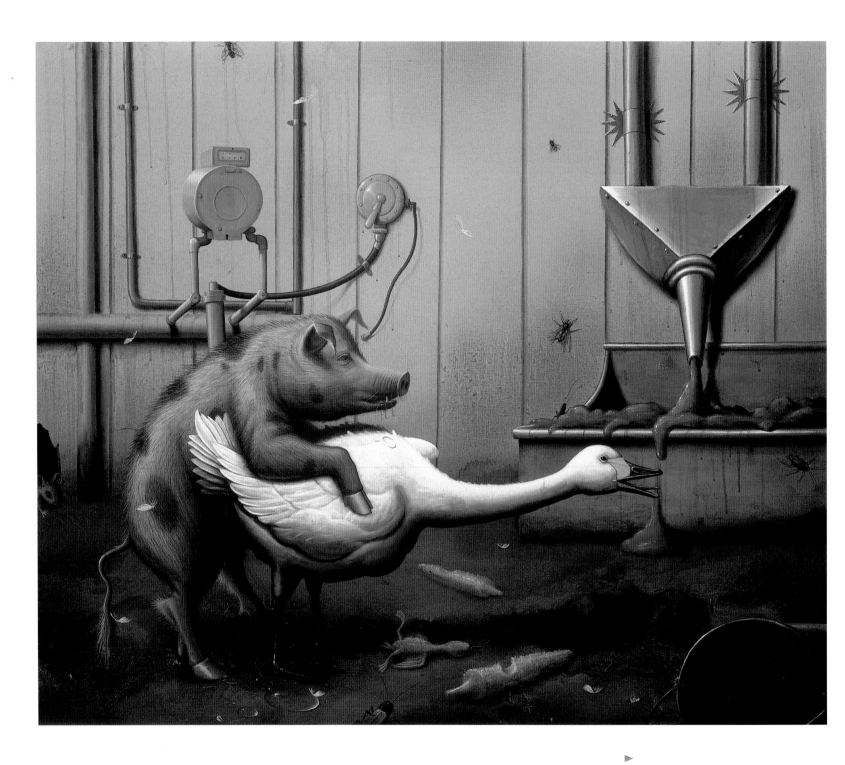

▶

Harvest, 1992
Patricia Bell
Cat. 14

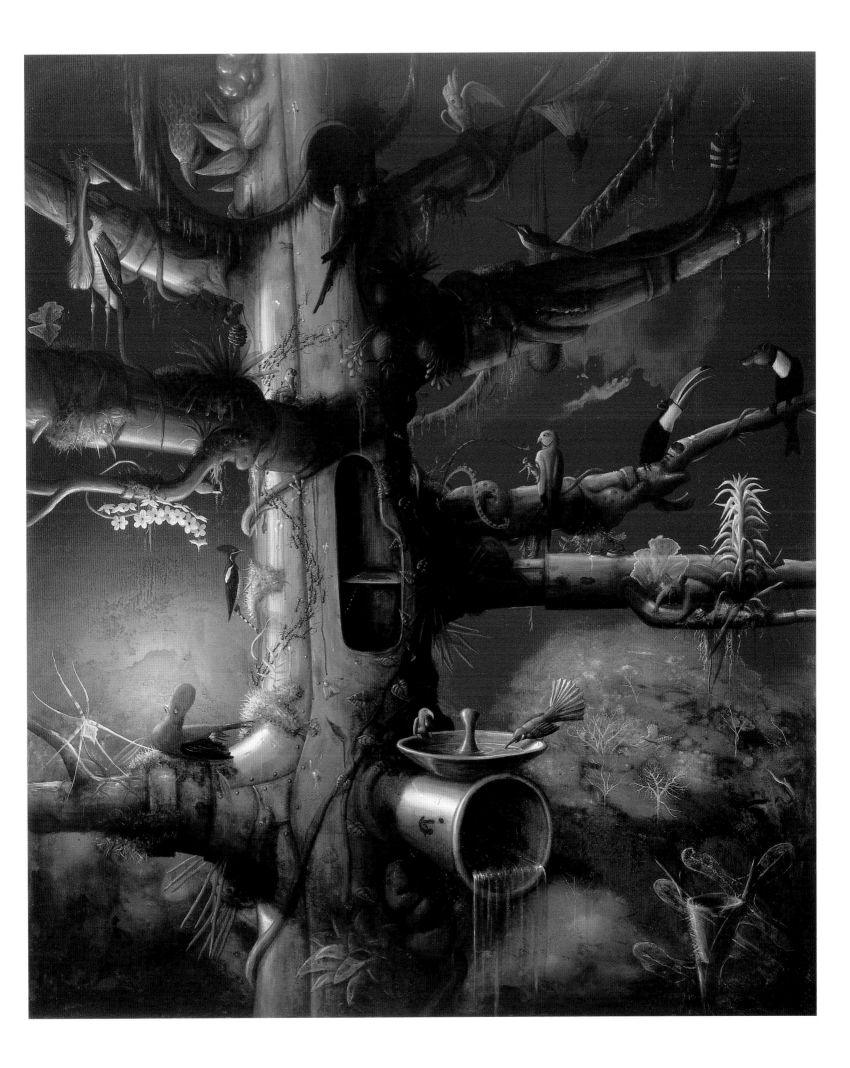

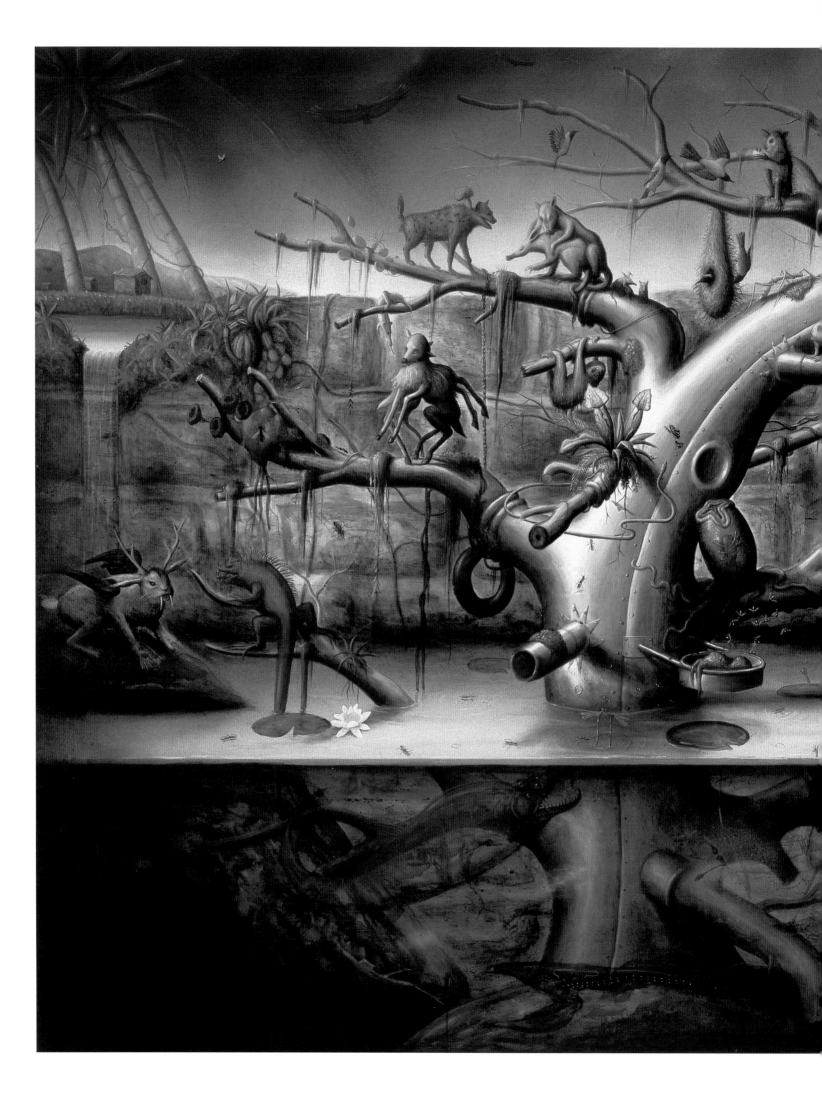

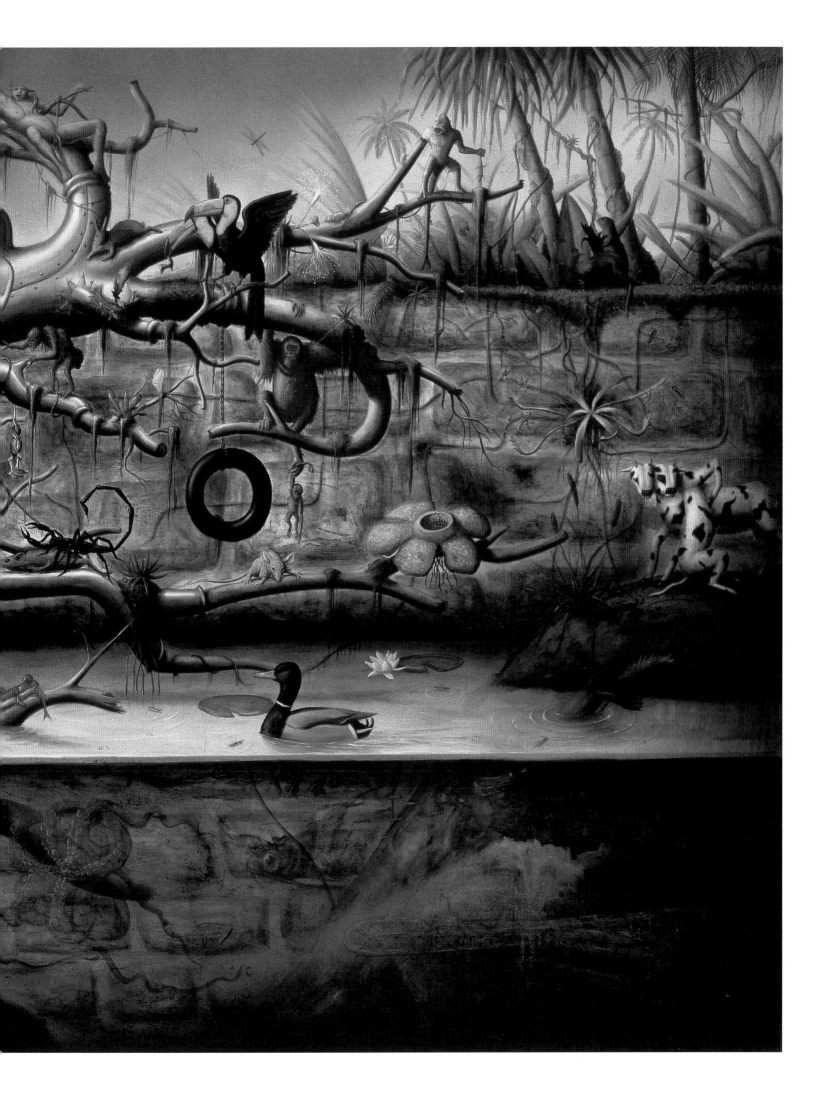

Biosphere: Tropical Tree Branch,
1992
Marshall and Wallis Katz
Cat. 11

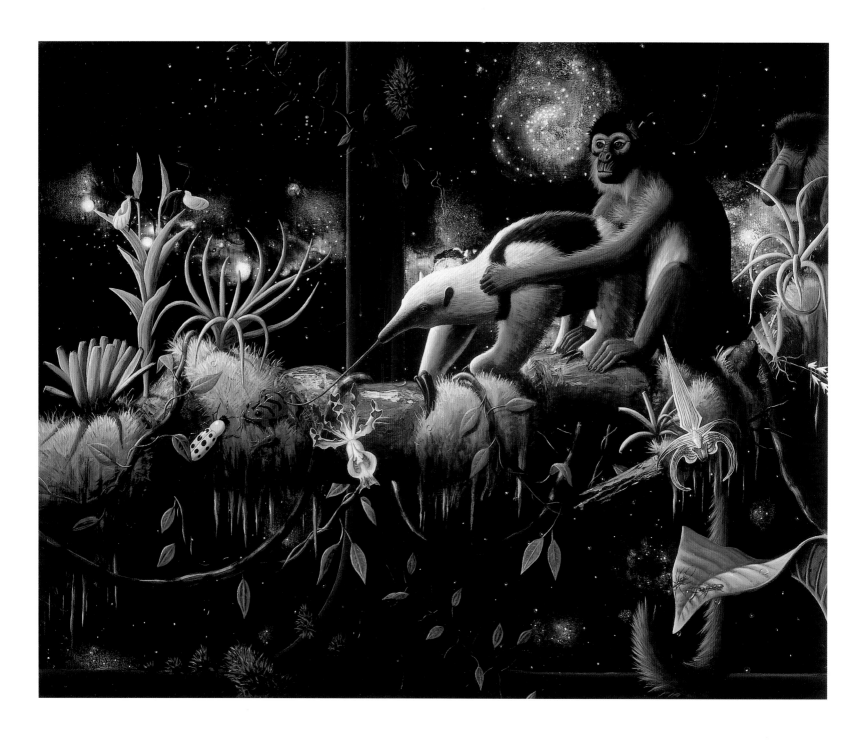

Biosphere: Orchids, 1993
Chuck and Joyce Shenk
Cat. 18

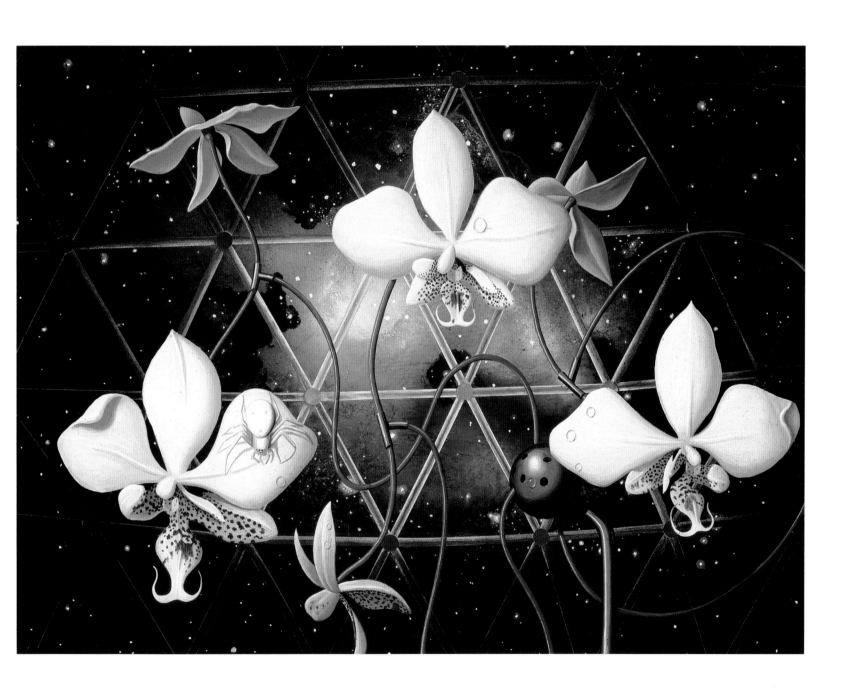

Biosphere: Mircoorganisms and Invertebrates, 1993
Carlos Brillembourg, Architect
Cat. 16

Biosphere: Monterey Bay, 1993
Laura-Lee Woods
Cat. 17

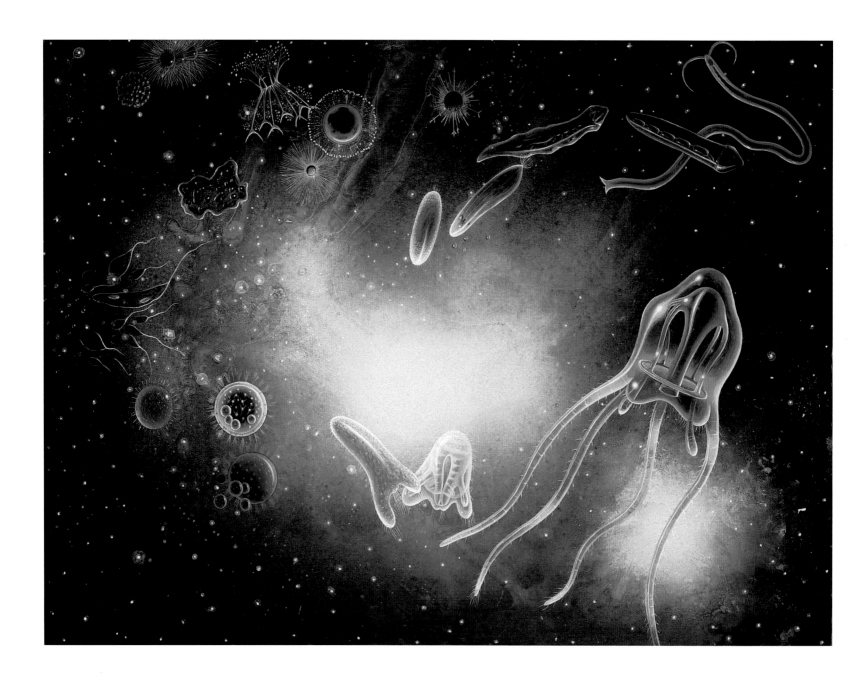

►

Bromeliad: Kaieteur Falls, 1994
Nestlé USA
Cat. 21

► ►

Host and Vector, 1996
Whitney Museum of American Art,
New York, Gift of the Nye Family
Cat. 30

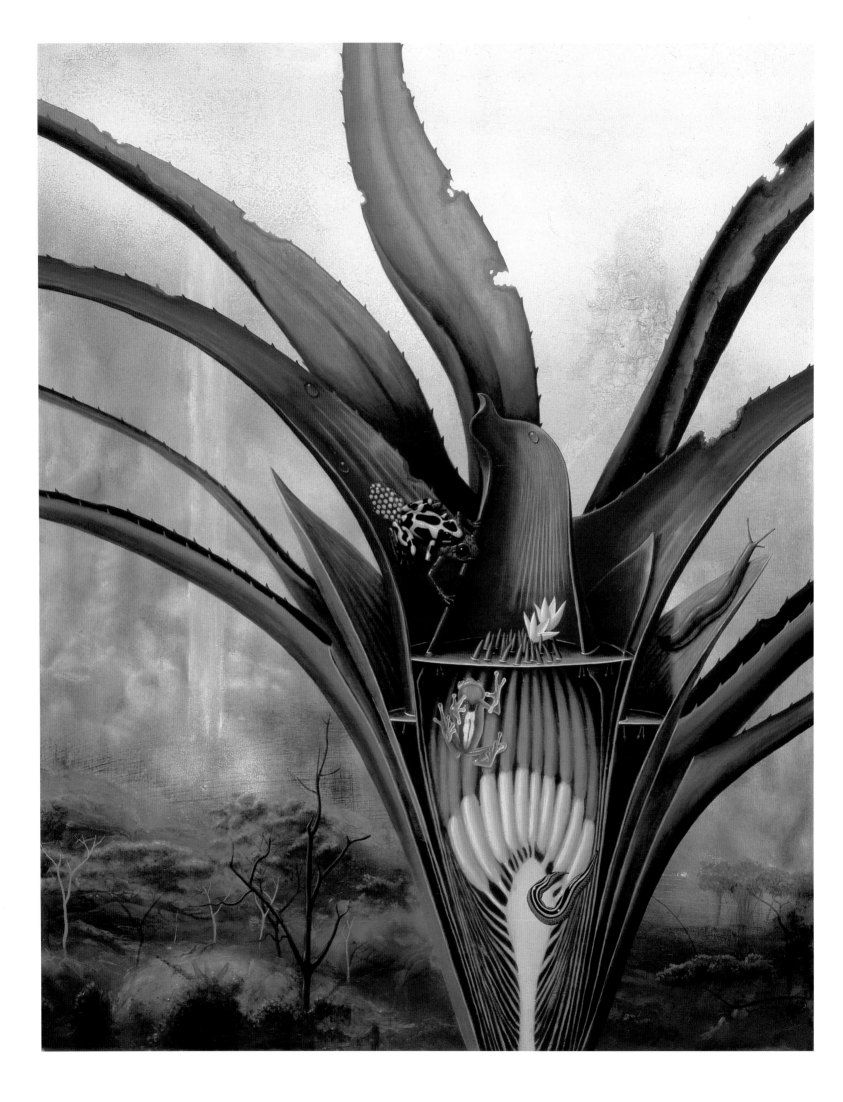

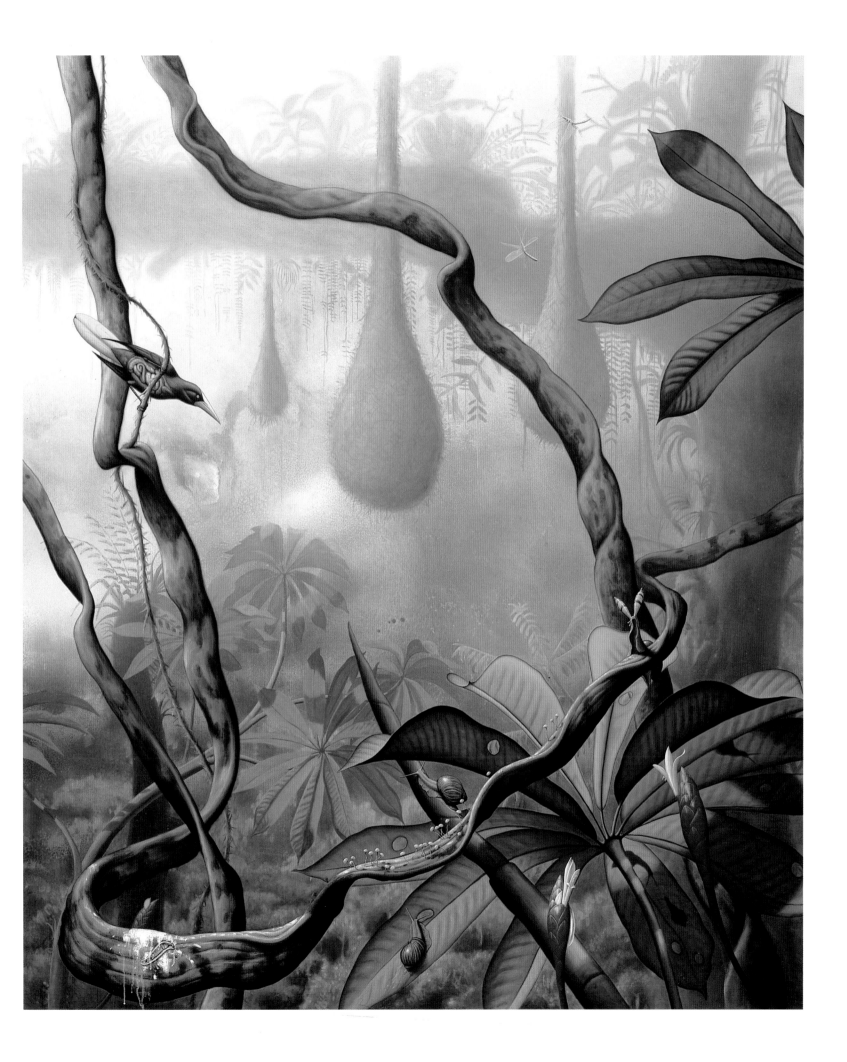

Kapok Tree, 1995
Haggerty Museum of Art,
Marquette University,
Milwaukee, Gift of Peter Norton
Cat. 27

*Juvenile Mantis on Bromeliad
Leaf,* 1995
Katherine Dunn
Cat. 26

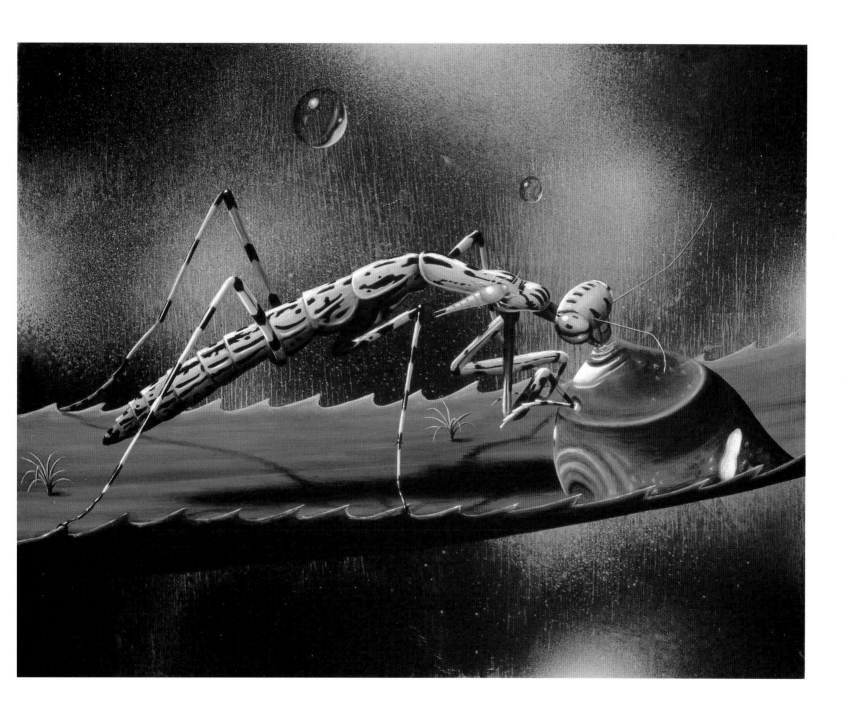

Bat Pursues Moth, 1995
Courtesy of the Artist and
Waqas Wajahat, New York
Cat. 23

Flies, 1995
London Shearer Allen
Cat. 25

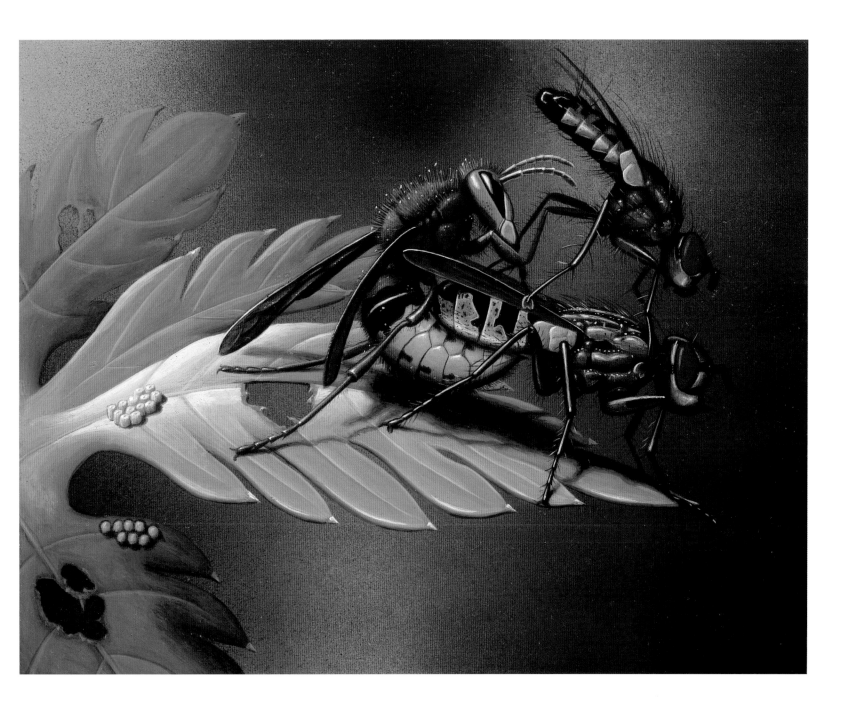

▶

Water Droplet, 1995
Barry Blinderman
Cat. 28

▶ ▶

Drunken Bees, 1996
Jay Gorney, New York
Cat. 29

Varzia, 1994
Cincinnati Art Museum, Ohio,
Museum Purchase, Gift of the
Docent Committee and Bequest
of Mr. and Mrs. Walter J. Wichgar
Cat. 22

▶

Drainage Ditch: Georgetown, 1995
Morris and Sherry Grabie,
Los Angeles, California
Cat. 24

▶ ▶

Concrete Jungle III, 1992
Private Collection,
Courtesy Jarla Partilager
Cat. 12

▶ ▶ ▶

Concrete Jungle V, 1993–94
Private Collection
Cat. 19

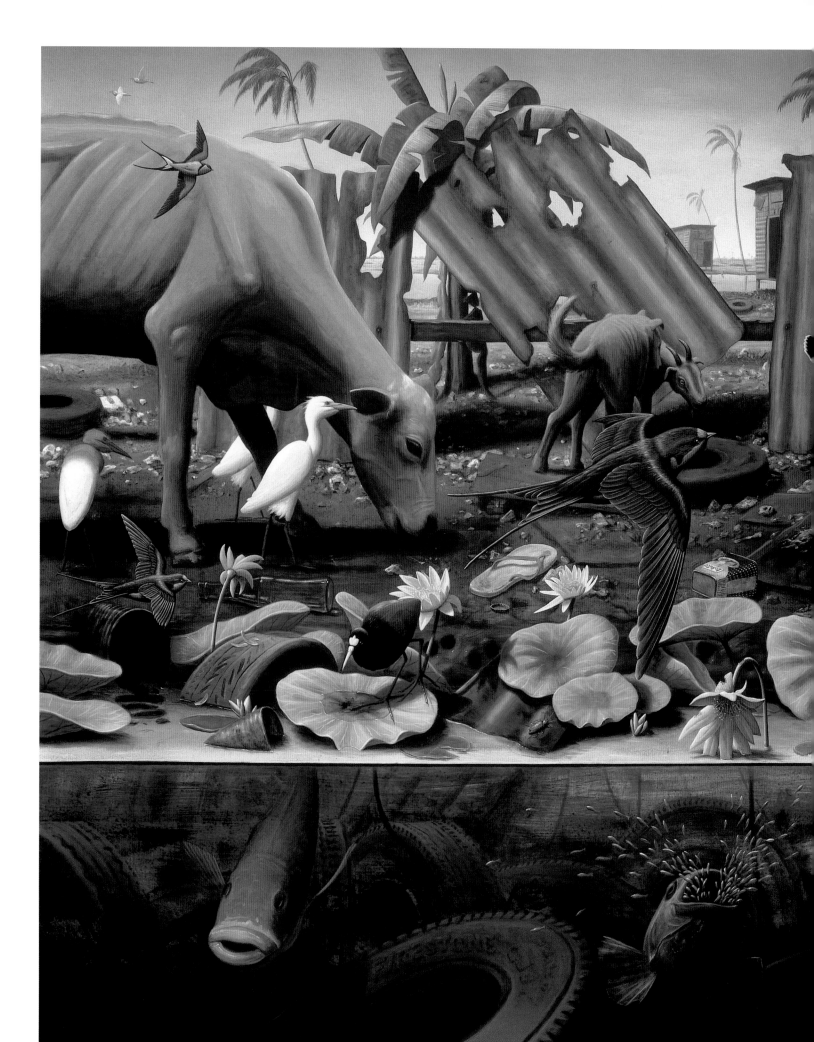

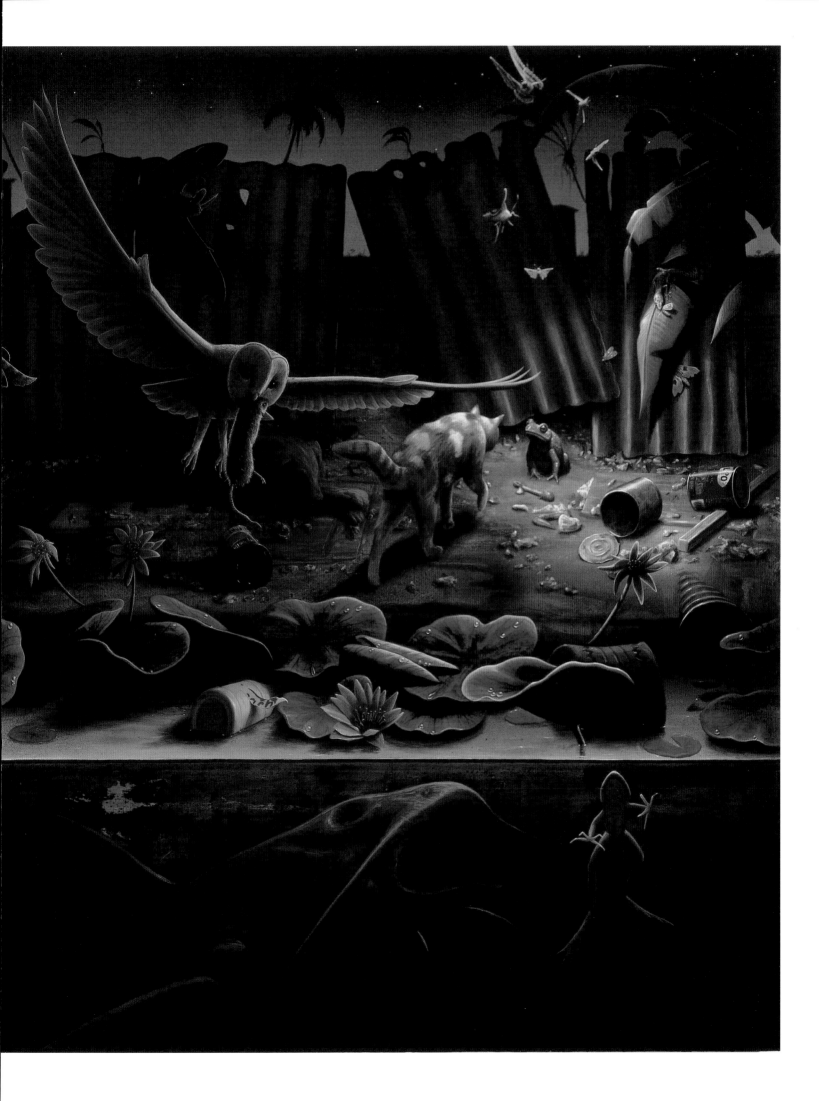

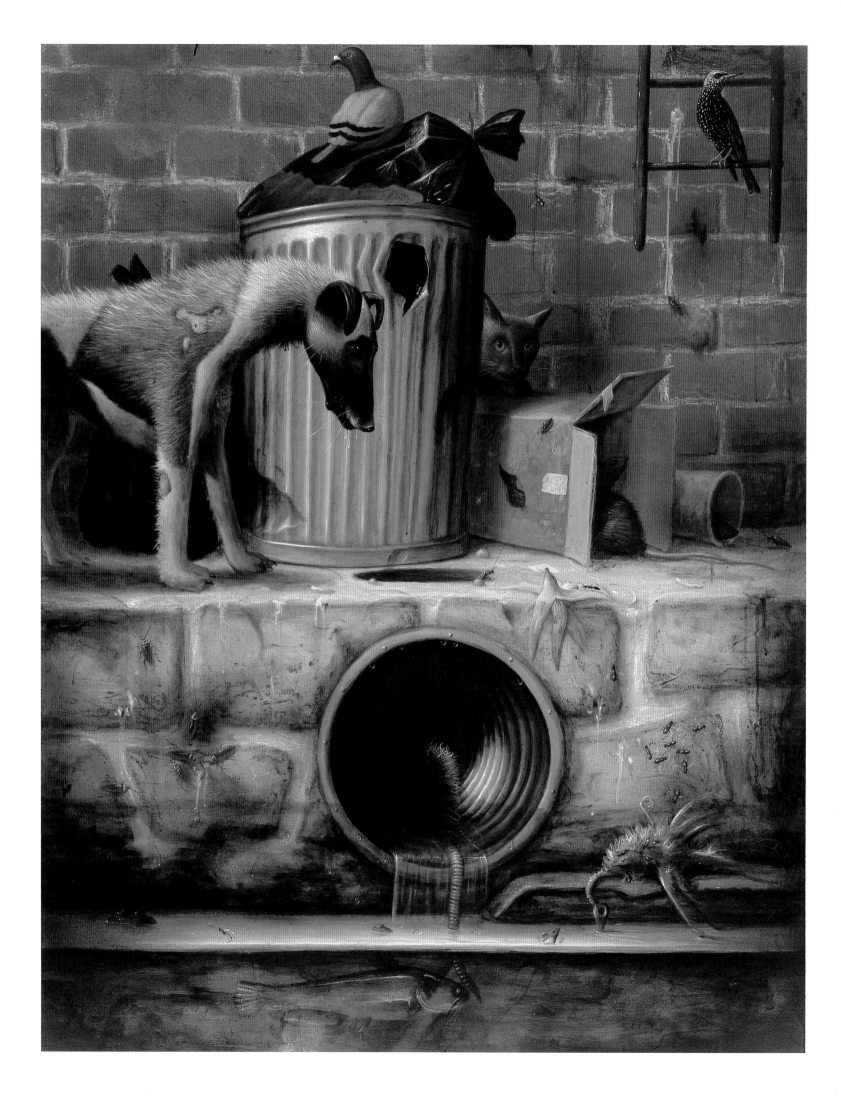

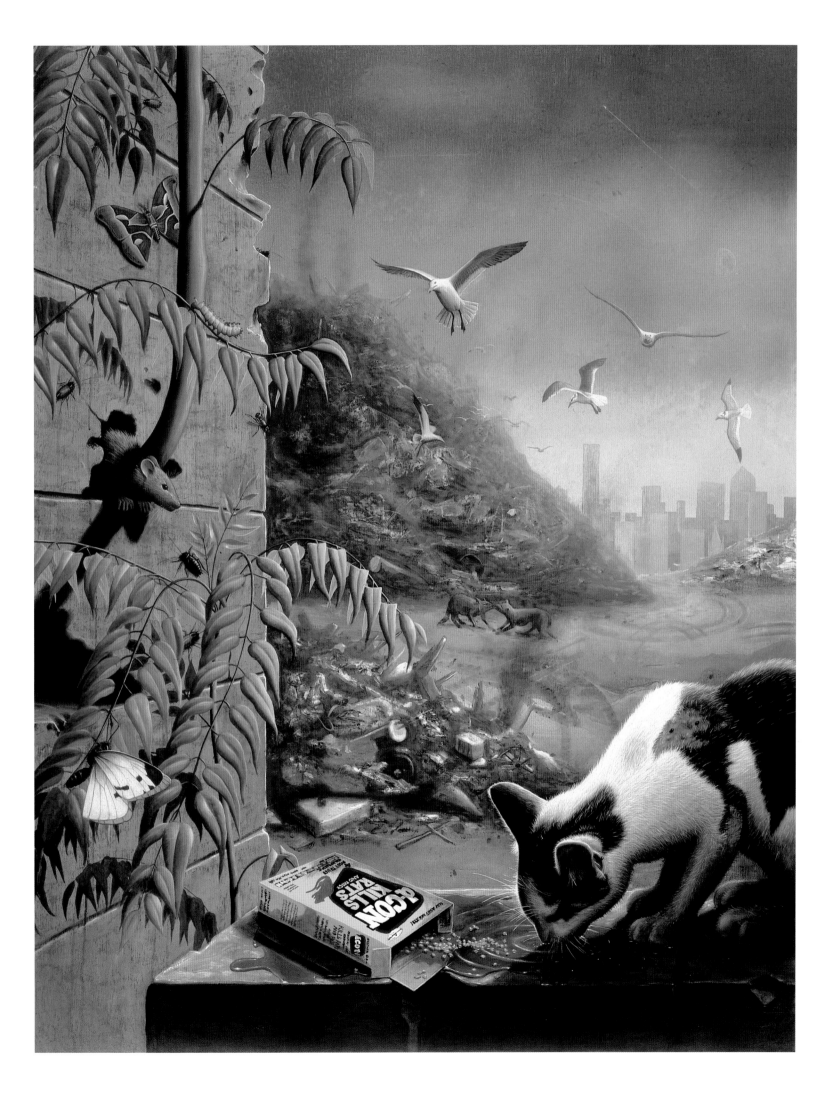

Ready to Rumble, 1997
Private Collection,
New York City
Cat. 34

Airport, 1997
Collection of Rachel and
Jean-Pierre Lehmann
Cat. 31

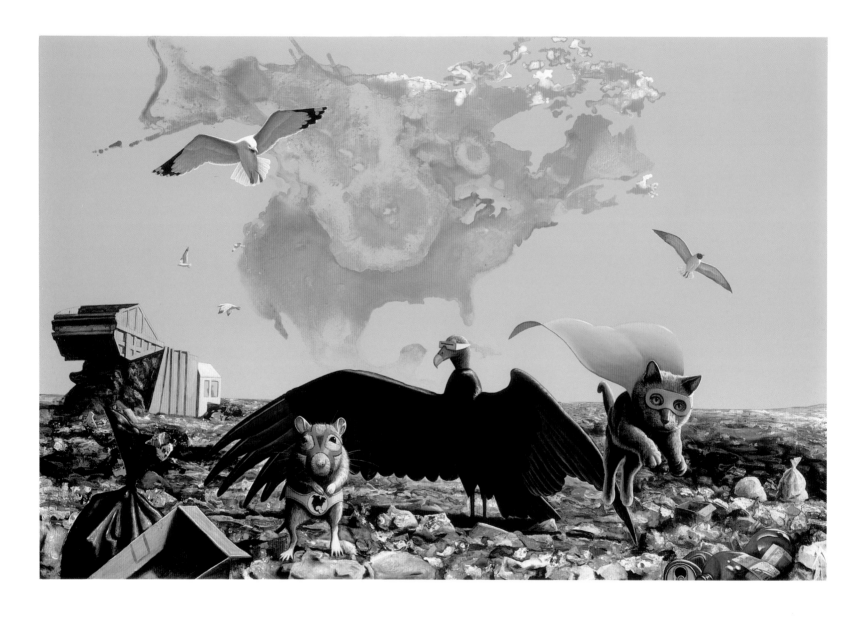

▶

Ecotourist, 1997
Collection of Gillian Anderson
Cat. 32

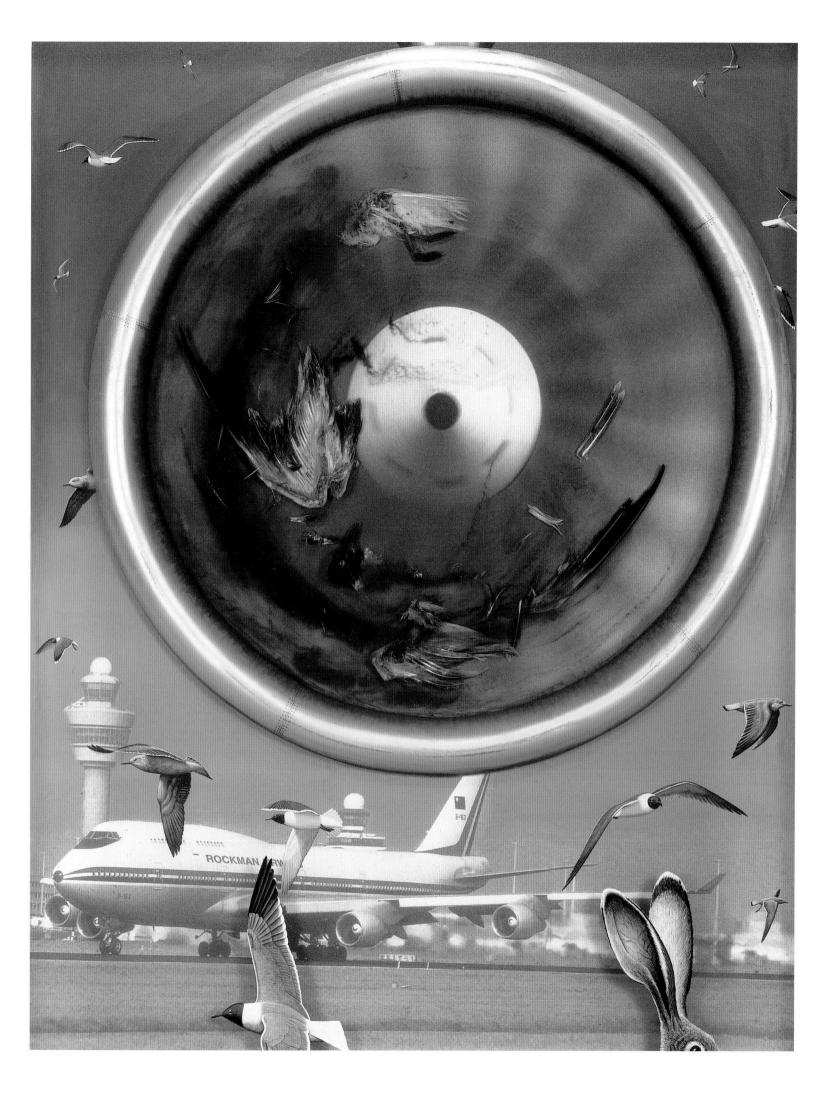

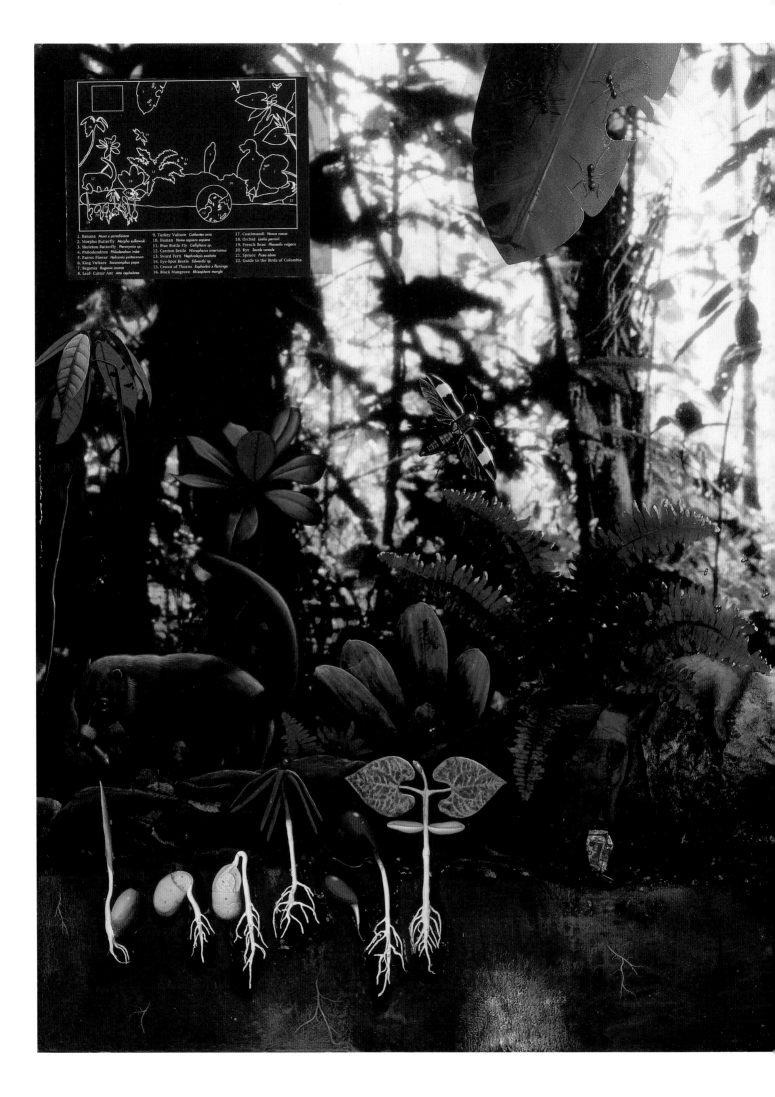

1. Banana *Musa x paradisiaca*
2. Morpho Butterfly *Morpho sulkowski*
3. Skeleton Butterfly *Pteronymia sp.*
4. Philodendron *Philodendron imbe*
5. Parrot Flower *Heliconia psittacorum*
6. King Vulture *Sacoramphus papa*
7. Begonia *Begonia incana*
8. Leaf-Cutter Ant *Atta cephalotes*

9. Turkey Vulture *Cathartes aura*
10. Human *Homo sapiens sapiens*
11. Blue Bottle Fly *Calliphora sp.*
12. Carrion Beetle *Nicrophorus americanus*
13. Sward Fern *Nephrolepis exaltata*
14. Eye-Spot Beetle *Edwardia sp.*
15. Crown of Thorns *Euphorbia x flamingo*
16. Black Mangrove *Rhizophora mangle*

17. Coatimundi *Nasua nasua*
18. Orchid *Laelia perrinii*
19. French Bean *Phaseolis vulgaris*
20. Rye *Secale cereale*
21. Spruce *Picea abies*
22. Guide to the Birds of Colombia

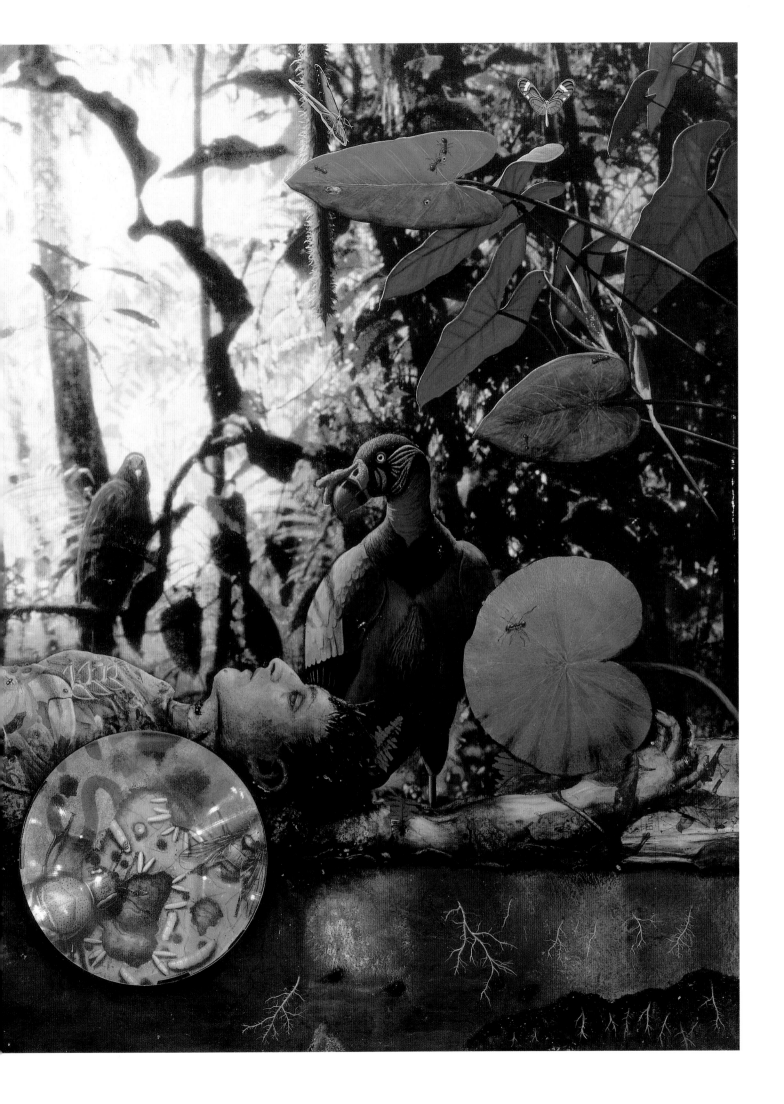

The Hammock, 2000
Collection of Ninah and
Michael Lynne
Cat. 37

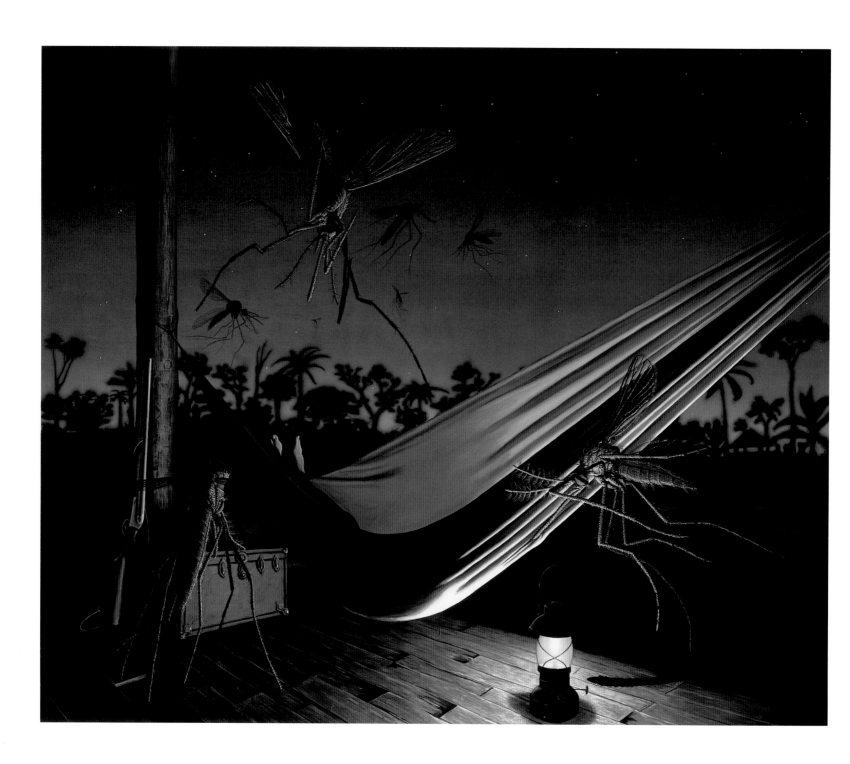

The Conversation, 2001
Collection of Richard Edwards,
Aspen, Colorado
Cat. 38

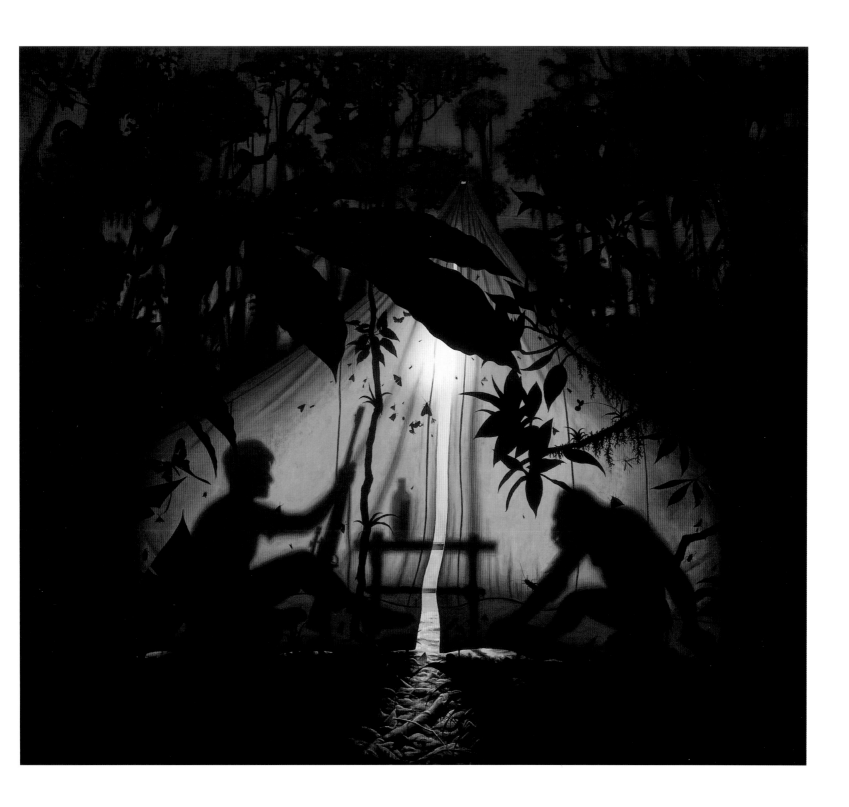

Gymnorhamphichthcys Bogardus,
2001
William G. Spears
Cat. 40

The Bass, 2002
Collection of Thomas Lee and
Ann Tenenbaum
Cat. 41

Cataclysm, 2003
Collection of Melva Bucksbaum
and Raymond Learsy
Cat. 42

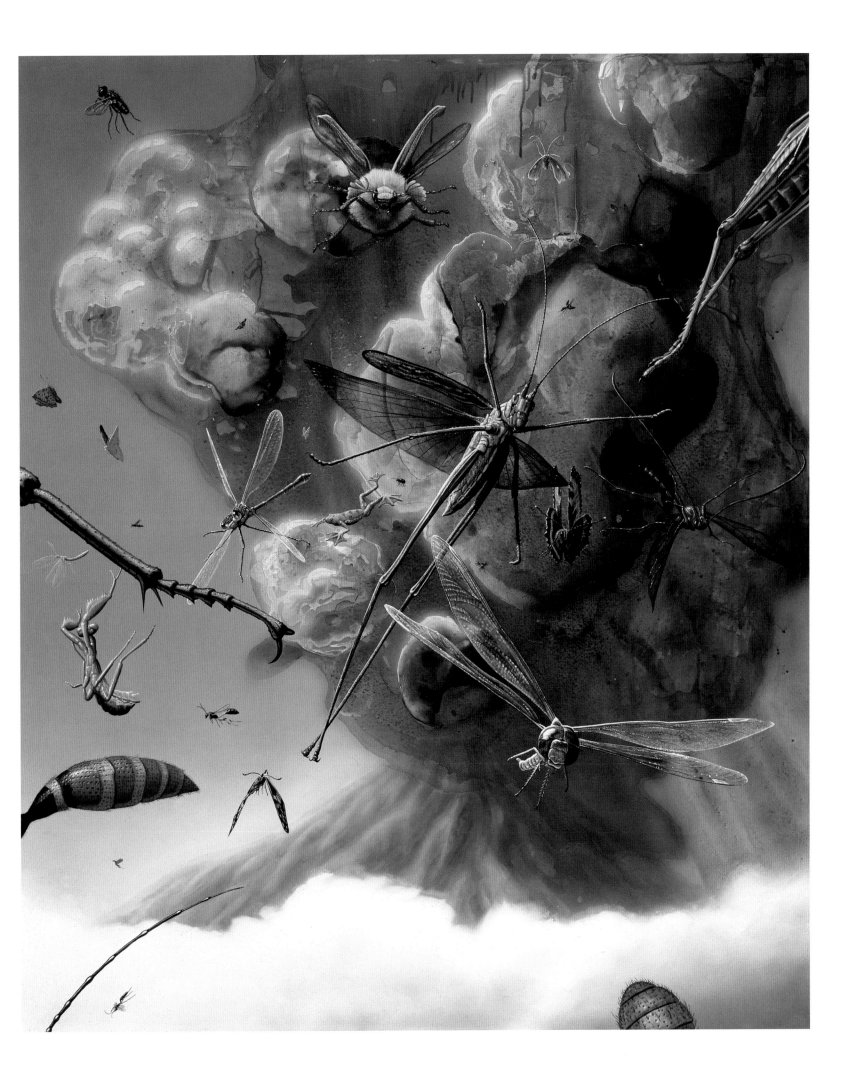

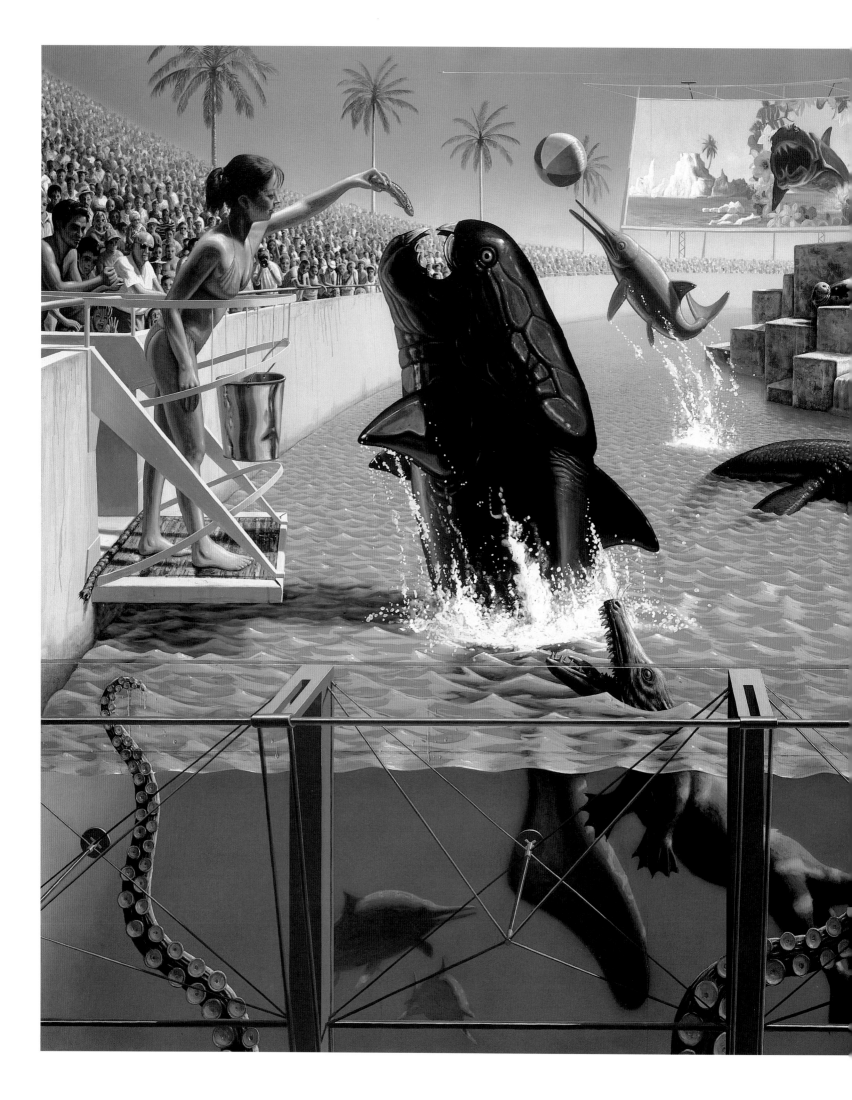

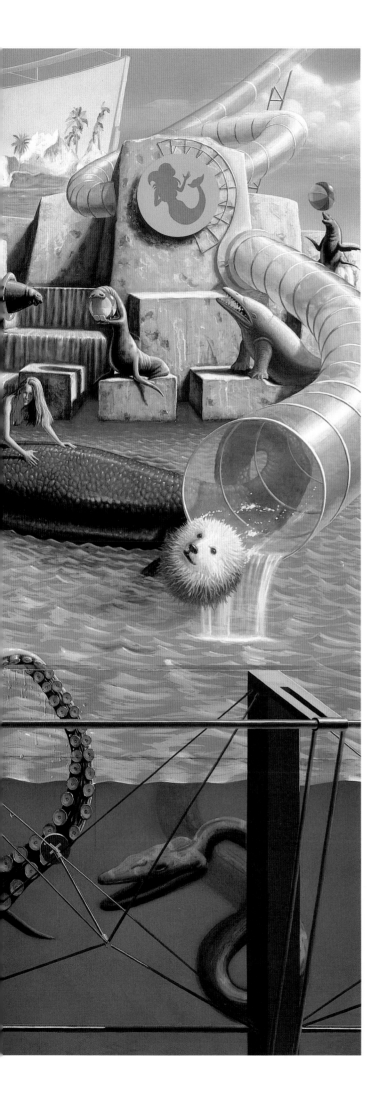

Sea World, 2004
Virginia Museum of Fine Arts,
Richmond, Gift of Pamela K.
and William A. Royall Jr.
Cat. 44

Manifest Destiny, 2003–4
Courtesy of the Artist and
Waqas Wajahat, New York
Cat. 43

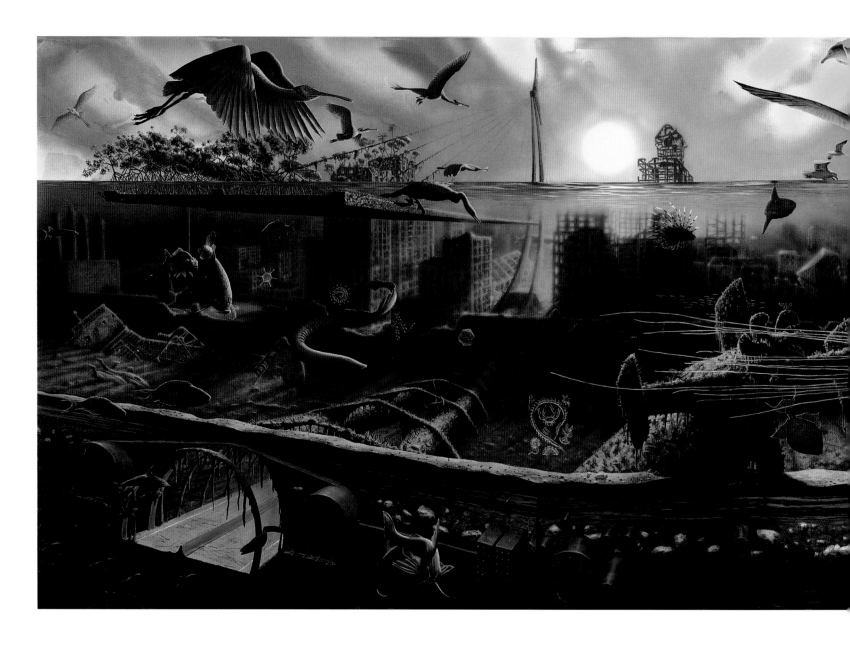

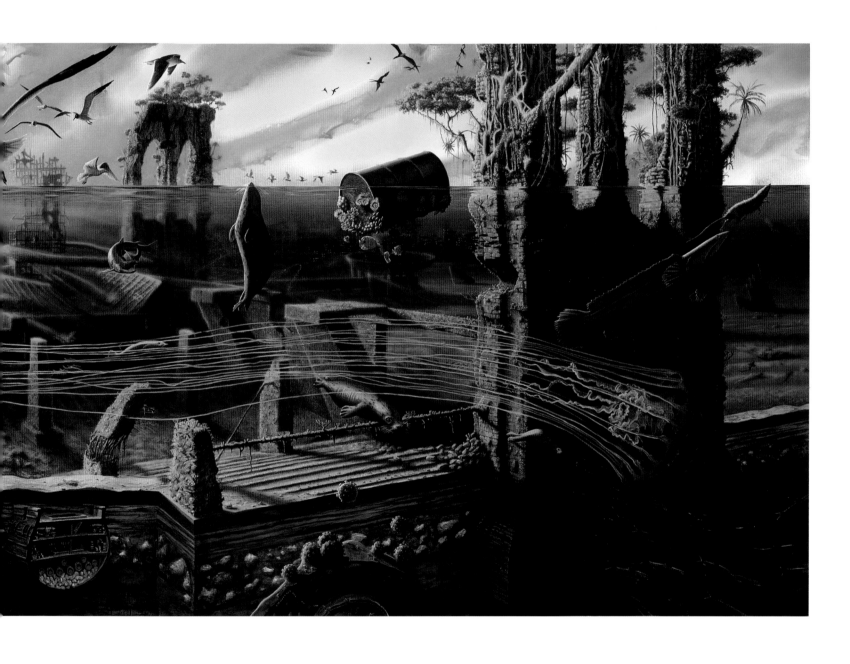

▶
Gateway Arch, 2005
Private Collection
Cat. 47

▶ ▶
Mount Rushmore, 2005
Jeffrey Seller and Joshua Lehrer
Cat. 50

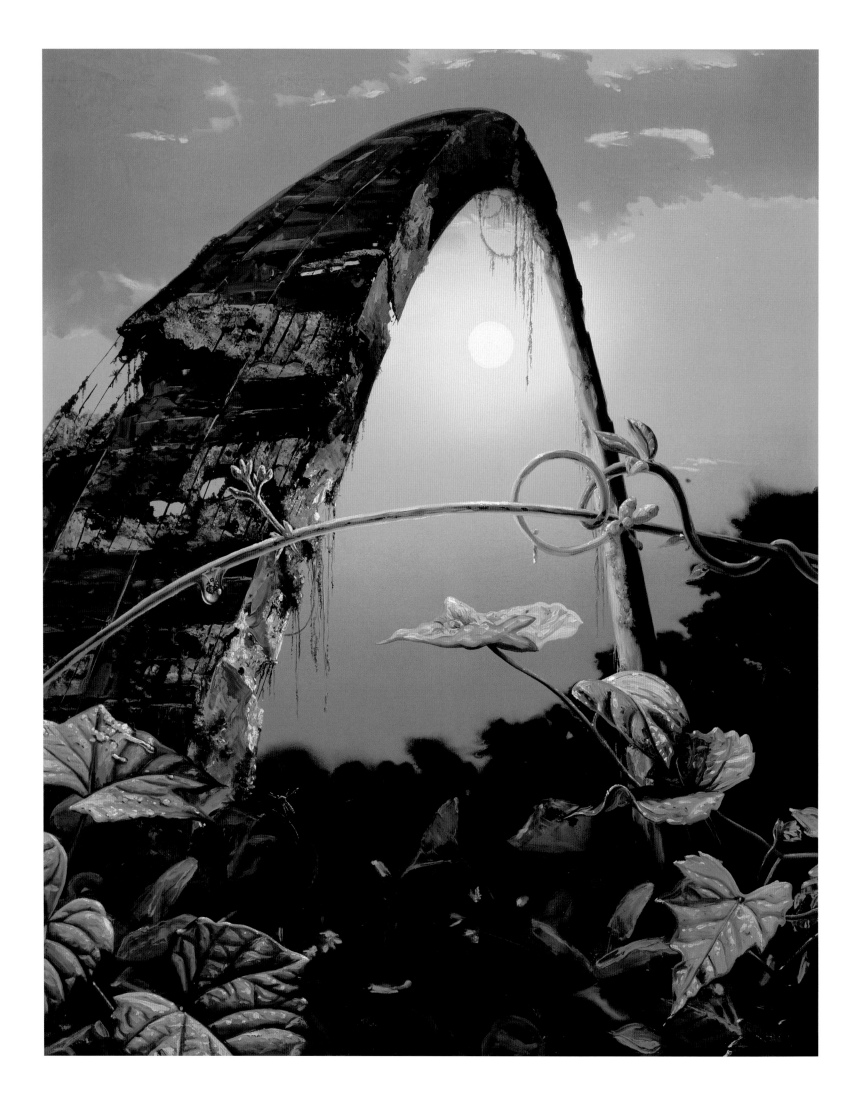

Disney World I, 2005
Beth Rudin DeWoody
Cat. 46

Hollywood at Night, 2006
Mr. and Mrs. Henry P. Davis
Cat. 52

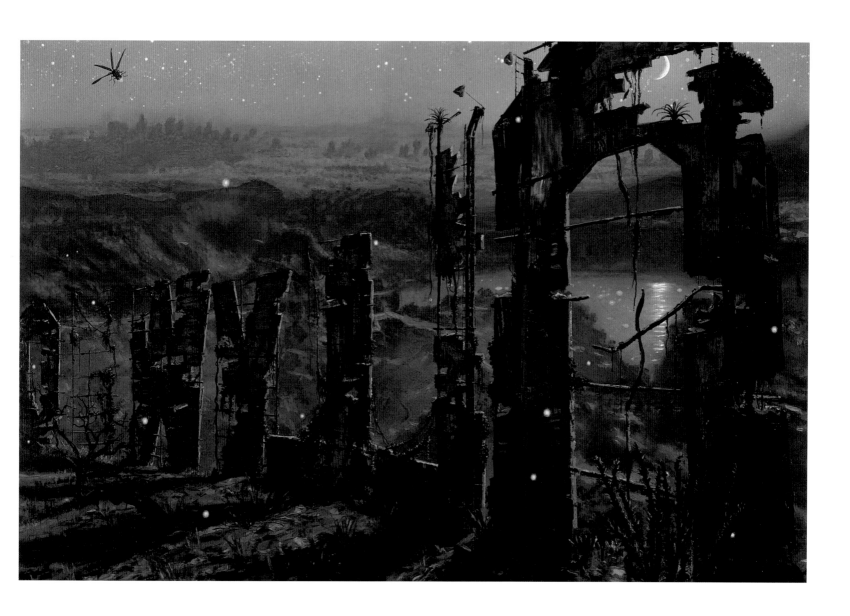

▶

East 82nd Street, 2006
The Pappas Family, Boston
Cat. 51

▶ ▶

The Pelican, 2006
Private Collection, New York;
Courtesy of Waqas Wajahat,
New York
Cat. 53

▶ ▶ ▶

Mangrove, 2005
Private Collection, New York;
Courtesy of Elizabeth Schwartz,
LLC, New York
Cat. 49

▶ ▶ ▶ ▶

High Jump, 2005
Judy and Robbie Mann
Cat. 48

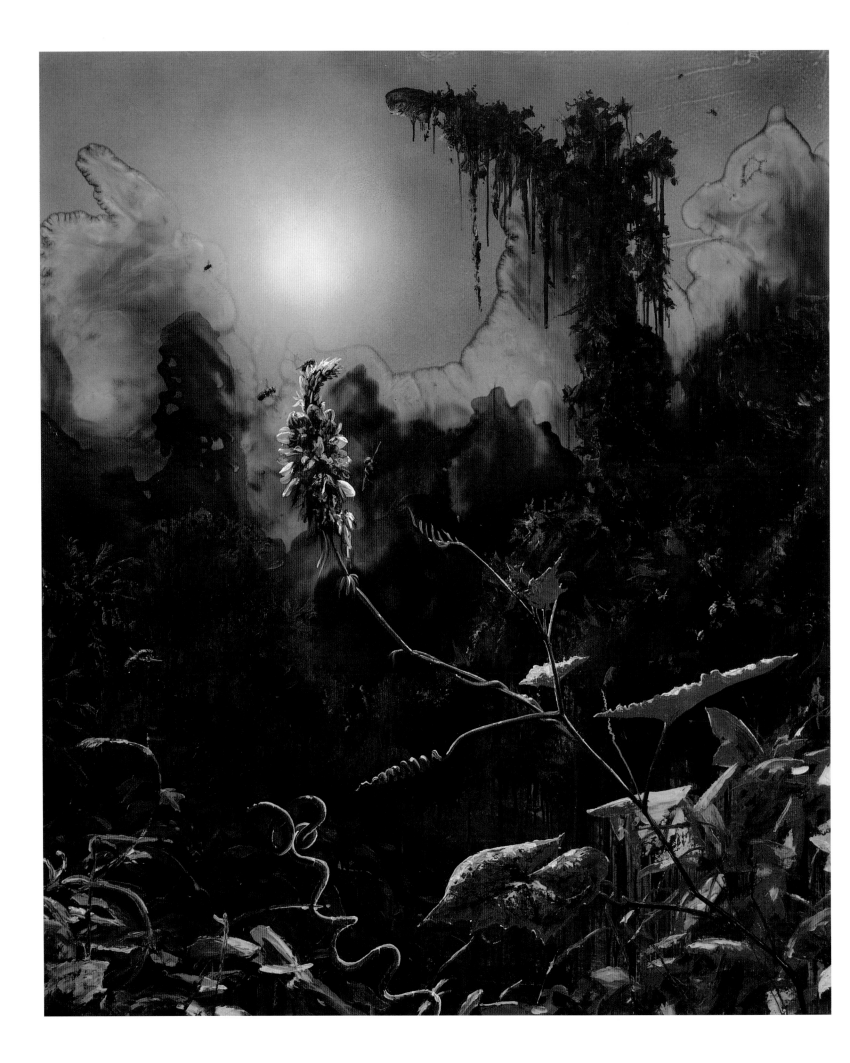

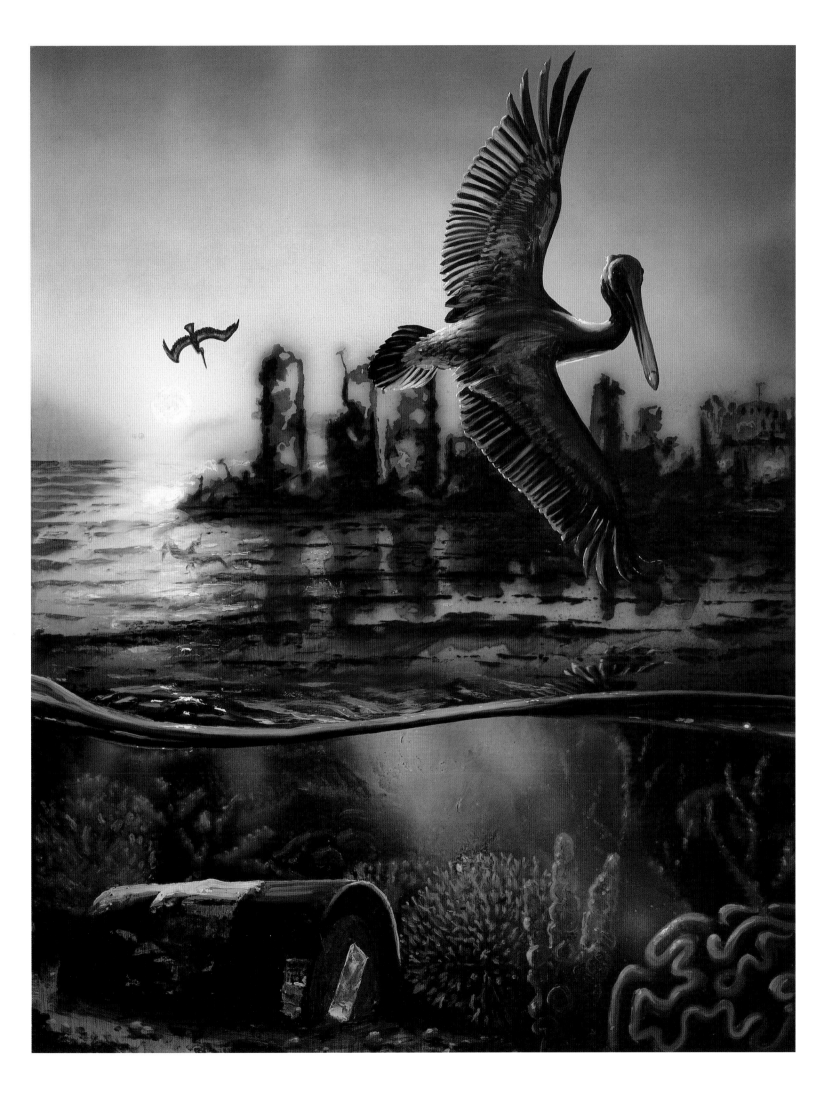

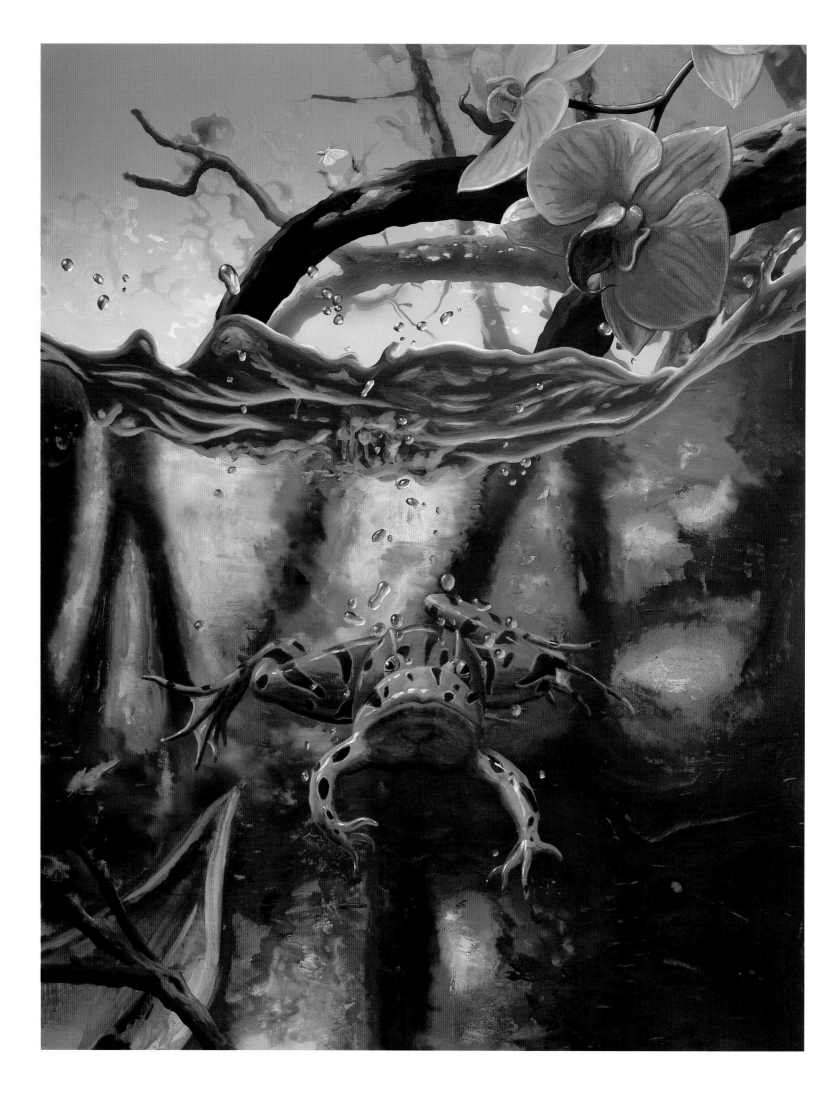

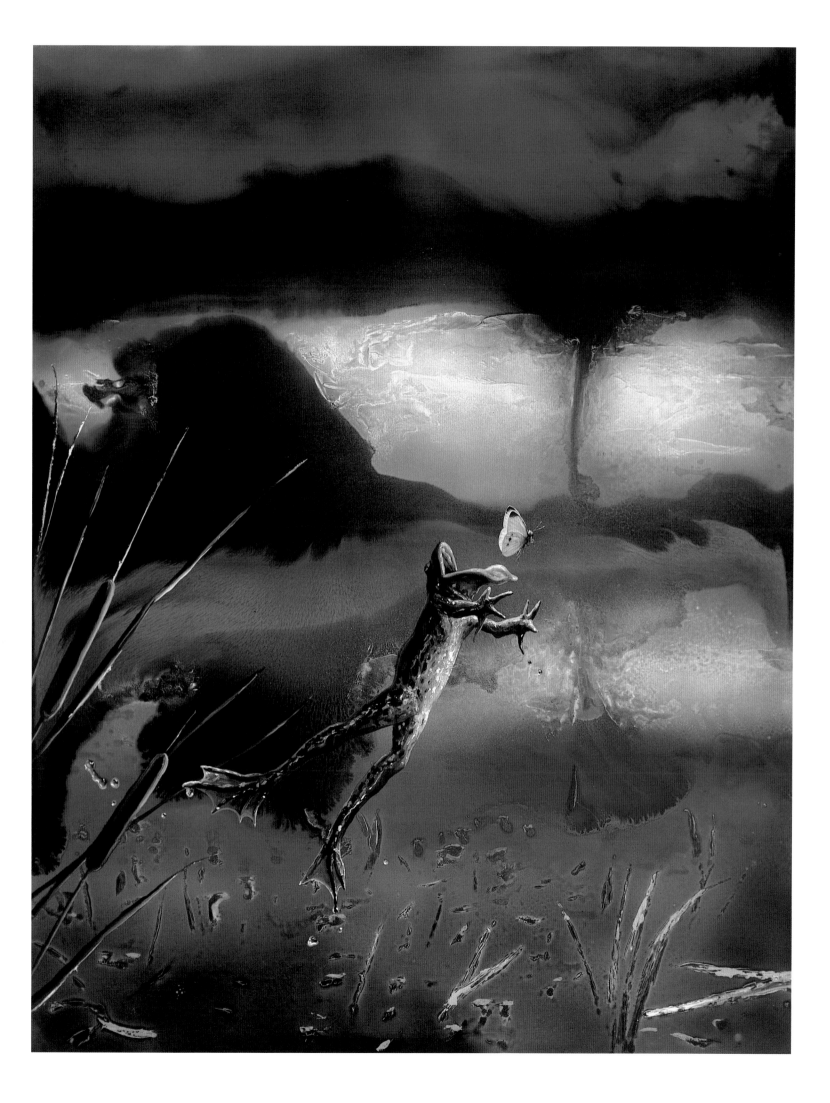

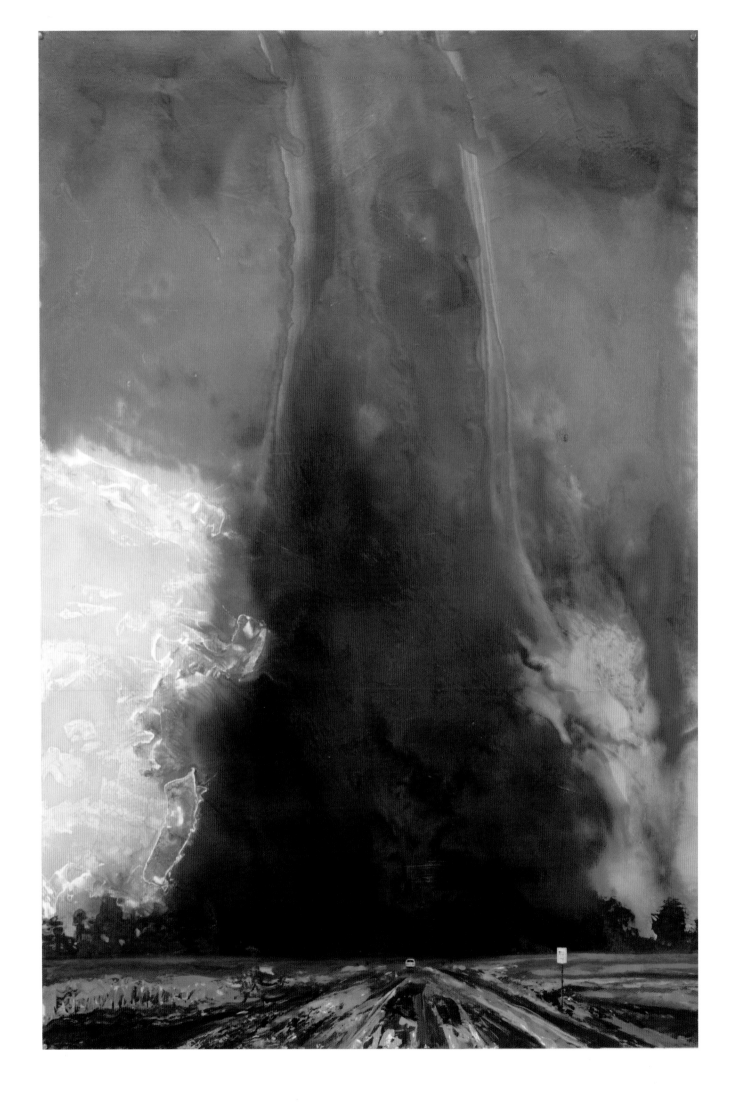

Old Dirt Road, 2007
Pamela C. Alexander,
Aspen, Colorado
Cat. 55

Supergrid, 2007
Michael Polsky
Cat. 56

Cambridgeshire, 2008
Collection of Melva Bucksbaum
and Raymond Learsy
Cat. 57

Railyard, 2008
Warren G. Lichtenstein
Cat. 59

South, 2008
The Pappas Family, Boston
Cat. 60

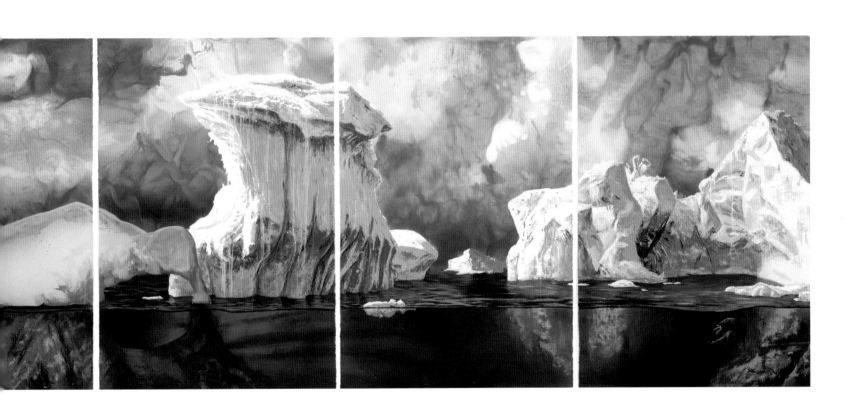

Only You, 2008
Courtesy of Tim Nye
Cat. 58

The Reef, 2009
Pamela K. and William A.
Royall Jr., Richmond, Virginia
Cat. 61

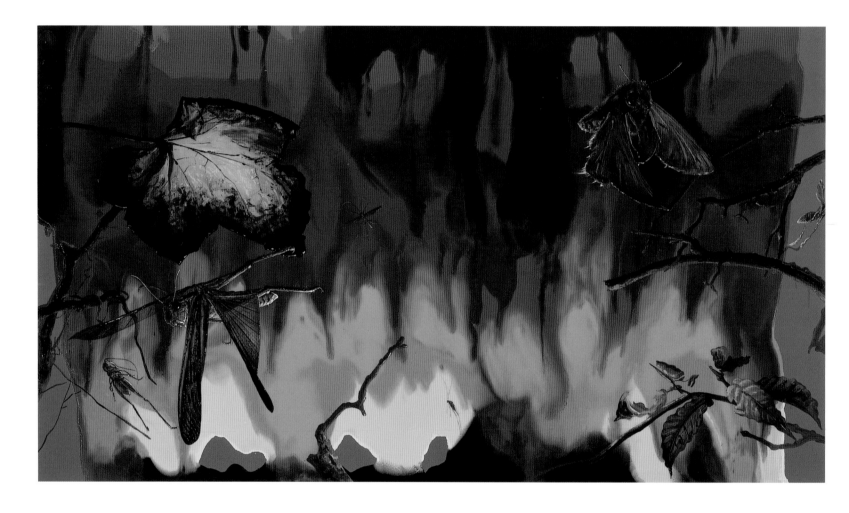

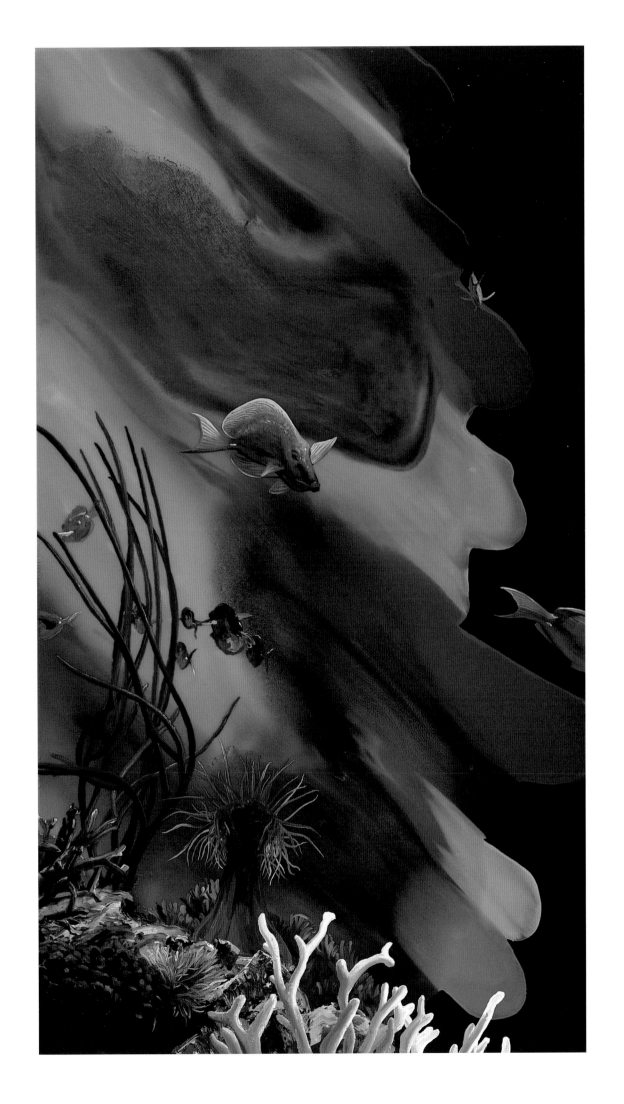

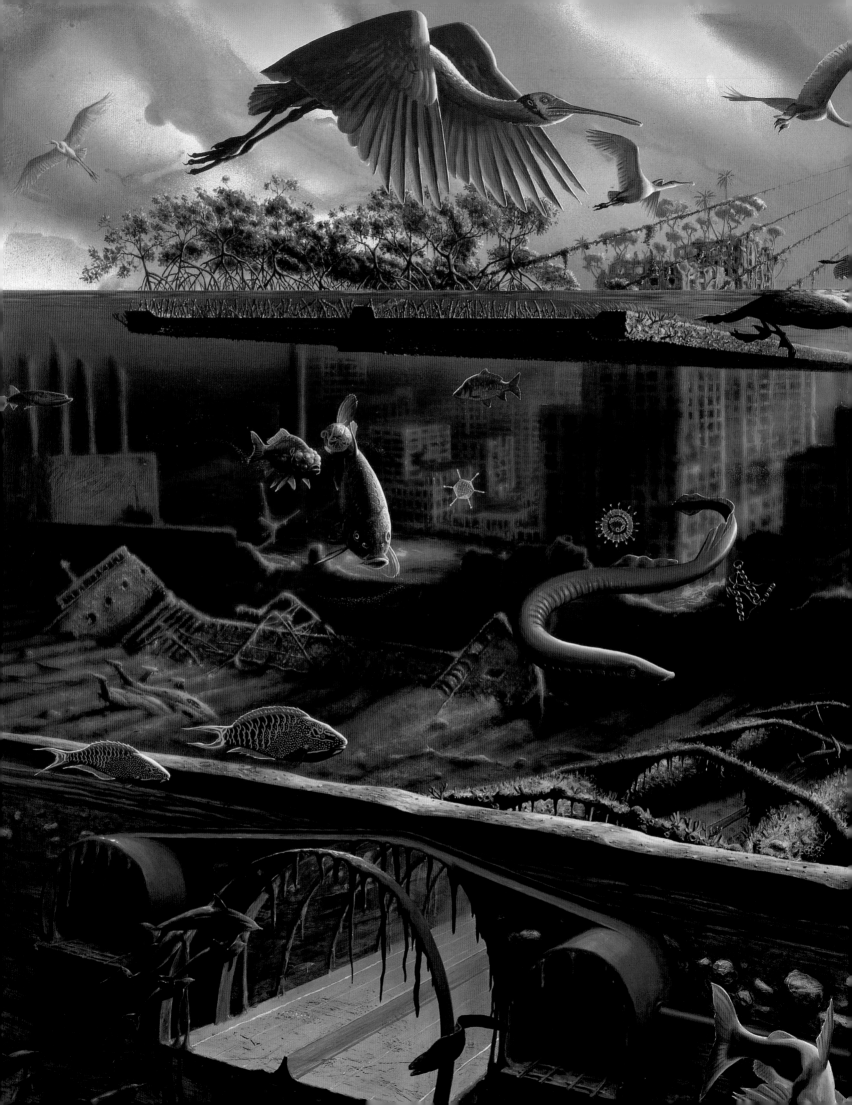

Kevin J. Avery

Panoramas of the Post-Apocalypse

ROCKMAN'S TRIPTYCH, AMERICAN LANDSCAPE, AND LANDSCAPE THEATER

In the summer of 1865 three of the American painter Frederic Church's monumental landscape paintings regaled the British public at McLean's Gallery in London. The exhibit of the trio—*Cotopaxi*, 1862, *Chimborazo*, 1864, and *Aurora Borealis*, 1865 [figs. 25–27]—represented the third time in six years that Church's art had been shown in England; the first two occurrences had been solo exhibitions of the largest and most ambitious paintings the artist would ever produce: *The Heart of the Andes*, 1859, and *The Icebergs*, 1861 [figs. 28, 29]. Regarding the 1865 exhibition, one British reviewer claimed that the artist had intended *Cotopaxi* and *Chimborazo* as pendants to *The Heart of the Andes* (each respectively at the larger picture's left and right), and that engravings of the pendants were to be produced to accompany the one already published of *The Heart of the Andes*. Of the peculiar coherence the critic claimed for that "triptic," he observed that *Chimborazo* embodied the "tropical witchery of landscape, the Andean *beauty*"; *Cotopaxi* "Andean *grandeur* and energy"; while *The Heart of the Andes* was a "comprehensive representation . . . of an entire class of noble scenery in nature."[1] Still, this linkage scarcely obviated the aesthetic complementariness the critic noted even in the current ensemble, what he termed "three graphic poems, awakening three different kinds of emotion; one ardently sublime [*Cotopaxi*], the second the very fullness of beauty [*Chimborazo*]; . . . the third, pensively tender, pathetic [*Aurora Borealis*]."[2] Had he thought a little more on the relationship, the critic might have discerned, too, the antipodal symmetry of subject in the trio: two tropical scenes, one frigid, and all portraying mountains of special significance either to the explorer-naturalist Alexander von Humboldt (in the eponymous *Cotopaxi* and *Chimborazo*), who had inspired the artist's expeditions to Ecuador, or to Church himself (*Aurora Borealis*). Prominent there is the pyramidal summit in Labrador that the Arctic

25

Frederic E. Church, *Cotopaxi*, 1862, oil on canvas, 48 × 85 in. The Detroit Institute of Arts, Founders Society Purchase with Funds from Mr. and Mrs. Richard A. Manoogian, Robert H. Tannahill Foundation Fund, Gibbs-Williams Fund, Dexter M. Ferry, Jr., Fund, Merrill Fund, and Beatrice W. Rogers Fund

26

Frederic E. Church, *Chimborazo*, 1864, oil on canvas, 48 × 84 in. Huntington Library and Art Gallery, San Marino, California

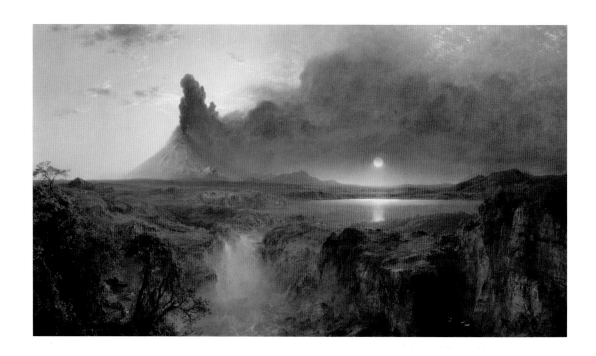

30

Frederic E. Church, *Rainy Season in the Tropics*, 1866, oil on canvas, 56 ¼ × 84 ¼ in. Fine Arts Museums of San Francisco, Museum Purchase, Mildred Anna Williams Collection

the climatic antipode of *Evolution*, the earlier picture teeming with animate life (if some of it mutant), the later one comparatively devoid of it.[8] We wouldn't necessarily venture to establish an order for the imagined display of Rockman's triptych—that is, what picture should take center place with the others flanking. But that they possess a coherence and requisite breadth of theme, that they inform one another's environmental agenda to assume global import—much as the various actual and conceptual ensembles of Church's panoramas did in the Civil War era—is undeniable. Indeed, the commonalities link

the two artists like bookends of their respective ages. On the one hand is optimism and possibility with reference to earthly exploration and human achievement, and on the other, bemused doubt and resignation with reference to earthly exploitation and human hubris. To exemplify the point with just one minute detail each of *Aurora Borealis* and *South*: In the former we descry an expeditionary schooner frozen in ice [fig. 31], a civilized haven to which a team of dogsledders are returning from a foray in search of the Northwest Passage; overhead arches the providential aurora. In *South*, in the sixth panel, we detect

31

Detail, Frederic E. Church, *Aurora Borealis*, 1865 [fig. 27], showing expedition schooner *United States*

32

Detail, Alexis Rockman, *South*, 2008 [plate pp. 120–21; cat 60], showing foundering tourist ship and floating sea ice

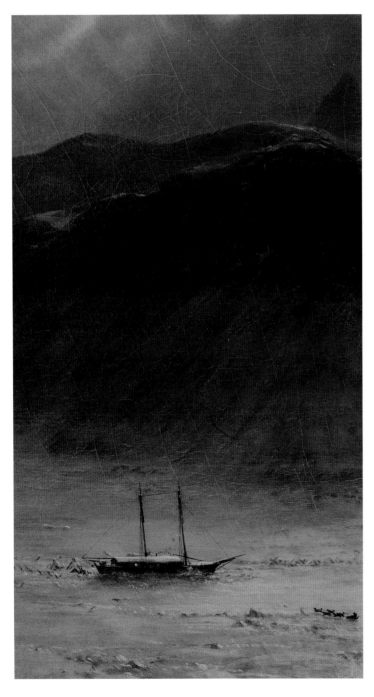

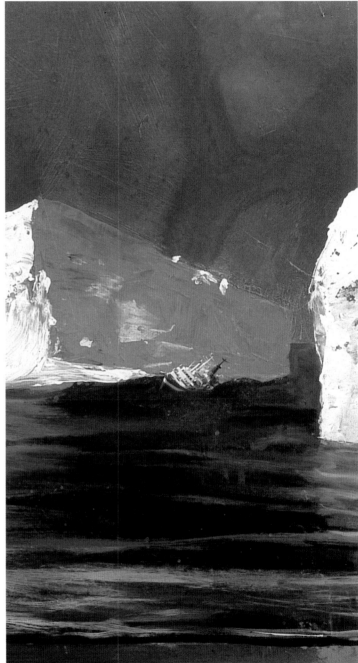

34

Thomas Cole. *The Course of Empire: The Savage State*, 1836, oil on canvas, 39 ¼ × 63 ¼ in. The New-York Historical Society

35

Thomas Cole, *The Course of Empire: Destruction*, 1836, oil on canvas, 39 ¼ × 63 ½ in. The New-York Historical Society

Common Dolphin diorama,
Millstein Hall of Ocean Life,
American Museum of Natural
History, New York

is plastic, resin, fiber glass, metal, papier-mâché, and the like or, more accurately, the artist's representation of those materials. Ironically, Rockman's act of representation may take the viewer one perceptual step back closer to the illusion of the reality (if an artificial one) from which

he had taken at least one step further away than the landscape painter.

Still, even the distinction between Rockman's trio and the major "frontier" landscapes of the Hudson River school manifests in part only their respective distances in time from art historical sources

that informed both: the arts of the panorama and the diorama that originated, respectively, in the late eighteenth and early nineteenth centuries and their symbiosis with the age of empiricism and exploration that fathered them. In 1786 an Irish-born painter named Robert

Barker conceived the idea of extending the traditional wide-angle prospect of a city into a view that would take in the complete circle of one's surroundings from a single vantage point. Translating that idea ideally onto a two-dimensional surface to create the impression of "being there" meant that the picture needed to be curved in a complete circle, end to end without interruption. After making a comprehensive set of drawings from atop Calton Hill in Edinburgh, Barker transferred them to the curved surface of a canvas measuring about twenty-five feet in diameter. To avoid the optical distortion attendant to transferring the straight lines from the flat surface of his drawings to the curved one of the canvas, the artist used a perspective system adapted from the painting of illusionistic scenes on the vaults of Baroque churches. For housing his painting, Barker constructed cylindrical wood sheds in Edinburgh, then London. There, just a little later, he built a larger and permanent structure [fig. 37] to hold subsequent pictures fully ninety feet in diameter to be accessed via a dark entranceway and up a gloomy staircase to a central viewing platform. Once there, the viewer was offered just one visual reference: the image surrounding him or her,

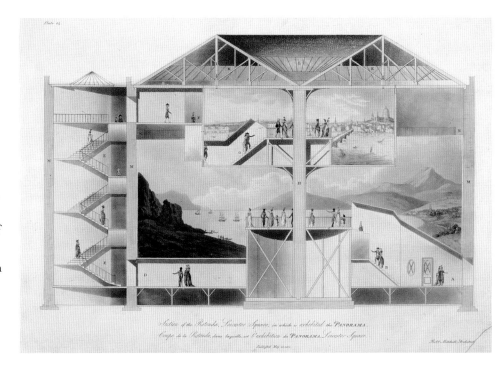

with whatever locality it represented. A canopy, usually of fabric, concealed both the skylights in the roof and the top of the picture but did not abut the canvas, so that light could still fall on the image. Dark wood paling extending away from the platform concealed the bottom of the painting. When Barker patented his concept in 1787, he had termed it "La Nature à Coup d'Oeil" ("Nature at a Glance"), but in London, art connoisseurs suggested to him a catchier name: "panorama," Greek for "all sight" or "all embracing view."[18]

Under Barker's and his successors' direction, the Panorama in Leicester Square became a popular mecca and remained so for seventy years; for a shilling or two per person, untold thousands flowed through its doors each season. The public saw not simply its native cities but, soon enough, its wars (of national defense and colonial expansion) and the outposts of the far-flung British Empire and expeditionary frontiers beyond: Sydney, Australia; Calcutta, New Delhi, and Bombay, India; Quebec and Boothia Peninsula, Canada; Cairo and

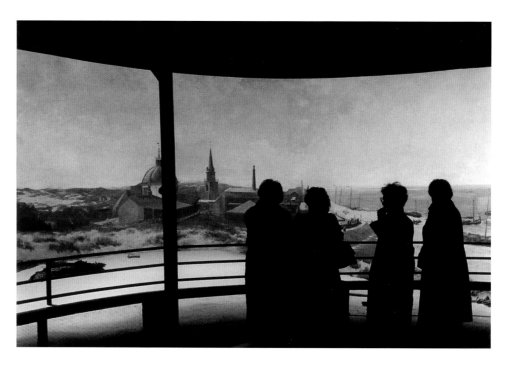

Hendrik Willem Mesdag, Sientje Mesdag-van Houten, Theophile de Bock, G. H. Breitner, B. J. Blommers, and Adrien Nijberck. *Panorama of Scheveningen*, 1881, as it is displayed today, with visitors. Oil on canvas, approximately 45 ½ × 390 feet. Collection, Panorama Mesdag, The Hague, Netherlands

Thebes, Egypt; Kabul, Afghanistan; the Himalayas, Kashmir, Hong Kong, and the Polar Regions of the North Atlantic.[19] Offerings changed approximately every six months or less to maintain public interest and, of course, the panorama as an art and entertainment species spread throughout Europe and America. As early as 1798 the American artist and inventor Robert Fulton bought the rights to it from Barker and brought it to Paris, where the panorama flourished until nearly the turn of the twentieth century.[20] (None of Fulton's or his successors' panoramas survive, but one by his American colleague John Vanderlyn, who saw Fulton's panoramas in Paris, made it into the collection of the Metropolitan Museum of Art. Vanderlyn's *Panoramic View of the Palace and Gardens of Versailles*, 1818–19, is the second-oldest surviving panorama in the world.[21]) By the mid-nineteenth century, French producers of the panorama had begun to add three-dimensional props, termed *faux terrain*, in front of the painting. The whole ensemble came to be called by a variety of names but in America the most frequent was "cyclorama." By the 1880s chiefly French, Belgian, and German "syndicates" of artists, working in their own countries and in the United States, produced cycloramas, of the Battle of Gettysburg or

the Crucifixion, for example, that were attended by millions of people and, in a few cases, have survived to this day.[22] One of the most striking of the extant cycloramas is Hendrik Mesdag's view of the Dutch beach and town of Scheveningen, still exhibited in its original setting, the Panorama Mesdag in The Hague [fig. 38].[23]

The suffix "orama" was eventually applied to myriad forms of art novelties directed at a mass audience. Most relevant here is the Diorama, the word and form patented in 1822 by Louis-Jacques-Mandé Daguerre—long before the patenting of his

photographic process in 1839. Over the years, the Diorama evolved to give new meaning to the inventor's coinage. In its first form, it comprised two panorama-sized, if not circular, pictures viewed in sequence by an audience seated on a pivoting viewing platform that rotated from one image to the other [see fig. 39]. Each picture, moreover, was painted on the front and back of an unprimed canvas with a combination of opaque and transparent pigments that was illuminated alternately from in front and behind to produce shifting effects of light and

John Britton and A. Pugin, "Diorama, Park Square, Regents Park: Plan of the Principal Story," plate opposite page 66 in *Illustrations of the Public Buildings of London: With Historical and Descriptive Accounts of Each Edifice*, vol. 1, 1825. Courtesy Smithsonian Institution Libraries, Washington, D.C.

atmosphere—that is, the passage of time in an outdoor scene, for example. By the mid-1830s, Daguerre had added what he termed the "double-effect" to the Diorama. By further embellishments to both the painting and lighting, the artist could produce the illusion of physical change in a scene: in a view of a cathedral interior, for example, not only did day dim to night but the empty nave began to glow with the candles of a host of worshipers—all as the visitor watched from his or her seat.[24]

The word "diorama" was also often applied to what became for its relatively brief fluorescence perhaps the most popular of all the "oramas" and the one that coincides most closely with the Hudson River school: the so-called moving panorama or diorama. Of the three essential types described here it probably least warrants the status of art yet speaks vividly to the sheer demand for presentments of travel—by a public that either longed for but couldn't afford it or had been there and wanted a reminder of it. The form probably evolved from moving stage backdrops that were expanded into narratives of travel in their own right—on a sailing ship, steamboat, or railroad car, across an ocean, down a river, or through a countryside—depicted on bolts of cheap fabric measuring

as long as thirteen hundred feet. Presenting the panorama required two spindles and a crank, a proscenium to frame the unrolling picture, a pianoforte, a lecturer, and about two hours (the length of an average movie, which panoramas prefigured) for their presentation. From 1848 to 1852, New York native John Banvard parlayed his *Grand Moving Panorama of the Mississippi and Missouri Rivers* throughout the United States (including New York, where at least 175,000 people are said to have seen it) and Great Britain, where the highlight of a multiyear tour was a command performance for Queen Victoria and Prince Albert at Windsor.[25]

For Church and Albert Bierstadt or their agents, perhaps the chief lesson of the panorama trade was that, in an age of global exploration and colonial conquest, painting landscape on a large scale and exhibiting it to a mass audience could be lucrative. Strictly speaking, however, the connection between Church and someone like Banvard represented only parallel streams in the history of what Ellwood Parry long ago called "landscape theater."[26] By the turn of the nineteenth century, the fine arts were already well along the way to adapting panoramic formats and display techniques: one thinks of Robert Ker Porter's semicircular paintings

of British battles or, a little later in the early nineteenth century, William Bullock's dramatic display, in his Egyptian Hall located in Piccadilly, of immense historical paintings such as Théodore Géricault's *Raft of the Medusa*, 1819 (Musée du Louvre, Paris), illuminated like a panorama by concealed skylights.[27] By mid-century, then, little about the London exhibition of John Martin's trio of ten-foot-wide apocalyptic landscapes, "The Judgment Triptych," 1853 (The Tate Gallery, London), being shown

in London brilliantly illuminated in an otherwise darkened gallery, was considered outlandish.[28] (Why *should* it have been thought so, when just a generation earlier another artist recast Martin's *Belshazzar's Feast*, 1821 [Laing Art Gallery, Newcastle upon Tyne], as a diorama presented in London and New York?[29]) "The Judgment Triptych" came to Broadway, New York, in 1856, where Church almost undoubtedly saw it, a few months before his own wide-angle painting, *Niagara*, 1857 (Corcoran Gallery of Art, Washington, D.C.), was shown in the same venue.[30] In 1857 he also embarked on his second journey to South America to collect material for *The Heart of the Andes*, which, in large scale like Martin's, was exhibited under similar gallery conditions in 1859. To complete the experience the artist or his agent added programs to be purchased at the door describing the painting in terms not unlike a guide to the actual region being vicariously toured. Advertisements urged spectators to use opera glasses, both to magnify the work's botanical and zoological details and to diminish awareness of the picture's limits. Lacking opera glasses, the visitor could at least imagine him- or herself peering through a window upon the Ecuadorian subtropics, uplands, and Andes because Church designed

its freestanding, curtained black-walnut frame to imitate a casement [fig. 40].[31] In obvious emulation of Church, Albert Bierstadt obtained a dark frame (i.e., one that absorbed light and thus did not compete with the image) in which to house his *Rocky Mountains, Lander's Peak*, 1863 (The Metropolitan Museum of Art), and in that and subsequent exhibitions of his major pictures in the 1860s at least, masked the frame with dark drapes so that only the picture could reflect light from above.[32]

If the history of single-picture fine art displays reveals an indirect lineage from panoramas and dioramas to the exhibitions of Church's and Bierstadt's paintings, the counsel of the Prussian naturalist Alexander von Humboldt almost certainly had at least some influence on their panoramic aesthetic, and more especially that of Church. That Humboldt, through his widely translated accounts of his expeditions and observations in the equatorial New World at the turn of the century, inspired Church's two sojourns there in 1853 and 1857 was well known even in the artist's day and, indeed, was a feature of *The Heart of the Andes*'s public promotion. Humboldt's conception of the equatorial Andes, as a microcosm of planet Earth encompassing varieties of torrid, temperate, and frigid

habitats, each with distinct vegetable growth, is expressly illustrated in *The Heart of the Andes* and contributed to the conceit of the verbal tours the spectator could take by reading one of the exhibition programs while viewing the painting.[33] But the naturalist's ardent advocacy of panoramas, voiced in his culminating work, *Cosmos* (1845–62), as the ideal means to represent the Andean regions, is less discussed. Humboldt termed the various oramas "improvements in landscape painting on a large scale" and a "substitute for traveling in different regions," but he complained:

> Hitherto panoramas...have been applied more frequently to the representation of cities and inhabited districts than to that of scenes in which nature revels in wild luxuriance and richness of life. An enchanting effect might be produced by a characteristic delineation of nature, sketched on the rugged declivities of the Himalayas and Cordilleras....The knowledge of the works of creation, and an appreciation of their exalted grandeur, would be powerfully increased if, besides museums, and thrown open like them, to the public, a number of panoramic buildings, containing alternating pictures of landscapes of different geographical latitudes and different zones of elevation, should be erected in our large cities.[34]

Humboldt had it essentially right. By the mid-nineteenth century, panoramas not only of countless British, Continental (ancient and modern), and American cities and military campaigns but also of the far-flung locales cited above—including the Himalayas (Humboldt was mistaken there)—had been presented; the tropics of either Africa or the New World had not. The reasons probably had as much to do with the challenges of artistic access and visual scope as with technical complexity: how does one get perspective on a jungle—and would the public anyway care? But after Humboldt threw down the gauntlet, Church thought viewers would respond, and for a time, primed by translations of the naturalist's accessible texts, they did. When the artist's audience withdrew, and Church and his torrid-zone "panoramas" faded from sight, the first herald of his comeback in the twentieth century was not the Metropolitan Museum's small memorial exhibition in 1900 of one of its founding trustees' work but rather, an article in 1924 honoring Church in a publication of the Metropolitan's counterpart across Central Park, the American Museum of Natural History. Not surprisingly, the piece was accompanied by an even longer one devoted to Humboldt. [35]

Even as that article was being published, the American Museum, with adventurous and innovative preparators such as Carl Akeley, was well on its way to revolutionizing natural history display in this country and, more than a half-century later, offering Alexis Rockman a wellspring of aesthetic inspiration. The example of the panorama (the expository potential of which Humboldt had likened to that of museums) proved simply indispensable to the advance of natural history presentation. In fact, it began in Europe, where the cyclorama, the panorama with *faux terrain*, originated. In Sweden the naturalist Gustaf Kolthoff essentially embellished the idea of *faux terrain* by posing wildlife specimens and artificial plants, naturalistically mounted, in front of bird painter Bruno Liljefors's landscape backdrops; Kolthoff also constructed a circular platform and canopy (concealing skylights) from which visitors viewed the surrounding display. By 1910, also in Sweden, the backdrops of individual habitat groups became curved. [36] The specimen-cum-painting idea was generations old: in the 1820s, Charles Willson Peale had tried it out in his Philadelphia museum, but those displays were essentially shadow cabinets. In 1889, in Milwaukee, Akeley

embellished the cabinet display with a background representing a fresh-water marsh arranged like a decorative screen about a family of mounted muskrats and even included a sheet of glass mimicking a water surface in the foreground.[37] But by introducing the conceit of the cyclorama, Kolthoff and Liljefors created what in its own time was referred to as a "panorama of animal life."[38] Their idea quickly caught on but almost nowhere earlier or more pervasively than at the American Museum—via the exhibition refinements of Akeley, who moved to New York in 1909—whence it spread virtually to every institution where the financial and technical resources could be mustered. The displays also came to be called dioramas. Precisely why and how the name for Daguerre's invention became adapted is unclear, but it is not inapt: the backdrops today, though still generally curved, are far from complete circles warranting the term "panorama." More important, "diorama," intentionally or not, acknowledges the duality of one- and two-dimensional presentation—to say nothing of the artful (and artificial) lighting that helps meld the mounted specimens and the painting into one "picture" of a place and its inhabitants, usually in a specific season and at a specific hour.

What has been justly called the "golden age of the diorama" in American museums in the first half of the twentieth century coincided almost exactly with a surge in its most impressionable audience, the baby boomers of post–World War II.[39] Those children, when they visited museums at all, were more apt to be led, and then direct themselves, to the Museum of Natural History than to the Metropolitan Museum of Art. Beginning in the late 1960s, Rockman was among those youngsters; he visited, repeatedly, having the added incentive of seeing his mother, who worked there as an assistant to anthropologist Margaret Mead. Among the dioramas Rockman recalls "looking up at" in awe is the "Forest Floor" in the Hall of North American Forests on the first floor, a vastly magnified counterfeit of leaf mold and soil, surface and substratum, populated with insect denizens in adult and larval forms.[40] Nearby are other displays of marsh and pond ecosystems, such as "From Field to Lake," that Rockman would have regarded, as a boy, from a perspective near level with the terrestrial and subaquatic plants and creatures mounted therein. He was scarcely a passive observer. At home in the same years, he assembled vivariums of tree frogs, terrain, and

plants. If there was nothing especially remarkable for a child cultivating wild pets in this way, the fact that Rockman also painted backgrounds for his home habitats undoubtedly distinguishes his activity from that of most of his contemporaries. Among his early paintings is a portrait of the "Forest Floor" diorama [plate p. 68].[41]

Even if Rockman's maturing persona as an artist surely challenged the early identification of his talent with his boyhood enthusiasm for natural history—and specifically as it was illuminated to him in natural history museum dioramas—clearly it never dispelled that passion. His artistic vision is rightly and inevitably complicated not merely by formal artistic education but by his head-on grappling with themes of modern environmental compromise and anticipated crisis. Still, for all the dire forecasting, one simply cannot escape the impression of an abiding glee driving Rockman's teeming panoramas of the post-apocalypse. It is a joy founded, perhaps, in a latent faith in the persistence of life, with or without us, or merely the resurgent rush of youthful wonderment before those windows on artificial wilds.

NOTES

1 W. P. B. [W. P. Bayley], "Mr. Church's Pictures. 'Cotopaxi,' 'Chimborazo,' and 'The Aurora Borealis,' Considered Also with References to English Art," *Art-Journal* 4 (September 1865): 265.

2 Ibid., 266.

3 Humboldt's special fascination with *Cotopaxi* and *Chimborazo* is evident throughout his major texts, most notably *Cosmos: A Sketch of a Physical Description of the Universe*, 5 vols., trans. E. C. Otté (London: Henry G. Bohn, 1848–58), and is reflected pictorially in one of the best-known portraits of him, a posthumous work (1859) by Julius Schrader in the Metropolitan Museum of Art that portrays the two mountains in the background at either side of the naturalist. A detailed account of the formulation of *Aurora Borealis* is given in William Truettner, "The Genesis of Frederic Church's 'Aurora Borealis,'" *Art Quarterly* 31 (Autumn 1968): 267–83; see also Franklin Kelly et al., *Frederic Edwin Church*, exh. cat. (Washington, DC: National Gallery of Art and Smithsonian Institution Press, 1989), 62–63.

4 See Gerald L. Carr, *Frederic Edwin Church: Catalogue Raisonné of Works of Art at Olana State Historic Site* (New York: Cambridge University Press, 1994), 2:287. The British critic's comments quoted above in the text on Church's "triptics" are not the only instances of contemporaneous links drawn between Church's paintings. At least four newspaper reports in early 1865 implied a link between Church's *Rainy Season in the Tropics*, then still unfinished but in his New York studio, and *Aurora Borealis*. The reports are cited in Carr, *Catalogue Raisonné*, 2:287. Modern historians have commented on the formal and thematic interrelatedness of his Civil War–period paintings. The links are perhaps most concertedly and cogently drawn in Joni L. Kinsey, "History in Natural Sequence: The Civil War Polyptych of Frederic Edwin Church," in Patricia M. Burnham and Lucretia Hoover Giese, eds., *Redefining American History Painting* (New York: Cambridge University Press, 1995), 158–73, esp. 161, 172–73; see also Gerald L. Carr, *Frederic Edwin Church—The Icebergs* (Dallas: Dallas Museum of Fine Arts, 1980), 107, n.2; Kelly, *Frederic Edwin Church*, 62–63.

5 The most extensive, and very cogent, discussion of *Evolution*, prefiguring several themes in this essay, is Prudence Roberts, "Rockman's Evolution and the 'Great Picture,'" in *Alexis Rockman: Second Nature*, exh. cat. (Normal: University Galleries of Illinois State University, 1995), 52–62, esp. 63.

6 Maurice Berger interprets the painting brilliantly in "Last Exit to Brooklyn," in *Alexis Rockman: Manifest Destiny*, exh. cat. (Brooklyn, NY: Brooklyn Museum of Art, 2004), 4–15.

7 Alexis Rockman, interview with the author, August 4, 2009, New York (hereafter, Rockman interview). According to the artist, *South* would not have come about without an invitation to join a Lindblad Expedition to Antarctica in late 2007. Most of the original source material for it is photographs Rockman took on the cruise, some of which became the source of numerous watercolors, where the vigorous, painterly style of *South* was rehearsed. Further Rockman commentary on the genesis and creation of *South* is included in Denise Markonish, ed., *Badlands: New Horizons in Landscape*, exh. cat. (North Adams: Mass MoCA, 2008), 66, 68.

8 Rockman interview. The artist confirmed that he conceived *South* with at least some reference to *Evolution* and *Manifest Destiny*.

9 Rockman interview; Markonish, *Badlands*, 66–68. On his cruise to Antarctica, Rockman personally witnessed the distressed cruise ship *Explorer*, formerly of the Lindblad fleet, which struck an iceberg in November 2007. Crew and passengers were all rescued, but the ship was lost. See Graham Bowley and Andrew C. Revkin, "Icy Rescue as Seas Claim a Cruise Ship," *New York Times*, November 24, 2007, http://www.nytimes.com/2007/11/24/world/americas/24ship.html.

10 Carr, *Icebergs*, 80; Eleanor Jones Harvey, *The Voyage of the Icebergs: Frederic Church's Arctic Masterpiece* (Dallas: Dallas Museum of Art, 2002), 45, 93; fig. 16. In the U.S. in 1861, the painting was exhibited as "The North." By the time it reached London for exhibition in 1863, it was called "The Iceberg" or "Icebergs."

11 Rockman interview. The artist asserts that *South* is as much criticism of the polar paintings of Church and, before him, Casper David Friedrich (specifically, *The Arctic Sea*, also called "The Wreck of the Hope," 1824 [Kunsthalle, Hamburg]) as it is homage. Neither, he feels, accurately conveys the qualities respectively of icebergs and broken sheet ice. See also the interview with Rockman in Markonish, *Badlands*, 68–69: "As much as I love painters like Church

and Friedrich, their work is very different from what I was looking at [in Antarctica]... I felt that I was in a landscape that has never really been painted."

12 A conspicuous example by Cole is his *Subsiding of the Waters of the Deluge*, 1828, in the Smithsonian American Art Museum. Among several examples by Wright of Derby is *A Cavern, Evening*, 1774, in the Smith College Museum of Art, Northampton, Massachusetts. Both Cole and Wright were inspired by the Neopolitan coastal scenes of Salvator Rosa, seventeenth-century paragon of the sublime landscape, such as his *Marine with Rock Arch*, ca. 1645, in the Galleria Doria Pamphilj, Rome. The same artists were undoubtedly also familiar with the Italian coastal scenes of Claude-Joseph Vernet, such as his *Rocky Coast Scene*, ca. 1782 (Private Collection, England), which like many of Vernet's landscapes was engraved.

13 Rockman interview. Technically, in great measure, the artist sees *South* as the culmination of several years' engagement with watercolor, broadly wielded. Executing these works represented for Rockman a release from the technical fastidiousness that had dictated his work from the beginning of his professional career up to *Manifest Destiny* in 2004. In some measure, the watercolors also represent an homage to J. M. W. Turner. Many are reproduced and discussed in Michael Rush, ed., *Alexis Rockman: The Weight of Air*, exh. cat. (Waltham, MA: Rose Art Museum at Brandeis University, 2008). In his interview with the author, Rockman was surprised to hear of the rich pigmentation of *The Icebergs*. He has never seen the original.

14 Roberts, "Rockman's Evolution and the 'Great Picture,'" 55.

15 The link to Bosch has been made previously by Jonathan Crary, "Between Carnival and Catastrophe" in Jonathan Crary, Stephen Jay Gould, and David Quammen, *Alexis Rockman* (New York: Monacelli Press, 2003), 9.

16 Rockman interview. To this observer, the dawn effect in *Manifest Destiny* even more vividly evokes the sunset in Church's *Coast Scene, Mount Desert*, 1863 (Wadsworth Athenaeum, Hartford), but Rockman insists it was not a source.

17 Rockman interview; see also Berger, "Last Exit to Brooklyn," 8–9, 15. Evidently from Rockman's testimony to him, Berger also cites Church's *Natural Bridge, Virginia*, 1852 (Bayley Art Museum at University of Virginia, Charlottesville), as a source in *Manifest Destiny*. Indeed, Church's image of the stone arch topped by trees is readily evoked in the forested tower of Brooklyn Bridge in Rockman's work.

18 The history of the panorama has been thoroughly recounted in the last generation, beginning with the pioneering master's thesis of Scott Wilcox, "The Panorama and Related Exhibitions in London," 2 vols., MLitt, University of Edinburgh (Edinburgh, 1976), 1:1–66; the history is most entertainingly narrated in Richard D. Altick, *The Shows of London* (Cambridge, MA: Harvard University Press, 1978), 128–62; it is most authoritatively told and expanded to include Continental and American manifestations in Stephan Oettermann, *The Panorama: History of a Mass Medium*, trans. Deborah Lucas Schneider (1980; reprint, New York: Zone Books, 1997); an exhibition on the subject with accompanying catalog was organized in 1988: Ralph Hyde, *Panoramania!*, exh. cat. (London: Barbican Art Gallery, 1988). For the origin of the name, see Wilcox (as above), 1:27; Altick (as above), 129, 132; Oettermann (as above), 105; Hyde (as above), 17–20.

19 A comprehensive chronology of panoramas shown in Leicester Square and in the nearby Strand, from 1793 to 1863, is given in Wilcox, "Panorama and Related Exhibitions," 2:254–65.

20 Ibid., 2:241–42; Altick, *Shows of London*, 134, see note*; Oettermann, *Panorama*, 143–46ff.

21 Kevin J. Avery and Peter L. Fodera, *John Vanderlyn's Panoramic View of the Palace and Gardens of Versailles* (New York: Metropolitan Museum of Art, 1988).

22 Wilcox, "Panorama and Related Exhibitions," 245–47, 250; Oettermann, *Panorama*, 158–71, 235–85, 342–43. Surviving cycloramas are Paul Philippoteaux's *Battle of Gettysburg*, 1881–83 (Gettysburg National Military Park, Pennsylvania); Friedrich Wilhelm Heine and August Lohr, *Battle of Atlanta*, ca. 1885–87 (Grant Park, Atlanta, Georgia); and Paul Philippoteaux, *Cyclorama of Jerusalem with the Crucifixion of Christ*, ca. 1888–92 (Ste. Anne de Beaupré, Quebec, Canada).

23 Evelyn J. Fruitema and Paul A. Zoetmulder, *The Panorama Phenomenon*,

exh. cat. (The Hague: Mesdag Panorama, 1981), esp. 101–11.

24 Wilcox, "Panorama and Related Exhibitions," 1:89–98; Altick, *Shows of London*, 163–72; Oettermann, *Panorama*, 69–83; Hyde, *Panoramania!*, 109–14.

25 John Francis McDermott, *The Lost Panoramas of the Mississippi* (Chicago: University of Chicago Press, 1958), 1–46; Wilcox, "Panorama and Related Exhibitions," 2:238–40; Altick, *Shows of London*, 198–210; Oettermann, *Panorama*, 63–67, 323–43; Hyde, *Panoramania!*, 133–35; Kevin J. Avery, "The Panorama and Its Manifestations in American Landscape Painting, 1795–1870," 2 vols. (PhD Dissertation, Columbia University, 1995), 1:108–203; 2:204–48.

26 Lee Parry [Ellwood C. Parry III], "Landscape Theater in America," *Art in America* 59 (November–December 1971): 52–61.

27 Wilcox, "Panorama and Related Exhibitions," 1:42–47; Altick, *Shows of London*, 135–36, 409–10, 435.

28 William Feaver, *The Art of John Martin* (Oxford: Clarendon Press, 1975), 200; see also 67–70, where the author discusses Martin's paintings with reference to panoramas and dioramas.

29 The diorama was painted by Hippolyte Sébron and exhibited in London in 1833 and at Niblo's Garden, Broadway, New York, in 1835. See *Mr. Martin's Grand Picture of Belshazzar's Feast, Painted with Dioramic Effect* (London: J. & G. Nichols, 1833); Wilcox, "Panorama and Related Exhibitions," 1:108; Altick, *Shows of London*, 414–15; Hyde, *Panoramania!*, 113–14. One of Martin's paintings, *Pandemonium*, based on Milton's *Paradise Lost*, was recast as a circular panorama exhibited at Leicester Square. It is cited, and its program illustration reproduced, in Wilcox (as above), 2:258 and pl. 60; see also Altick (as above), 181–82.

30 Carr, *Icebergs*, 27–28; Kevin J. Avery, *Church's Great Picture: The Heart of the Andes*, exh. cat. (New York: Metropolitan Museum of Art, 1993), 21–22; Avery, "Panorama in American Landscape Painting," 2:275–76.

31 Kevin J. Avery, "The Heart of the Andes Exhibited: Frederic E. Church's Window on the Equatorial World," *American Art Journal* 18 (Winter 1986): 52–72; Avery, *Church's Great Picture*, 33–36; Avery, "Panorama in American Landscape Painting," 2:279–88.

32 Avery, "Panorama in American Landscape Painting," 2:303–9.

33 Avery, *Church's Great Picture*, 14–15, fig. 6; 31. See also Theodore Winthrop, *A Companion to the Heart of the Andes*, exh. cat. (New York: D. Appleton, 1859), 13, wherein the author divides the painting into "regions." The strategy is discussed in Avery, "Heart of the Andes," 59; and Avery, "Panorama in American Landscape Painting," 2:284.

34 Alexander von Humboldt, *Cosmos: A Sketch of a Physical Description of the Universe*, trans. E. C. Otté (London: Henry G. Bohn, 1848), 1:457.

35 H. W. Schwarz, "Frederic E. Church, Painter of the Andes," 442–48, and "Alexander von Humboldt, South American Explorer and Progenitor of Explorers," in *Natural History* 24 (July–August 1924): 449–53.

36 The origins and evolution of the natural history diorama are closely described in Karen Wonders, *Habitat Dioramas: Illusions of Wilderness in Museums of Natural History* (Uppsala, Sweden: Acta Universitatis Upsaliensis, 1993). For the critical innovations of Gustaf Kolthoff, see pp. 46–71. The history is summarized in Stephen Christopher Quinn, *Windows on Nature: The Great Habitat Dioramas of the American Museum of Natural History* (New York: Harry N. Abrams, 2006), 8–19.

37 Wonders, *Habitat Dioramas*, 134–35, fig. 75.

38 Exterior signs for Stockholm's Biological Museum, quoted in ibid., 58.

39 Quinn, *Windows on Nature*, 18.

40 Telephone interview with Alexis Rockman, September 9, 2009.

41 Ibid.; some Rockman testimony to this effect is in Crary, Gould, and Quammen, *Alexis Rockman*, 64–67, including a reproduction of his *Forest Floor* and a photograph of the diorama of the same title under construction at the American Museum of Natural History.

Thomas Lovejoy

From Chameleons in the Curtains to *Manifest Destiny*

Guyana has been synonymous with adventure for centuries. A distant, wild country of largely intact rain forest situated on the northern coast of South America, it attracted explorer-naturalists of the early twentieth century such as William Beebe. In 1954 the Pulitzer Prize–winning muralist Rudolph Zallinger went there to do illustrations for *LIFE* magazine (and later entertained me, when I was an undergraduate, with his explanation for wearing pajamas when working, because they made it easy to get at the ubiquitous ants and itches). A bit earlier the siren call of Guyana's nature had lured Paul (P. W.) Richards and provided much of the basis of his landmark volume *The Tropical Rain Forest: An Ecological Study* (1952)—literally the only book on the topic when I was a graduate student in the 1960s.

Although I did not travel to Guyana until considerably later than those American pioneers, the spell of that country as they described it is what led me in many ways to the Amazon in the summer of 1965, when only one road existed in a vast wilderness larger than the forty-eight contiguous states. It was to Guyana that Alexis Rockman went almost thirty years later, in 1994, on a naturalist/artist expedition and that brought us first to meet. By then I was at the Smithsonian Institution, having accumulated somewhat of a track record on tropical forest science and conservation, and Alexis was good enough to send me a copy of the book of his art from his Guyanan adventure.[1] I could readily see from those images that he shared the wonder and fascination I felt the first time I set foot in the great forest on that June day. It had taken Guyana to connect two nature-loving kids—one now an artist and the other a scientist—from New York City, both of whom liked to let Anolis lizards (then sold as "chameleons") have the run of apartment curtains.

Unknown figure shows a leaf of the tree *Victoria regia* (now *Victoria amazonica*), ca. 1930. The plant grows in the Amazonas region in South America; its leaf easily bears the weight of an adult man.

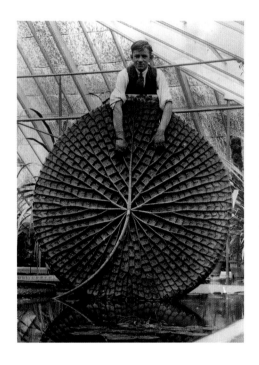

Alexis had grown up with the stimulation provided in the halls of that exalted temple to natural science, the American Museum of Natural History on Central Park West. I am sure I would have been so inspired, but instead—anoles in the curtains notwithstanding— it was a remarkable teacher, Frank W. Trevor, at a wonderful school, the Millbrook School in Millbrook, New York—the only American high school to house an actual zoo, thanks to its founding by Trevor—that ignited my lifelong passion for nature in but my first three weeks in attendance. Thereafter, the American Museum and the New York Zoological Society became dual meccas for me, and I continued to have great mentors and role models in, among others, the ornithologist S. Dillon Ripley, who led the Smithsonian as Secretary for twenty years (1964–84); the founder of modern ecology G. Evelyn Hutchinson; and environmentalist Russell E. Train.

Alexis clearly draws ideas from the marvels of organic form—what Darwin termed "endless forms, most beautiful." Indeed, organic form is a common source of awe for science and art. One of the most illustrious examples of that interplay is the story of horticulturist and architect Joseph Paxton, who as head gardener for the Duke of Devonshire was the first to get the giant Amazon water lily (*Victoria amazonica*) to bloom in Europe. Paxton, intrigued by the complex of cellulose ribs and girders that underlies the pads of the largest of all water lilies [fig. 41], later used that as the basis for designing a glass house for the Duke's tropical plants. That in turn became the inspiration for his plan of the Crystal Palace for London's Great Exhibition of 1851 [fig. 42], the acknowledged origin of modern metal-beam architecture. Evelyn Hutchinson remarked that half the buildings in the industrialized world derive from the underside of that magnificent plant. Today that influence of the giant Amazon water lily spreads yet further.

One of the distinguishing qualities of Alexis's work is the clear boundary between the realism of the impeccably precise portrayal of animals and plants and the fantasy born of his artistic imagination. That aspect was already apparent in the Guyana work [plates pp. 80–91], which is firmly based on the same great natural science of Beebe, Richards, and others that was and still is inspirational to me. But Alexis's leap beyond rendering accurate images is arresting in its departure from realism. His pictures have been called carnivalesque, but they are more than

Completed transept of Joseph
Paxton's Crystal Palace, from
the *Illustrated London News*,
January 25, 1851, 57. Courtesy
Colgate University Libraries,
Hamilton, New York

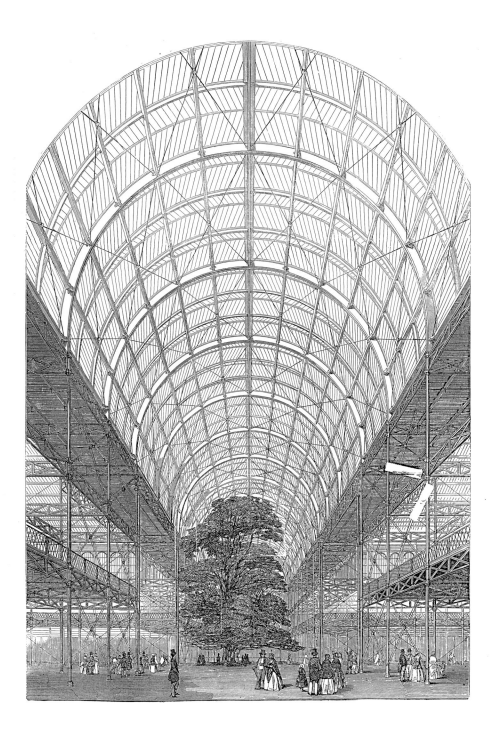

that. They go beyond whimsy and
singerie of a sort, to a realm of fantasy
rooted in disturbing reality.

My path crossed Alexis's again, in
the later nineties, when *Natural History*
magazine commissioned artwork for
a special issue.[2] The report was to
feature what in some respects is the
centerpiece of my Amazon work and
probably the largest experiment to
date in landscape ecology, namely,
the study of the forest fragmentation
that was taking place in the Amazon
through deforestation as cattle
ranches were being developed. In the
mid-1970s it was apparent that forest
fragments become altered; forests lose
species and undergo other ecological
and biological changes once they are
no longer part of a continuous wil-
derness. At the time, I was leading the
program at the World Wildlife Fund
that was engaged in recommending
various conservation projects. The
topic of forest fragmentation obvious-
ly had an important bearing on how
to design and manage conservation
areas including national parks. But
in the absence of direct data about
fragmentation, a raging brush fire of
debate was taking place in academia.
How to respond? What were the solu-
tions? Keeping in mind the need for
direct data, I had the audacious no-
tion of taking advantage of a Brazilian
law that required that 50 percent

Fragments, 1998
Chuck and Joyce Shenk
Cat. 36

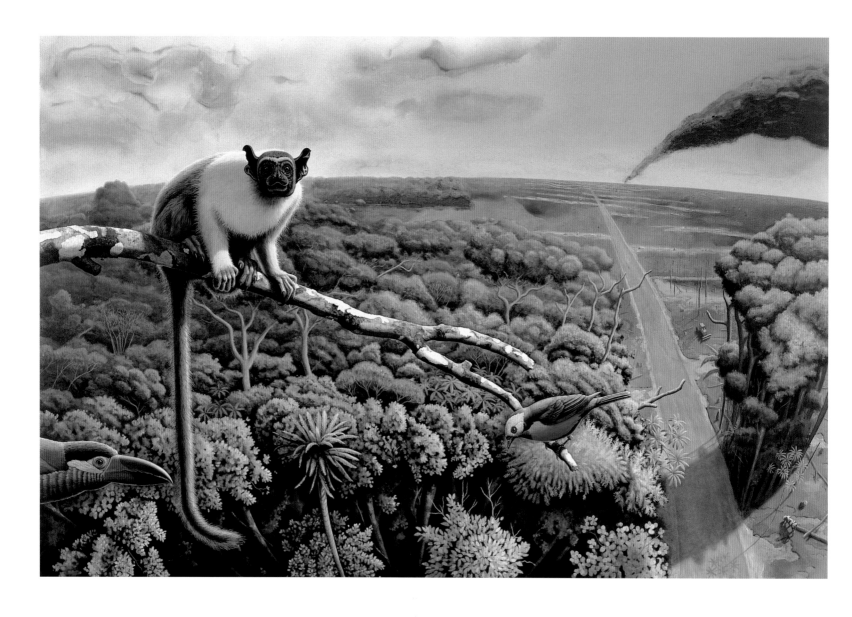

(today 80 percent) of any Amazon project to remain in forest. I proposed a giant experiment, namely, to study the fragments of different sizes that would be left in the course of cattle-ranch development. We would then compare the conditions of the fragments to their original states when they were part of continuous forest; in addition, we would compare them to matched plots well inside the remaining forest. Brazilian colleagues and I were able to persuade the authorities, and the project was officially initiated in 1979. For many years the work has been collaborative between the Smithsonian Tropical Research Institute (STRI) and Brazil's National Institute for Amazon Research (INPA).

Standard photography is limited in what it can do in the rain forest, where light levels are low, which is why *LIFE* contracted Rudolph Zallinger in the 1950s and *Natural History* magazine commissioned Alexis. Art, which can combine elements that a lens cannot, can go beyond those constraints as well as convey the sense of the experiment. So in 1997, eighteen years after the forest-fragmentation study had commenced, Alexis was sent off to Manaus, Brazil, in the center of the Amazon, while I occupied myself with Smithsonian business. In retrospect I will forever regret not having spent

some time with him as he worked. The results were surely spectacular. The foldout cover of the issue depicts a bicolor tamarin, a paradise tanager, and a Guianan toucanet in the canopy of the forest-fragment edge, with a deforested landscape stretching beyond [plate p. 148]. Vignettes of natural history altered by forest fragmentation illuminated the text within: *After the Fall: Stages of Succession*[3] shows the stages as forest recovers from a clear cut, with a cow in the foreground reminding of the forces causing deforestation and fragmentation. A trio of army ants following birds—which never venture from the forest interior out into the open—are seen from behind looking out onto bleak pasture etched with the shadow of a dead tree. Tree frogs, which thrive in the forest but also can live and breed in cattle-pasture ponds, look out from the forest toward the bovine habitat.

I was smitten with the work, inquired whether it was for sale, and was deflated to learn that not only had it already been sold but also the price was something I could never have competed with in any case. What was certain is that even within the relatively restrictive artistic space involved in such an assignment, Alexis secured an amazing marriage of natural history with imagination and creativity.

Alexis Rockman, *Untitled*, 1994,
mud and acrylic polymer on paper,
5 × 7 in., Private Collection

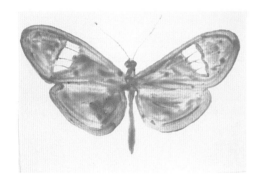

What I had no sense of until much later was that while in the field for that work, Alexis had experimented in truly Amazonian watercolors: works on paper with muddy Amazon River water as the medium. (He had already included local materials in some of his Guyana paintings from 1994 [see fig. 43].) When we finally met, Alexis was so nice as to give me a couple of the watercolors, so the personal identity with my science and his art was made whole. It is clear that from the outset he has been sensitive to the impact humans are wreaking upon the living planet. His sensitivity imbues *Balance of Terror*, 1988 [plate p. 67], *Aviary*, 1992 [plate p. 73], the "Biosphere" series, 1992–94 [plates pp. 38, 76–79], and *Recent History of the World*, 1997–98 [plate pp. 152–53]. The latter is mostly about the force of alien species—ones introduced to places where they do not occur naturally, and where, like kudzu, they often cause ecological havoc.

A worldview on panoramic scale, *Recent History of the World* dwells on the impact of people on other living things. Invasive alien species (rats, cats, mongoose) play a huge role in the extinction of multiple island species of rail, the Dodo, and many more life forms. A major transformation, the "ecology of animal invasion," was first identified as a significant vector of change by British ecologist Charles Elton,[4] who I met in the Amazon on his first trip to the tropics (and my first to the Amazon) in 1965. Alexis's *Recent History of the World* also shows how hunting and harvest have been decimated by highlighting African trophy hunting and the extinction of the zebra relative, the quagga, before the end of the nineteenth century. It is a beautiful but haunting view of a world being tipped in favor of weeds and pests.

Alexis's depiction of humans' mark on Earth reaches a zenith with *Manifest Destiny*, 2003–4 [plate pp. 106–7], which dwells on our ultimate impact, namely on the planet's climate system. An enormous work (8 by 24 ft.), it envisions the Brooklyn waterfront after substantial climate change and sea-level rise. It was quite visionary when painted in 2003–4 as this country remained in a post–September 11 daze, oblivious to accumulating greenhouse gases and implications for climate.

It seems less remarkable in the light of the recent (August 2009) revision of projected sea-level rise in this century to one meter and the virtual certainty that that number is an underestimate and will be revised upward. Notwithstanding, *Manifest Destiny* is no less a disturbing painting

in the abstract. Many will bring personal perspective to the experience of viewing it. In my case, I think about my great-grandfather's role as chair of the commission that designed the New York subway system; it is likely that this great-grandson could see the system flooded by a rise in sea level. Even today a Category 2 storm sweeping up the New York Bight will flood Lower Manhattan. So there is less fantasy in *Manifest Destiny* than most realize.

This Ozymandian perspective carries through the "American Icons" series. The Gateway Arch in Saint Louis is overgrown with vines. Mount Rushmore is up to the presidential chins with water. Capitol Hill is slowly disappearing under vegetation—perhaps, ironically, including kudzu. Symbols of American pop culture, Hollywood and Disney World, are abandoned and falling apart, ignored in the latter case by rutting animals (a recurring theme) in the foreground.

The "Big Weather" series uses a dramatically different and looser style but is essentially similar thematically. It concerns Nature, in this case the weather system, and the influence of humanity through alterations of the climate system. Big weather events are increasingly frequent in the news.

Rockman has described his work up to the point of *Manifest Destiny* as

that of an "artist-advocate." That would seem to be an accurate description. Starting with a fascination with natural history nurtured by the riches of the American Museum of Natural History on New York's Central Park West, he clearly did not have to travel far to recognize the impacts humanity collectively is having on life on Earth. From that realization sprang his paintings of evolution, extinct species, and invasive species. He has shown awareness, too, of ecosystems: how not all species are affected negatively but rather, sort out in favor of "weedy" species, like dandelions and rats, with life histories that enable them to gain an upper hand.

Manifest Destiny is probably the apogee of his artist-advocate phase in terms not only of the time involved (seven years) and its monumental size but also the environmental imperative involved. For most people, climate change is an abstraction: a state that seems far off as a problem. Indeed, for some it seems impossible that our actions as a species could affect the world's climate. Basically our collective impact has distorted the normal carbon cycle. It has done so by releasing the energy trapped by green plants in photosynthesis in the geological past and stored as fossil fuels (gas, oil, and coal). It also is releasing the energy trapped by modern-day

photosynthesis, primarily today by tropical forests; as much as 20 percent of annual carbon dioxide emissions is estimated to come from tropical deforestation.

What makes *Manifest Destiny* so special from an environmental point of view is that it provides a way to visualize climate change and where it could well be leading. It may appear as an apocalyptic vision, but the reality is that climate change is coming faster and harder than almost any realize. There are enormous lags in the climate system, so today, with about 0.8 degrees increase in global average temperature, we would actually be stuck with an additional 0.5 degrees even if we stopped emissions immediately. That adds up to 1.3 degrees. In Italy in July 2009 the G8 agreed to a limit of 2.0 degrees. Yet the last time the planet was 2 degrees warmer—during the last interglacial (125,000 years ago)—sea level was 4 to 6 meters higher. So Rockman is hardly some surreal-artist Cassandra, whose prophecy of the fall of Troy nobody believed.

One of the enthralling aspects of Rockman's work is one touched on already, namely, the interplay between art and science, distinct facets of human endeavor. The two have long been overdrawn as not only naturally discrete but also distant (C. P. Snow's

Recent History of the World,
1997–98
School of Aquatic & Fishery
Sciences, University of
Washington, Seattle
Cat. 35

"two cultures"[5]), as immiscible as oil and water. Drawing consistently on science and the real world, Rockman is nonetheless extremely unambiguous in his art. A fine technical capacity is everywhere evident, of course, but the paintings unmistakably spring from a vivid imagination and a sense of fun that are obvious even in the midst of environmental concern.

What is not particularly apparent is that the practice of science itself, while rigorous and self-questioning, has its own creative aspects. New concepts and perspectives come, more often than not, from some kind of epiphany rather than a mindless step-by-step plotting of a proof. It is clear that Darwin for a long time was assembling natural science information before he made the great synthetic leap. Similarly, his contemporary and codiscoverer of natural selection, Alfred Russel Wallace, had been wandering about the Malay Archipelago as a professional collector of natural science samples, carefully gathering information as well as specimens, before he made the same theoretical vault while struggling with a fever.

A similar visual orientation is involved in visual arts and at least in the type of biological science that studies plants and animals as functioning organisms in an ecological system (rather than at the cellular or physiological level). Indeed, my maternal grandfather was an architect and did beautiful watercolors when studying at the École des Beaux-Arts in the first decade of the twentieth century. My mother plainly had the same artistic talent, as did her brother. I believe it is this visual orientation that draws me to natural beauty.

Art takes science beyond the visual and the pictorial by adding imagination, which in the case of Rockman is arresting: plants eat animals, a pitcher plant traps a hummingbird, there are inexplicable couplings (such as raccoon and rooster, pig and goose, mantis and chipmunk-like rodent, or monkey and anteater), and a rabbit sprouts horns. Rockman's art catches our notice by adding the improbable or impossible and becomes something no newspaper story or fervent environmentalist ever can be, namely, attention getting not preachy.

The Smithsonian American Art Museum's *Alexis Rockman: A Fable for Tomorrow* provides an opportunity for an overview of the artist's work firsthand, from *Pond's Edge* and *Amphibian Evolution* of the late 1980s [plates pp. 64, 65] through the "Big Weather" series of 2007–8 [plates pp. 57, 116–19], and more recently, *The Reef*, 2009 [plate p. 123]. And what a magnificent sweep it is and clearly will continue to be once the exhibit closes: ever evolving, just like a work of the nature that this artist finds so inspirational.

I am certain too that the awareness of environmental change will compel his oeuvre in the future. Even as his painting evolves, so does the environment, but hopefully less so than might be otherwise because of the grip on our attention stirred by Rockman's art.

Alexis has asked me how I can face reality when I know how dark the biological future of the planet seems to be. Daily I wonder what kind of world my grandchildren will live in, especially compared to what I enjoyed as a child and a student. Indeed, environmental change is occurring so rapidly that on occasion I have felt like I am a character in the middle of a short story with words by Edgar Allan Poe and paintings by Alexis, surely a Gothic, macabre universe. But just as in the real world full of beauty and grim portent, Alexis Rockman's art leaves us with a feeling of unease as well as "taken" by the splendor of other living things. What he and I share is the idea that we must try to make our planet better than it would otherwise be. And there is plenty of evidence that each of us can make a difference.

NOTES

1 *Alexis Rockman: Guyana* (Santa Fe, NM: Twin Palms/Twelvetrees Press, 1996).

2 The multiauthored special issue illustrated with Rockman's paintings was "Fragments of the Forest," *Natural History* 107, no. 6 (July/August 1998): 34–51.

3 *After the Fall* is illustrated in the first article, "Fragments of the Forest" by William F. Laurance (pp. 34–38), on pages 36–37.

4 Charles S. Elton, *The Ecology of Invasions by Animals and Plants* (London: Methuen, [1958]).

5 C. P. Snow, *The Two Cultures and the Scientific Revolution* (New York: Cambridge University Press, 1959).

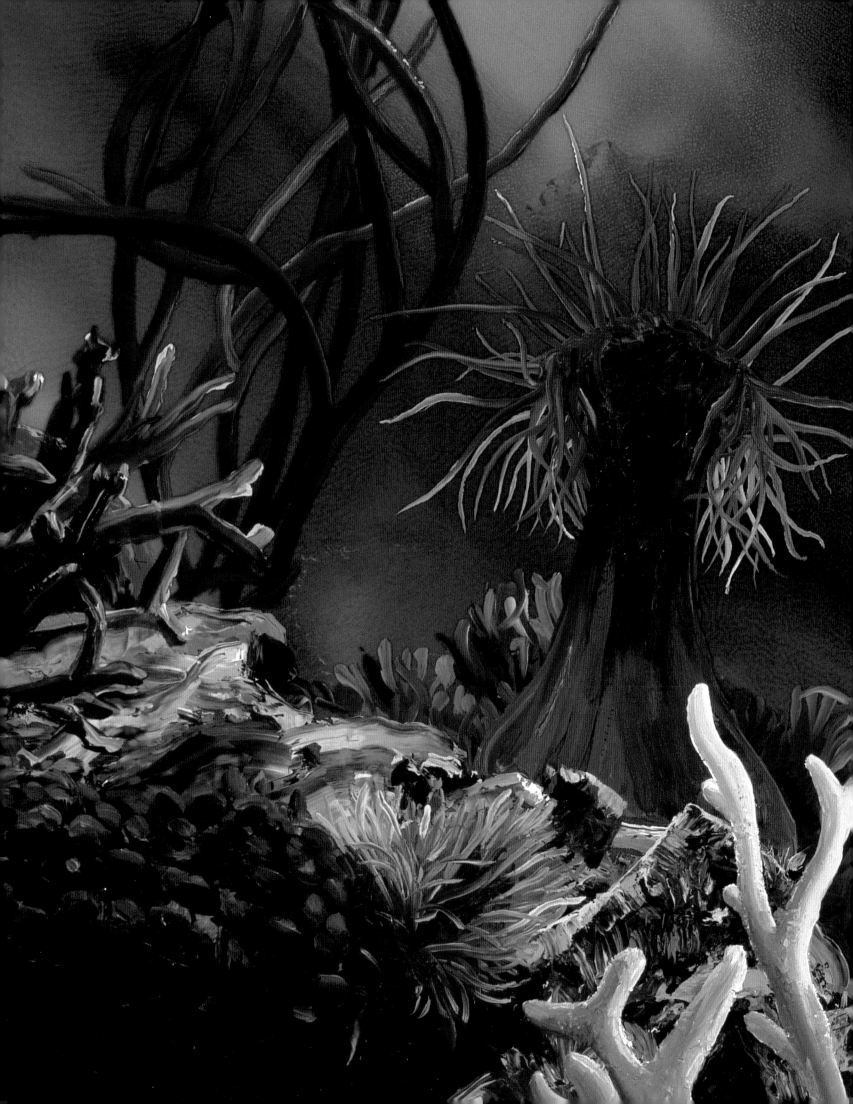

CATALOG OF PLATES

Works marked with an asterisk () are
not in the exhibition.*

1. *Amphibian Evolution*, 1986
Oil and acrylic on canvas
64 × 96 inches
Courtesy of the Artist and
Waqas Wajahat, New York
Plate p. 65

2. *Pond's Edge*, 1986
Oil and acrylic on canvas
60 × 112 inches
Rubell Family Collection,
Miami
Plate p. 64

3. *The Balance of Terror*, 1988
Oil on canvas
72 × 84 inches
James and Abigail Rich
Plate p. 67

4. *Object of Desire*, 1988
Oil and acrylic on canvas
48 × 40 inches
Courtesy of the Artist and
Waqas Wajahat, New York
Plate p. 66

5. *The Dynamics of Power*, 1989
Oil on canvas
80 × 68 inches
The Carol and Arthur
Goldberg Collection
Plate p. 69

6. *Forest Floor*, 1989
Oil on wood
68 × 112 inches
Courtesy of the Artist and
Waqas Wajahat, New York
Plate p. 68

7. **Phylum*, 1989
Oil on canvas
112 × 66 inches
Private Collection
Plate p. 26

8. **Jungle Fever*, 1991
Oil on wood
18 × 24 inches
Private Collection
Plate p. 71

9. *Still Life*, 1991
Oil on wood
40 × 48 inches
Collection of Samuel and
Ronnie Heyman, New York
Plate p. 70

10. *Aviary*, 1992
Oil on wood
80 × 68 inches
Private Collection
Plate p. 73

11. *Biosphere: Tropical Tree Branch*,
1992
Oil on wood
32 × 40 inches
Marshall and Wallis Katz
Plate p. 76

12. **Concrete Jungle III*, 1992
Oil on wood
56 × 44 inches
Private Collection,
Courtesy Jarla Partilager
Plate p. 92

13. *Evolution*, 1992
Oil on wood
96 × 288 inches
Collection of George R.
Stroemple
Plate pp. 32–33

14. **Harvest*, 1992
Oil on wood
68 × 112 inches
Patricia Bell
Plate pp. 74–75

15. *The Trough*, 1992
Oil on wood
40 × 48 inches
Museum of Sex, New York,
Gift of the Peter Norton
Foundation
Plate p. 72

16. *Biosphere: Mircoorganisms and
Invertebrates*, 1993
Oil on wood
18 × 24 inches
Carlos Brillembourg, Architect
Plate p. 78

17. **Biosphere: Monterey Bay*, 1993
Oil on wood
56 × 24 inches
Laura-Lee Woods
Plate p. 79

18. *Biosphere: Orchids*, 1993
Oil on wood
18 × 24 inches
Chuck and Joyce Shenk
Plate p. 77

19. **Concrete Jungle V*, 1993–94
Oil and acrylic on wood
56 × 44 inches
Private Collection
Plate p. 93

20. *Biosphere: Hydrographer's
Canyon*, 1994
Oil on wood
48 × 40 inches
Andrea Feldman Falcione
and Greg Falcione
Plate p. 38

21. *Bromeliad: Kaieteur Falls*, 1994
Oil and lacquer on wood
40 × 32 inches
Nestlé USA
Plate p. 80

22. *Varzia*, 1994
Oil, sand, leaves, and poly-
mer medium on wood
84 × 72 inches
Cincinnati Art Museum,
Ohio, Museum Purchase,
Gift of the Docent Committee
and Bequest of Mr. and Mrs.
Walter J. Wichgar
Plate p. 88

23. *Bat Pursues Moth*, 1995
Oil on wood
14 × 11 inches
Courtesy of the Artist and
Waqas Wajahat, New York
Plate p. 84

24. *Drainage Ditch: Georgetown* 1995
Oil on wood
60 × 100 inches
Morris and Sherry Grabie,
Los Angeles, California
Plate pp. 90–91

25. *Flies*, 1995
Oil on wood
11 × 14 inches
London Shearer Allen
Plate p. 85

26. *Juvenile Mantis on Bromeliad Leaf*, 1995
Oil on wood
11 × 14 inches
Katherine Dunn
Plate p. 83

27. *Kapok Tree*, 1995
Oil on wood
96 × 64 inches
Haggerty Museum of Art,
Marquette University,
Milwaukee, Gift of Peter
Norton
Plate p. 82

28. *Water Droplet*, 1995
Oil on wood
14 × 11 inches
Barry Blinderman
Plate p. 86

29. *Drunken Bees*, 1996
Oil on wood
14 × 11 inches
Jay Gorney, New York
Plate p.87

30. *Host and Vector*, 1996
Oil on wood
84 × 72 inches
Whitney Museum of
American Art, New York,
Gift of the Nye Family
Plate p. 81

31. *Airport*, 1997
Envirotex, digitized photograph, vacuum-formed
Styrofoam with aluminum
finish, Plasticene, oil paint,
and laughing gull specimen
on wood
56 × 44 × 4 ½ inches
Collection of Rachel and
Jean-Pierre Lehmann
Plate p. 95

32. *Ecotourist*, 1997
Envirotex, digitized photograph, artificial plants, carved
Styrofoam, botanical models,
latex rubber, synthetic hair,
nylon waist pouch, metal wedding ring, Fresnel lens, plastic
taxidermy human eyeball,
acrylic, and oil paint
56 × 88 × 5 inches
Collection of Gillian
Anderson
Plate pp. 96–97

33. *Golf Course*, 1997
Envirotex, digitized photograph, trash, oil paint,
Astroturf, golf ball and club,
soil, and cast plastic human
femur on wood
40 × 32 × 4 ½ inches
Collection of Ruth and Jacob
Bloom, California
Plate p. 42

34. *Ready to Rumble*, 1997
Oil on wood
40 × 60 inches
Private Collection,
New York City
Plate p. 94

35. *Recent History of the World*, 1997–98
Oil and acrylic on wood
58 × 255 ¾ inches
School of Aquatic & Fishery
Sciences, University of
Washington, Seattle
Plate pp. 152–53

36. *Fragments*, 1998
Oil and acrylic on wood
64 × 96 inches
Chuck and Joyce Shenk
Plate p. 148

37. *The Hammock*, 2000
Oil on wood
60 × 72 inches
Collection of Ninah and
Michael Lynne
Plate p. 98

38. *The Conversation*, 2001
Oil and acrylic on wood
72 × 84 inches
Collection of Richard
Edwards, Aspen, Colorado
Plate p. 99

39. *The Farm*, 2001
Oil and acrylic on wood
96 × 120 inches
Joy of Giving Something, Inc.
Plate p. 48

40. *Gymnorhamphichthcys Bogardus*, 2001
Oil on wood
84 × 72 inches
William G. Spears
Plate p. 100

41. *The Bass*, 2002
Oil on wood
56 × 44 inches
Collection of Thomas Lee
and Ann Tenenbaum
Plate p. 102

42. *Cataclysm*, 2003
Oil and acrylic on wood
48 × 40 inches
Collection of Melva
Bucksbaum and
Raymond Learsy
Plate p. 103

43. *Manifest Destiny*, 2003–4
Oil and acrylic wood
96 × 288 inches
Courtesy of the Artist and
Waqas Wajahat, New York
Plate pp. 106–7

44. *Sea World*, 2004
Oil and acrylic on wood
96 × 120 inches
Virginia Museum of Fine
Arts, Richmond, Gift of
Pamela K. and William A.
Royall Jr.
Plate pp. 104–5

45. *Capitol Hill*, 2005
Oil on wood
32 × 40 inches
Mr. and Mrs. Jonathan Lee
Plate p. 54

46. *Disney World I*, 2005
Oil on wood
72 × 84 inches
Beth Rudin DeWoody
Plate p. 110

47. *Gateway Arch*, 2005
Oil on wood
40 × 32 inches
Private Collection
Plate p. 108

48. *High Jump*, 2005
Oil on wood
56 × 44 inches
Judy and Robbie Mann
Plate p. 115

49. *Mangrove*, 2005
Oil on wood
56 × 44 inches
Private Collection, New
York; Courtesy of Elizabeth
Schwartz, LLC, New York
Plate p. 114

50. *Mount Rushmore*, 2005
Oil on wood
40 × 32 inches
Jeffrey Seller and
Joshua Lehrer
Plate p. 109

51. *East 82nd Street*, 2006
Oil on wood
80 × 68 inches
The Pappas Family, Boston
Plate p. 112

52. *Hollywood at Night*, 2006
Oil on wood
64 × 96 inches
Mr. and Mrs. Henry P. Davis
Plate p. 111

53. *The Pelican*, 2006
Oil on wood
56 × 44 inches
Private Collection, New
York; Courtesy of Waqas
Wajahat, New York
Plate p. 113

54. *Blue Tornado*, 2007
Oil on gessoed paper
75 × 50 ½ inches
Private Collection
Plate p. 57

55. *Old Dirt Road*, 2007
Oil on gessoed paper
75 ¼ × 51 inches
Pamela C. Alexander,
Aspen, Colorado
Plate p. 116

56. *Supergrid*, 2007
Oil on gessoed paper
75 ¼ × 51 inches
Michael Polsky
Plate p. 117

57. *Cambridgeshire*, 2008
Oil on gessoed paper
51 × 75 ⅛ inches
Collection of Melva
Bucksbaum and
Raymond Learsy
Plate p. 118

58. *Only You*, 2008
Oil on wood
54 × 96 inches
Courtesy of Tim Nye
Plate p. 122

59. *Railyard*, 2008
Oil on gessoed paper
51 ¾ × 75 inches
Warren G. Lichtenstein
Plate p. 119

60. *South*, 2008
Oil on gessoed paper
75 × 358 ¾ inches
The Pappas Family, Boston
Plate pp. 120–21

61. *The Reef*, 2009
Oil and resin on wood panel
64 × 36 inches
Pamela K. and William A.
Royall Jr.,
Richmond, Virginia
Plate p. 123

BIOGRAPHY

Born 1962,
New York, NY

EDUCATION

1980–82
Rhode Island School of
Design, Providence

1983–85
School of Visual Arts,
New York, NY

SELECTED SOLO EXHIBITIONS

An asterisk () indicates an exhibition publication
is listed in Selected Bibliography.*

2009 *Half-Life*, NyeHaus, New York,
NY, March 17–April 18

*Motion Parallax: Jason Fox and Alexis
Rockman*, Franklin Parrasch
Gallery, New York, NY,
February 26–April 25

2008 *Aqua Vitae*, Baldwin Gallery,
Aspen, CO, December 26–
January 31, 2009

**The Weight of Air*, The Rose Art
Museum, Brandeis University,
Waltham, MA, May 8–July 27

South, Leo Koenig Inc., New
York, NY, March 28–April 26

Barometric Pressure, Sabine Knust
Galerie Maximilian Verlag,
Munich, Germany, January 25–
March 1

2006 **American Icons*, Leo Koenig Inc.,
New York, NY, April 8–May 5

**Big Weather*, Baldwin Gallery,
Aspen, CO, March 17–April 16

2005 **Fresh Kills*, Gary Tatintsian
Gallery, Moscow, Russia, May 1–
August 31

2004 **Manifest Destiny*, Brooklyn
Museum of Art, NY, April 17–
September 12; traveled to Grand
Arts, Kansas City, MO, January
14–February 26, 2005; Addison
Gallery of American Art,
Andover, MA, March 12–June 5,
2005; Rhode Island School of
Design, Providence, June 17–
September 18, 2005

**Wonderful World*, Camden Arts
Centre, London, England,
April 23–June 24

2003 *New Watercolors*, Baldwin Gallery,
Aspen, CO, November 28–
December 22

Recent Paintings, Gorney Bravin +
Lee, New York, NY, March 14–
April 19

2002 *The Great Outdoors*, Baldwin Gallery,
Aspen, CO, February 15–March 12

2001 **Future Evolution*, Henry Art Gallery,
University of Washington, Seattle,
April 27–August 19

2000 *Expedition*, Gorney Bravin + Lee,
New York, NY, October 14–
November 11

The Farm, Creative Time, New
York, NY, September 5–30

1999 *Tar from the Pits of LaBrea*, Works on Paper, Inc., Los Angeles, CA

Alexis Rockman: A Recent History of the World, The Aldrich Museum of Contemporary Art, Ridgefield, CT, March 21–May 23

1998 *Works on Paper*, London Projects, London, England

1997 *Dioramas*, Jay Gorney Modern Art, New York, NY, May 16–June 28; Contemporary Arts Museum, Houston, TX, November 21–January 11, 1998

1996 *Dioramas*, London Projects, London, England

Alexis Rockman: Zoology A–Z, Wildlife Interpretive Gallery, The Detroit Zoological Society, Royal Oak, MI

1995 *Neblina*, Koyanagi Gallery, Tokyo, Japan

Alexis Rockman: Second Nature, Illinois State University Gallery, Normal, August 17–September 29; traveled to Portland Art Museum, OR, June 5–July 23; Cincinnati Art Museum, OH, October 22–December 31; Tweed Museum of Art, Duluth, MN, February 6–March 17, 1996

Guyana Paintings, Tom Solomon's Garage, Los Angeles, CA

Works on Paper: Guyana, Jay Gorney Modern Art, New York, NY

Guyana Paintings, Studio Guenzani, Milan, Italy

1994 *Alexis Rockman*, Gian Enzo Sperone, Rome, Italy, September 29

1993 *Biosphere*, Jay Gorney Modern Art, New York, NY

1992 *Alexis Rockman*, The Carnegie Museum of Art, Pittsburgh, PA, December 12–January 31, 1993

Evolution, Sperone Westwater Gallery, New York, NY, October 1–November 28

Alexis Rockman, Jay Gorney Modern Art, New York, NY, January 7–February 1

Alexis Rockman, Tom Solomon's Garage, Los Angeles, CA, January 11–February 2

1991 John Post Lee Gallery, New York, NY

Galerie Thaddaeus Ropac, Salzburg, Austria, May 17–June 22

1990 Jay Gorney Modern Art, New York, NY

1989 Fawbush Gallery, New York, NY

Jay Gorney Modern Art, New York, NY

1988 Michael Kohn Gallery, Los Angeles, CA

Currents: Alexis Rockman, The Institute of Contemporary Art, Boston, MA, January 28–March 27

1987 McNeil Gallery, Philadelphia, PA

Jay Gorney Modern Art, New York, NY

1986 Jay Gorney Modern Art, New York, NY

Michael Kohn Gallery, Los Angeles, CA

1985 Patrick Fox Gallery, New York, NY

SELECT GROUP EXHIBITIONS

2010 *Prospect .2 New Orleans*,
New Orleans, LA,
November 13–February 13, 2011

2008 *NY Future Tense: Reshaping the
Landscape*, Neuberger Museum of
Art, Purchase, NY, May 11–
July 20

*Feeling the Heat: Art, Science and
Climate Change*, Deutsche Bank
Gallery, New York, NY,
May 20–October 24

**Badlands*, MASS MoCA, North
Adams, MA, May 24–April 12,
2009

Moving Towards a Balanced Earth,
Museum of New Zealand Te Papa
Tongarewa, Wellington, June 5–
November 16

Paradiso Terrestre, Bonelli Arte
Contemporanea, Canneto
sull'Oglio, Italy, October 25–
February 19, 2009

2007 *The Disappearance*, Galeria Llucia
Homs, Barcelona, Spain,
September–October

**Molecules That Matter*, The Frances
Young Tang Teaching Museum
and Art Gallery, Skidmore
College, Saratoga Springs,
NY, September 8, 2007–
April 13, 2008; traveled to
Chemical Heritage Foundation,
Philadelphia, PA, August 18,
2008–January 9, 2009; College
of Wooster Art Museum, MA,
March 24–May 10, 2009

Baroque Biology: Tony Matelli and
Alexis Rockman, Contemporary
Arts Center, Cincinnati, OH,
May 4–July 22

Landscape: Form and Thought,
Ingrao Gallery, New York, NY,
May 3–July 14

Failure (Scheitern),
Landesgalerie, Linz, Austria,
June 21–August 19

*Surrealism and Beyond in the Israel
Museum*, Israel Museum,
Jerusalem

2006 *Into Me / Out of Me*, P.S.1/MoMA,
New York, NY, June 25–
September 25; traveled to KW
Institute for Contemporary Art,
Berlin, Germany, November
26–March 4, 2007; MACRO
Museo d'Arte Contemporanea
Roma, Rome, Italy

**Cryptozoology: Out of Time, Place,
Scale*, Bates College Museum of
Art, Lewiston, ME, June 24–
October 7

2005 *Future Noir*, Gorney Bravin + Lee,
New York, NY

2003 *Pulp Art: Vamps, Villains, and Victors
from the Robert Lesser Collection*,
Brooklyn Museum of Art,
Brooklyn, NY, May 16–April 19

2002 *The Empire Strikes Back*, The ATM
Gallery, New York, NY, March–
April 28

2000 **Desert and Transit*, Schleswig-
Holsteinischer Kunstverein,
Kunsthalle zu Kiel, Germany,
July 16–September 10; trav-
eled to Museum der bildenden
Kunste, Leipzig, Germany,
November 16–January 21, 2001

*Paradise Now: Picturing the Genetic
Revolution*, Exit Art, New York,
NY, September 9–October 28;
traveled to University of Michigan
Museum of Art, Ann Arbor,
March 17–May 27, 2001; The
Frances Young Tang Teaching
Museum and Art Gallery,
Skidmore College, Saratoga
Springs, NY, September 16,
2001–January 6, 2002

"OO," Barbara Gladstone Gallery, New York, NY, July–August

Small World: Dioramas in Contemporary Art, Museum of Contemporary Art, San Diego, CA, January 23–April 30

1999 *Get Together: Art as Teamwork*, Kunsthalle Wien, Austria, October 8–January 9, 2000

1997 *Gothic: Transmutations of Horror in Late Twentieth-Century Art*, The Institute of Contemporary Art, Boston, MA, April 24–July 6

1996 *Screen*, Friedrich Petzel Gallery, New York, NY, January 19–February 24

1993 *Some Went Mad, Some Ran Away*, The Serpentine Gallery, London, England; traveled to Nordic Arts Centre, Helsinki, Finland; Kunstverein Hannover, Germany; Museum of Contemporary Art, Chicago, IL; Louisiana Museum of Modern Art, Humlebæk, Denmark

1992 *Transgressions in the White Cube: Territorial Mappings*, Suzanne Lemberg Usdan Gallery, Bennington College, Vermont, November 17–December 16

Group exhibition with Ellen Berkenblit, Albert Oehlen, Alexis Rockman, Philip Taaffe, and Christopher Wool, Luhring Augustine Gallery, New York, NY, May 2–June 5

1990 *The (Un)Making of Nature*, Whitney Museum of American Art, Downtown at Federal Reserve Plaza, New York, NY, May 31–July 27

1989 *The Silent Baroque*, Galerie Thaddaeus Ropac, Salzburg, Austria, May 30–August 30

SELECTED BIBLIOGRAPHY

BOOKS, EXHIBITION CATALOGS, AND BROCHURES

Adler, Tracy L. *Nature Is Not Romantic*. Exh. cat. New York: Hunter College of the City University of New York, 1999.

Alexis Rockman. Exh. cat. New York: Jay Gorney Modern Art; Los Angeles, CA: Tom Solomon's Garage, 1992. Index by Douglas Blau.

Alexis Rockman. Exh. cat. New York: John Post Lee Gallery, 1991. Essay by Joshua Decter.

Alexis Rockman. New York: Monacelli Press, 2003. Essays by Jonathan Crary, Stephen Jay Gould, and David Quammen.

Alexis Rockman: Big Weather/American Icons. Exh. cat. New York: Leo Koenig; Aspen, CO: Baldwin Gallery, 2006. Introduction by Dorothy Spears. Essays by Robert Rosenblum and Bill McKibben.

Alexis Rockman: Biosphere. Exh. postcards. New York: Jay Gorney Modern Art, 1994.

Alexis Rockman: Dioramas. Exh. brochure. Houston, TX: Contemporary Arts Museum, Houston, 1997. Essay by Alexandra Irvine.

Alexis Rockman: Evolution. Exh. cat. New York: Sperone Westwater, 1992.

Alexis Rockman: Fresh Kills. Exh. cat. Moscow: Gary Tatintsian, 2005. Essay by Dorothy Spears.

Alexis Rockman: Guyana. Santa Fe, NM: Twin Palms/Twelvetrees Press, 1996. Essay by Katherine Dunn.

Alexis Rockman: Manifest Destiny. Exh. cat. New York: Brooklyn Museum of Art, 2004. Essay by Maurice Berger.

Alexis Rockman: A Recent History of the World. Exh. brochure. Ridgefield, CT: Aldrich Museum of Contemporary Art, 1999. Essay by David Quammen.

Alexis Rockman: Romantic Attachments. Exh. cat. New York: Leo Koenig and Contemporary Arts Center, Cincinnati, 2007. Essay by Matt Distel.

Alexis Rockman: Second Nature. Exh. cat. Normal, IL: University Galleries of Illinois State University, 1995. Essays by Barry Blinderman, Douglas Blau, Stephen Jay Gould, Prudence Roberts, and Peter Ward.

Alexis Rockman: Wonderful World. Exh. cat. London: Camden Arts Centre, 2004. Foreword by Jenny Lomax. Essays by Frances Ashcroft, Dan Cameron, and Francis Fukuyama.

Anker, Suzanne, and Dorothy Nelkin. *The Molecular Gaze: Art in the Genetic Age*. Cold Spring Harbor, NY: Cold Spring Harbor Laboratory Press, 2004.

Bamber, Judie, et al. *(Not So) Simple Pleasures: Content and Contentment in Contemporary Art*. Exh. cat. Cambridge, MA: MIT List Visual Arts Center, 1990.

Bessire, Mark H. C., and Raechell Smith. *Cryptozoology: Out of Time, Place, Scale*. Exh. cat. Lewiston, ME: Bates College Museum of Art; Zurich: JRP/Ringier, 2006.

Bloemink, Barbara J. *Reality Bites: Realism in Contemporary Art*. Exh. cat. Kansas City, MO: Kemper Museum of Contemporary Art and Design, 1996.

Cameron, Dan. *Just What Is It That Makes Today's Homes So Different, So Appealing?* Exh. cat. Glens Falls, NY: Hyde Collection, 1991.

Cappellazzo, Amy. *Wild/Life, or The Impossibility of Mistaking Nature for Culture*. Exh. cat. Greensboro, NC: Weatherspoon Art Gallery, 1998.

Cork, Richard. *Breaking Down the Barriers: Art in the 1990s*. New Haven, CT: Yale University Press, 2003.

Currents: Alexis Rockman. Exh. brochure. Boston: Institute of Contemporary Art, 1988.

Decter, Joshua. *Don't Look Now*. Exh. cat. New York: Thread Waxing Space, 1994.

———. *Screen*. Online exh. cat. New York: Friedrich Petzel, 1996.

———. *Transgressions in the White Cube: Territorial Mappings*. Exh. cat. Bennington, VT: Bennington College, Suzanne Lemberg Usdan Gallery, 1992.

Dion, Mark, and Alexis Rockman, eds. *Concrete Jungle: A Pop Media Investigation of Death and Survival in Urban Ecosystems*. New York: Juno Books, 1996.

Drucker, Johanna. *Sweet Dreams: Contemporary Art and Complicity*. Chicago: University of Chicago Press, 2005.

Ede, Siân. *Art and Science*. New York: I. B. Tauris, 2005.

Fig, Joe. *Inside the Painter's Studio*. New York: Princeton Architectural Press, 2009.

Forum: Alexis Rockman. Exh. brochure. Pittsburgh, PA: Carnegie Museum of Art, 1992. Interview with Alexis Rockman by Richard Armstrong.

Gamwell, Lynn. *Exploring the Invisible: Art, Science, and the Spiritual*. Princeton, NJ: Princeton University Press, 2002.

Get Together—Art as Teamwork. Exh. cat. Vienna, Austria: Kunsthalle Wien, 1999.

Giguere, Raymond J., ed. *Molecules That Matter*. Exh. cat. Philadelphia: Chemical Heritage Foundation and the Frances Young Tang Teaching Museum and Art Gallery at Skidmore College, 2008.

Giovannotti, Micaela, and Joyce Korotkin, eds. *Neo-Baroque!* Exh. cat. New York: Charta, 2006.

Glick, Bernard R., and Jack J. Pasternak. *Molecular Biotechnology: Principles and Applications of Recombinant DNA*. 3rd ed. Washington, DC: ASM Press, 2003.

Godfrey, Tony. *Painting Today*. Oxford: Phaidon, 2009.

Grunenberg, Christoph, ed. *Gothic: Transmutations of Horror in Late Twentieth-Century Art*. Exh. cat. Boston: Institute of Contemporary Art; Cambridge, MA: MIT Press, 1997.

Haw, Richard. *The Brooklyn Bridge: A Cultural History*. New Brunswick, NJ: Rutgers University Press, 2005.

Heartney, Eleanor. *Art and Today*. London: Phaidon, 2008.

Heil, Axel, and Wolfgang Schoppman, eds. *Most Wanted: The Olbricht Collection*. Cologne: Walther König, 2006. Introduction by Jean-Christophe Ammann.

Hirst, Damien. *Some Went Mad, Some Ran Away*. Exh. cat. London: Serpentine Gallery, 1994.

Kane, Mitchell. *Tahiti: Contemporary Art in an Age of Uncertainty*. Northbrook, IL: Hirsch Foundation, 1996.

Leigh, Christian. *The Silent Baroque*. Exh. cat. Salzburg: Thaddaeus Ropac, 1989.

Markonish, Denise, ed. *Badlands: New Horizons in Landscape*. Exh. cat. North Adams: Mass MoCA, 2008.

Maxwell, Douglas. *Flora*. Exh. cat. Sag Harbour, NY: Elise Goodheart Fine Arts, 1998.

———. *Timely and Timeless*. Exh. cat. Ridgefield, CT: Aldrich Museum of Contemporary Art, 1993.

Milner, Richard. *Darwin's Universe: Evolution from A to Z*. Berkeley: University of California Press, 2009. Foreword by Ian Tattersall. Preface by Stephen Jay Gould.

Mitchell, W. J. T. *What Do Pictures Want? The Lives and Loves of Images*. Chicago: University of Chicago Press, 2005.

Morgan, Dahlia. *American Art Today: Night Paintings*. Exh. cat. Miami: Art Museum at Florida International University, 1995.

Nestle, Marion. *Safe Food: Bacteria, Biotechnology, and Bioterrorism*. Berkeley: University of California Press, 2003.

Page, Max. *The City's End: Two Centuries of Fantasies, Fears, and Premonitions of New York's Destruction*. New Haven, CT: Yale University Press, 2008.

Pastemak, Anne R., and Ellen F. Salpeter. *Garbage!* Exh. cat. New York: Thread Waxing Space, 1995.

Philbrick, Jane, ed. *The Return of the Cadavre Exquis*. Exh. cat. New York: Drawing Center, 1993.

Richer, Francesca, and Matthew Rosenzweig, eds. *No. 1: First Works of 362 Artists*. New York: Distributed Art Publishers, 2005.

Robertson, Jean, and Craig McDaniel. *Themes of Contemporary Art: Visual Art after 1980*. New York: Oxford University Press, 2010.

Rosenblum, Robert. *On Modern American Art: Selected Essays*. New York: Harry N. Abrams, 1999.

Rubin, David S., ed. *Birdspace: A Post-Audubon Artists Aviary*. Exh. cat. New Orleans: Contemporary Arts Center, 2004.

Rush, Michael, ed. *Alexis Rockman: The Weight of Air*. Exh. cat. Waltham, MA: Rose Art Museum, Brandeis University, 2008. Essay by Helen Molesworth. Interview with Alexis Rockman by Brett Littman.

Saltz, Jerry, ed. *Beyond Boundaries: New York's New Art*. New York: Alfred van der Marck, 1986.

Sensation: Young British Artists from the Saatchi Collection. Exh. cat. London: Thames and Hudson in association with The Royal Academy of Arts; New York: Thames and Hudson, 1998. Essays by Brooks Adams, Lisa Jardine, Martin Maloney, Norman Rosenthal, and Richard Shone.

Small World: Dioramas in Contemporary Art. Exh. cat. La Jolla, CA: Museum of Contemporary Art, San Diego, 2000. Essays by Toby Kamps and Ralph Rugoff.

Spectacular Optical. Exh. cat. New York: Thread Waxing Space, 1998.

The (Un)Making of Nature. Exh. cat. New York: Whitney Museum of American Art, 1990. Essays by Julia Einspruch and Helen Molesworth.

Ward, Peter. *Future Evolution: An Illuminated History of Life to Come*. New York: New York Times Books, 2001. Foreword by Niles Eldredge.

Wilson, Stephen. *Art + Science Now*. New York: Thames and Hudson, 2010.

———. *Information Arts: Intersections of Art, Science, and Technology*. Cambridge, MA: MIT Press, 2002.

Zummer, Thomas, and Robert Reynolds. *Crash: Nostalgia for the Absence of Cyberspace*. Exh. cat. New York: Thread Waxing Space, 1995.

ARTICLES AND REVIEWS

Agovino, Michael. "Next Up: Alexis Rockman/What a Few of Our Favorite Cultural Figures Are Up To." *Esquire*, June 1997, 34.

"Alexis Rockman: Our True Nature." *Greenpeace.org*, May 6, 2004. http://www.greenpeace.org/international/news/alexis-rockman-our-true-natur.

Appelo, Tim. "Sci-fi movie classics infiltrate paintings." *Oregonian*, June 11, 1995.

Atkins, Amy. "Seeds of the Future." *BoiseWeekly.Com*, April 22, 2009. http://www.boiseweekly.com/boise/seeds-of-the-future/Content?oid=1014618.

Atkins, Robert. "Unnatural Habitats." *Vogue*, May 1995, 172–73.

Baker, Kenneth. "Revisiting Surreal, Nightmarish Visions in the Rockman Show." *San Francisco Chronicle*, April 27, 2004.

Ball, Edward. "Alexis Rockman." *Arts Magazine* 63, no. 8 (April 1989): 80.

Bayliss, Sarah. "Creature Discomfort." *Artnews* 98, no. 3 (March 1999): 52.

Belverio, Glenn. "Stars on Stage: New York." *Condé Nast Traveler*, September 2000, 131.

Bergeron, Chris. "Alexis Rockman Paints Mother Nature in a Foul Mood." *MetroWest Daily News*, June 15, 2008.

Bernard, Sarah. "Jungle Boy." *New York Magazine*, October 16, 2000, 48–49.

Birnbaum, Daniel. "Concrete Jungle (Book Review)." *Artforum International* 36 (November 1997): 48–49.

Braff, Phyllis. "Art Reviews: Flora." *New York Times*, August 9, 1998.

Brenson, Michael. "Straitened Landscapes of a Post-Modern Era." *New York Times*, January 13, 1989.

Brody, David. "Ernst Haeckel and the Microbial Baroque." *Cabinet*, no. 7 (Summer 2002): 25–27.

Cembalest, Robin. "Turning Up the Heat." *Artnews* 107, no. 6 (June 2008): 102–3.

Cline, Elizabeth. "After the Fall." *SeedMagazine.Com*, April 2, 2009. http://seedmagazine.com/content/article/after_the_fall.

Cook, Greg. "The Folk and the Fine." *Boston Phoenix*, June 16, 2008.

Corbett, Rachel and Adam P. Schneider. "Global Warning: A Portfolio." *Artnews* 107, no. 6 (June 2008): 110–13.

Cork, Richard. "From Lambs to Slaughter." *Times* (London), May 3, 1994.

Cotter, Holland. "Art in Review: Crash." *New York Times*, July 29, 1994.

———. "Brooklyn-ness, a State of Mind and Artistic Identity in the Un-Chelsea." *New York Times*, April 16, 2004.

———. "The Tyranny of Time in Every Detail? Creepy." *New York Times*, June 20, 1997.

Dannatt, Adrian. "Some Went Mad . . . Some Ran Away." *Flash Art*, no. 177 (Summer 1994): 61.

Denson, G. Roger. "Alexis Rockman." *Artscribe*, no. 75 (May 1989): 82–84.

———. "Sperone Westwater, New York." *Flash Art*, no. 168 (January/February 1993): 89.

Diaz, Eva. "Review: Future Noir." *Time Out/New York*, February 5–12, 2004, 58.

Dillehay, Thomas D. "The Battle of Monte Verde." *Sciences* 37, no. 1 (January/February 1997): 28–33.

Dion, Mark. "The Origin of Species: Alexis Rockman on the Prowl." *Flash Art*, no. 172 (October 1993): 114–15.

Donohoe, Victoria. "Exhibit Broadens Range of Sci-Fi Art." *Philadelphia Inquirer*, July 13, 2003.

Dorment, Richard. "Science Friction." *Daily Telegraph*, January 11, 1995.

Dunn, Katherine. "Eden Rocks: The Art of Alexis Rockman." *Artforum International* 34, no. 6 (February 1996): 72–75, 109.

Eldredge, Niles, and Alexis Rockman. "Abundance and Scarcity: Thoughts on Biodiversity." *Documents* (Winter 1998): 5–15.

Eskin, Blake. "Creature Discomforts." *Artnews* 103, no. 10 (November 2004): 104.

Fehlau, Fred. "Alexis Rockman." *Flash Art*, no. 140 (May/June 1988): 109.

Fishman, Steve. "Beast Master." *Wired*, April 2004, 150–55.

Francis, Kevin. "Natural Wonders." *Williamette Week*, June 7, 1995.

Gambino, Erica-Lynn. "Perspectives: Symbolism in Two Shows." *Southampton Press*, August 6, 1998.

Gardner, Paul. "Flora, Fauna and Fossils in the Drawings of Alexis Rockman." *Art on Paper* 6, no. 2 (November–December 2001): 58–63.

———. "It's Not Over Until—." *Artnews* 101, no. 5 (May 2002): 154–57.

———. "Studio Visits: Pleasure, Pain & Protocol." *Artnews* 95, no. 3 (March 1996): 106–9.

Geer, Suvan. "A Bow to Hitchcock." *Los Angeles Times*, March 16, 1990, 24.

Genocchio, Benjamin. "Art Review: Sometimes Birds Are Symbols, Sometimes Just Birds." *New York Times*, November 28, 2004.

———. "More Than Just a Pretty Scene." *New York Times*, March 14, 2004.

———. "Today's Landscape, Tomorrow's Dystopia." *New York Times*, June 1, 2008.

Gimelson, Deborah. "Art and Commerce." *New York Observer*, June 12, 1995.

Gladman, Randy. "Fresh Kills." *Artext*, no. 76 (Spring 2002): 24–25.

Gorman, James. "Amphibian Rights: The Frog That Insisted on Being a Frog." *Sciences* 28, no. 3, (May/June 1988): 18–21.

Green, Penelope. "Mirror, Mirror; Rockwell, Irony Free." *New York Times*, October 28, 2001.

Green, Roger. "At Cranbrook, Works of Disquieting Beauty." *Ypsilanti Press*, October 10, 1996.

Greenfield-Sanders, Timothy. "Up, Up, and Away." *Art Review* 2, no. 7 (July/August 2004): 80–83.

Greenman, Ben. "Concrete Jungle." *Time Out/New York*, March 20–27, 1997, 52.

Greeven, Cristina. "The Return of the Cadavre Exquis." *Manhattan File*, May 1995.

Grega, Chris. "Alexis Rockman at Gorney Bravin + Lee." *NYArts*, December 2000, 77.

Grimes, Nancy. "Jay Gorney Modern Art." *Artnews* 91, no. 4 (April 1992): 120.

Hakanson Colby, Joy. "Exhibitionists: A Young New York Surrealist." *Detroit News*, August 28, 1996.

———. "N.Y. Artist Rockman Turns Nature on Its Ear." *Detroit News*, September 12, 1996.

Halard, François. "Portraits of the Artists as Young Men: Comme des Garçons. . . ." *GQ*, February 1995, 164–69.

Halkin, Talya. "Reviews: Alexis Rockman." *Time Out/New York*, April 3, 2003, 57.

Halle, Howard. "Take Out: A Sampling of the Best Things to See and Do This Week." *Time Out/New York*, May 15–22, 1997, 2.

Hayes, Jonathan. "The Picture of Alexis Rockman." *Detour*, November 1997, 81–82.

Hayt, Elizabeth. "Nature Painting That Looks Unnatural." *New York Times*, October 15, 2000.

———. "What We're Wearing Now: A Restaurateur and an Artist." *New York Times*, June 23, 2002.

Heartney, Eleanor. "Alexis Rockman." *Artnews* 88, no. 4 (April 1989): 211.

Helfand, Glen. "Naughty by Nature." *San Francisco Bay*, November 18–24, 1998, 54–55.

Hess, Elizabeth. "Secret Garden: Alexis Rockman." *Village Voice*, January 28, 1992, 91.

Hoban, Phoebe. "The Frog Prince." *Artnews* 98, no. 8 (September 1999): 138–41.

Hoberman, J. "Reviews: Spectacular Optical." *Village Voice*, June 30, 1998, 161.

Hubbard, Sue. "Alexis Rockman." *Time Out/London*, February 4–11, 1998.

Indiana, Gary. "From Organism to Architecture." *Village Voice*, March 5, 1985, 83.

Johnson, Barry. "Creature Feature." *Oregonian*, June 11, 1995.

Johnson, Ken. "Alexis Rockman at Jay Gorney." *Art in America* 77, no.6 (June 1989): 168–69.

———. "A Landfill in the Eyes of Artists Who Beheld It." *New York Times*, February 1, 2002.

Johnson, Patricia C. "Rockman's images seduce, educate." *Houston Chronicle*, December 9, 1997.

Kalina, Richard. "Alexis Rockman at Jay Gorney Modern Art." *Tema Celeste*, April/June 1991.

Karabell, Zachary. "Grime Statistics." *Village Voice*, April 8, 1997, 50.

Kaufman, Jason Edward. "Brooklyn Museum Unveils $63 Million Makeover." *Art Newspaper*, April 17, 2004.

Kimmelman, Michael. "Alexis Rockman/Jay Gorney Modern Art." *New York Times*, January 12, 1990.

———. "Art Review; Flags, Mom and Apple Pie Through Altered Eyes." *New York Times*, November 2, 2001.

Kino, Carol. "Alexis Rockman." *Artnews* 94, no. 10 (December 1995): 139–40.

———. "Jay Gorney Modern Art." *Artnews* 92, no. 9 (November 1993): 160.

———. "New York Round-Up." *Modern Painters* 6 (Winter 1993).

Kirschbaum, Susan M. "Questionnaire: Escape Artists." *New York Times Magazine*, April 1, 2001.

Klemic, Mary. "Science Friction: 'Second Nature' examines strange world." *Observer and Eccentric*, October 17, 1996.

Knight, Christopher. "Nature and Culture: Alexis Rockman." *Los Angeles Times*, July 23, 1999, F31.

Kohen, Helen L. "Talent in the Dark: Artists shine with paintings of night." *Miami Herald*, January 21, 1995.

Kosenko, Peter. "Alexis Rockman." *Art Issues*, no. 22 (March/April 1992): 33.

Krinsky, Anne. "Alexis Rockman: The Weight of Air." *Art New England* 29, no. 5 (August/September 2008): 44.

Lander, Eric S. "In the Wake of Genetic Revolution, Questions About Its Meaning." *New York Times*, September 12, 2000.

Larson, Kay. "Speak, Memory." *New York Magazine*, January 23, 1989, 76–77.

———. "Sperone Westwater." *New York Magazine*, November 16, 1992, 91.

Laster, Paul. "Review: Nonfiction-Art." *Boldtype*, no. 3 (January 2004).

Latter, Ruth. "A Complicit! Affair." *Daily Progress*, September 21, 2006, D1–D2.

Laurance, William F., et al. "Fragments of the Forest." Special Issue, *Natural History* 107, no. 6 (July/August 1998).

Liebman, Lisa. "'Slow Art' at P.S.1." *Interview Magazine* 22, no. 5 (May 1992): 61.

Leigh, Christian. *Flash Art*, no. 146 (May/June 1989): 113–14.

Leith, Anne. "Alexis Rockman: Gorney Bravin + Lee." *Modern Painters* 16, no. 2 (Summer 2003): 123–24.

"Let Us Count the Ways [1–9]." *New York Times Magazine*, November 11, 2001, 78.

Levin, Kim. "Choices Art: Alexis Rockman." *Village Voice*, January 31, 1989, 44.

———. "Choices Art: Alexis Rockman." *Village Voice*, January 22, 1991, 91.

———. "Earthworks." *Village Voice*, July 4, 1989, 97.

———. "Sperone Westwater." *Village Voice*, November 10, 1992, 75.

———. "Voice Choices." *Village Voice*, September 21, 1993, 73.

———. "Voice Choices: Alexis Rockman." *Village Voice*, October 31, 2000, 102.

Lewinson, David. "Small World: Dioramas in Contemporary Art at MCA San Diego." *Artweek* 31, no. 3 (March 2000): 21–22.

Lewis, James. "Alexis Rockman." *Artforum International* 28, no. 7 (March 1990): 163.

Lombardi, D. Dominick. "A Show That Shapes Perception of Animals." *New York Times*, December 5, 1999.

Long, Andrew. "In Rockman's Nature." *Departures*, March–April 2003, 102.

Lovelace, Carey. "How to Visit a Studio." *Artnews* 103, no. 9 (October 2004): 178–79.

Lyman, David. "Critic's Choice." *Detroit Free Press*, September 4, 1996.

———. "Other-worldly Paintings Have Art Down to a Science." *Detroit Free Press*, October 25, 1996.

MacAdam, Barbara. "Splashing in the Gene Pool." *ID* 51, no. 2 (March/April 2004): 56–59.

Mahoney, Robert. "New York in Review." *Arts Magazine* 64, no. 8 (April 1990): 108–9.

———. "Reviews: Spectacular Optical." *Time Out/New York*, June 18–25, 1998.

Marincola, Paula. "Jay Gorney Modern Art; Exhibit." *Artnews* 87, no. 3 (March 1988): 212.

"Mark Dion and Alexis Rockman: Concrete Jungle." *Journal of Contemporary Art* 4.1 (1991): 24–33.

Martin, Richard. "Alexis Rockman: An Art Between Taxonomy and Taxidermy." *Arts Magazine* 62, no. 2 (October 1987): 22–24.

McAllister, Jackie, and Alexis Rockman. "Mud Drawings." *Grand Street*, no. 57 (Summer 1996): 2–3, 155–64.

McCormick, Carlo. "Science/Fiction: Painter Alexis Rockman's Believe It or What." *Paper*, May 1997, 19.

McKibbon, Bill. "The Present Future." *Orion*, January–February 2006, 28–37.

Meehan, Emily. "Great Escape: Peep Show." *Time Out/New York*, February 10–17, 2000.

Melrod, George. "Openings: Exploring the World Around Us." *Art and Antiques* 18 (June 1995): 29.

———. "Something Wild." *Mirabella*, August 1994, 40–42.

Miles, Chris. "Supernature." *Bay Area Reporter*, January 8, 1998.

Miller, Francine Koslow. "Alexis Rockman, Rose Art Museum." *Artforum International* 47, no. 1 (September 2008): 465.

Mueller, Cookie. "Alexis Rockman." *Details*, April 1985.

———. "Art and About." *Details*, May 1987, 56–57.

Mumford, Steve. "Alexis Rockman: Dioramas." *Review Magazine*, June 1997, 6–7.

"My New York; Places That Changed Us: Alexis Rockman." *New York Magazine*, December 18, 2000, 118.

Nathan, Jean. "Portrait of an Artist." *New York Observer*, February 12, 1991.

Newhall, Edith. "It's a Jungle Out There." *New York Magazine*, October 12, 1992.

Ollman, Leah. "Tiny Worlds Create Grand Illusions." *Los Angeles Times*, January 23, 2000, 69.

Pagel, David. "Alexis Rockman: Unholy Alliance of Disney, Bosch." *Los Angeles Times*, January 16, 1992, F5.

———. "An Eye for Putrescence." *Los Angeles Times*, June 21, 1995, F8.

Pasfield, Veronica. "A Museum Elevated to the Edge." *Hour Detroit Magazine*, Fall 1996.

Patterson, Tom. "The Arts: Animalistic Art." *Winston-Salem Journal*, May 10, 1998.

Paumgarten, Nick. "Salesman." *New Yorker*, October 17, 2006, 144–55.

Pearse, Emma. "Artist Alexis Rockman on the Montauk Monster and the Even Uglier Art Market." *New York Magazine*, March 16, 2009. http://nymag.com/daily/entertainment/2009/03/artist_alexis_rockman_on_paint.html.

Pincus, Robert L. "Massive Painting is Exhibit All by Itself." *San Diego Union-Tribune*, December 18, 1994, E2.

———. "One Man's Trash; Diorama Artist Treasures What Can Be Learned at the Landfill." *San Diego Union-Tribune*, January 20, 2000.

———. "'World' Toys with Magic of Dioramas." *San Diego Union-Tribune*, February 6, 2000, E3.

Plagens, Peter. "Sketchbook: The Return of the Limp Watch." *Civilization*, 1997, 30–32.

———. "The Soho Scene Lights Up." *Newsweek*, October 11, 1993, 58.

Pollack, Barbara. "Alexis Rockman: Leo Koenig." *Artnews* 105, no. 8 (September 2006): 144.

Pollock, Lindsay. "From Darkness to Light." *Artnews* 103, no. 4 (April 2004): 52.

Quammen, David. "Planet of Weeds: Tallying the Losses of Earth's Animals and Plants." *Harper's* 297 (October 1998): 57–69.

———. "Small Things Considered." *Sciences* 37, no. 6 (November/December 1997): 28–33.

Rau, David D. J. "Alexis Rockman: Aldrich Museum of Contemporary Art." *New Art Examiner* 26, no. 10 (July/August 1999): 55–56.

———. "Alexis Rockman." *New Art Examiner* 24 (March 1997): 46–47.

Rhein, Alice. "Apocalyptic Zoo: Alexis Rockman's Perverse Animal Kingdom." *Detroit Metro Times*, September 25–October 1, 1996, 18–19.

Rimanelli, David. "Alexis Rockman." *New Yorker*, June 9, 1997, 24.

———. "Jay Gorney Modern Art." *Artforum International* 30, no. 8 (April 1992): 94–95.

———. "Jay Gorney Modern Art." *Artforum International* 32, no. 4 (December 1993): 81.

Rockman, Alexis. "Airport 1997." *Natural History* 106, no. 11 (December/January 1997): 66–67.

———. "The Donkey." *Natural History* 107, no. 2 (March 1998): 78–79.

———. "The Ecotourist." *Natural History* 106, no. 9 (October 1997): 82–83.

———. "Golf Course." *Natural History* 106, no. 10 (November 1997): 70.

———. "The Rec-Room." *Natural History* 107, no. 1 (February 1998): 68–69.

———. "Rt. 10." *Natural History* 107, no. 3 (April 1998): 90–91.

Rönnau, Jens. "Desert and Transit." *Kunstforum International*, no. 152 (October–December 2000): 321–24.

Rosenblum, Robert. "A Post-script: Some Recent Neo-Romantic Mutations." *Art Journal* 52, no. 2 (Summer 1993): 74–84.

Runnette, Charles. "Online: Pictures from an Expedition." *New York Magazine*, September 2, 1996, 77.

Saint Louis, Catherine. "The Nature of the Beast." *New York Times Magazine*, October 22, 2000, 144.

Saltz, Jerry. "Borough Hall." *Village Voice*, May 11, 2004, 82.

———. "Notes on a Painting: A Thorn Tree in the Garden." *Arts Magazine* 64, no. 1 (September 1989): 13–14.

———. "Sperone Westwater, New York." *Art in America* 80, no. 12 (December 1992): 113.

———. "A Year in the Life: Tropic of Painting." *Art in America* 82, no. 10 (October 1994): 90–101.

Schjeldahl, Peter. "Screenery." *Village Voice*, February 13, 1996, 77.

———. "Yuck Stop: Alexis Rockman." *Village Voice*, June 10, 1997, 85.

Schubert, Charlotte. "Life on the Edge: Will a Mass-Extinction Usher in a World of Weeds and Pests?" *Science News* 160, no. 11 (September 15, 2001): 168–70.

Searle, Adrian. "Concrete Jungle." *Time Out/London*, January 1994.

———. "Tense? Nervous? It might be art." *Independent*, January 3, 1995.

———. "Tomorrow's World." *Guardian*, April 27, 2004.

Seidler, Rosa. "First Buzz: It's Not Nice to Paint Mother Nature." *Elle*, September 2000.

Semonin, Paul. "Empire and Extinction: The Dinosaur as a Metaphor for Dominance in Prehistoric Nature." *Leonardo* 30, no. 3 (1997): 171–82.

Shaw, Lytle. "Art: Alexis Rockman." *Time Out/New York*, November 9–16, 2000, 81.

Shearing, Graham. "A Startling Look at Evolution." *Tribune Review*, December 13, 1992.

Sirmans, Franklin. "Metamorphosis." *Flash Art*, no. 193 (March/April 1997): 79.

Shick, Malcolm J. "Toward an Aesthetic Marine Biology." *Art Journal* 67, no. 4 (Winter 2008): 62-86.

Smith, Phil. "Alexis Rockman: Second Nature." *Dialogue* (Columbus, OH), November/December 1995, 22, 36.

Smith, Roberta. "Art in Review: Alexis Rockman Jay Gorney Modern." *New York Times*, January 17, 1992.

———. "Art in Review; Before They Became Who They Are." *New York Times*, February 9, 2001.

———. "The Horror: Updating the Heart of Darkness." *New York Times*, June 1, 1997.

———. "More Spacious and Gracious, Yet Still Funky at Heart." *New York Times*, October 31, 1997.

———. "Realism with a Vengeance." *New York Times*, June 13, 1997.

———. "Spectacular Optical." *New York Times*, July 3, 1998, E28.

Smolik, Noemi. "Concrete Jungle." *Artforum International* 30, no. 10 (Summer 1992): 121.

Sozanski, Edward J. "A Painter of Creatures Creates His Own Genre." *Philadelphia Inquirer*, October 29, 1987.

Spears, Dorothy. "Alexis Rockman Goes West." *Aspen Magazine* (Winter 2002): 78–79, 142.

———. "Drawing on Extinction." *Art on Paper* 5, no. 3 (January/February 2001): 26–27.

Steffens, Daneet. "Websites: Guyana." *Entertainment Weekly*, September 13, 1996, 137.

Sterling, Bruce. "The Sleep of Reason." *SeedMagazine.Com*, March 1, 2009, http://seedmagazine.com/content/article/the_sleep_of_reason.

Tager, Alexandra. "'Concrete Jungle' at Marc Jancou." *Art and Auction* 17, no. 5 (December 1994): 50.

Tasker, Georgia. "Creativity Flowers When Artists Turn Eyes, Souls on Their Gardens." *Miami Herald*, January 19, 1997.

Thill, Robert. "Alexis Rockman: Evolving Visions." *Surface*, Fall 1995.

Thorson, Alice. "Seeing the Big Picture." *Kansas City Star*, January 23, 2005.

Thurman, Judith. "Formal Modernism on Park: Young New Yorkers Lend Tradition a Provocative Edge." *Architectural Digest* 53 (May 1996): 100–107.

Tozian, Gregory. "What's So Natural about Nature? The Paintings of Alexis Rockman." *Organica* (Winter 1995): 4–5, cover.

Urstadt, Bryant. "Imagine There's No Oil: Scenes from a Liberal Apocalypse." *Harper's* 313, no. 1875 (August 2006): 31–40.

Vallongo, Sally. "Rockman: Weird Science" and "Detroit Zoo Includes Rockman Works." *Toledo Blade*, October 9, 1996.

Van Meter, Jonathan. "Preternatural Man: Alexis Rockman." *Vogue*, August 1999, 232–37, 274–75.

Walsh, Meeka. "A Frankenstein Poignancy: The Pieced and Painted World of Alexis Rockman." *Border Crossings* 21, no. 4 (November 2002): 44–59.

Ward, Frazer. "Alexis Rockman." *Frieze*, no. 36 (September/October 1997): 85–87.

Wasilik, Jeanne Marie. "Alexis Rockman: Dioramas." *NY Arts Magazine*, June 1997, 22.

Wehr, Anne. "Art: The Funny Farm." *Time Out/New York*, August 31–September 7, 2000.

Weschler, Lawrence. "Fevered Imagination." *Nation*, May 7, 2007, 36–40.

Wilson, Andrew. "Out of Control." *Art Monthly*, no. 177 (June 1994): 3–4.

Yablonsky, Linda. "New York's Watery New Grave." *New York Times*, April 11, 2004.

Zimmer, William. "Nature Comes into Its Own in 'Secret Life of Plants' at Lehman." *New York Times*, February 18, 1990.

INDEX

Note: Italic page numbers refer to plates and figures.

ARTIST'S ACKNOWLEDGMENTS

I wish to offer special thanks to my partner and collaborator, Dorothy Spears, and to her sons Alex and Ferran Brown. I am especially grateful to the collectors and museums who lent their artworks for this show, and to the contributors who have helped make this exhibition possible. Special thanks to my agent, Waqas Wajahat, for working so hard on this show; to Richard Edwards and Kiki Raj at Baldwin Gallery, Aspen; to Jon Kalish, for his help with the book's cover design; and to several people who have worked with me over the years, including Gabe Valencia, Tom Sanford, Martin Basher, Chris Sampson, and Kimi Weart. Finally, much appreciation also goes to the dedicated staff at the Smithsonian American Art Museum for their superb commitment to this exhibition and book.

IMAGE CREDITS